SNAPSHOTS *in* HISTORY'S GLARE

SNAPSHOTS *in* HISTORY'S GLARE

Gore Vidal

Image Research by Ann Schneider

ABRAMS, New York

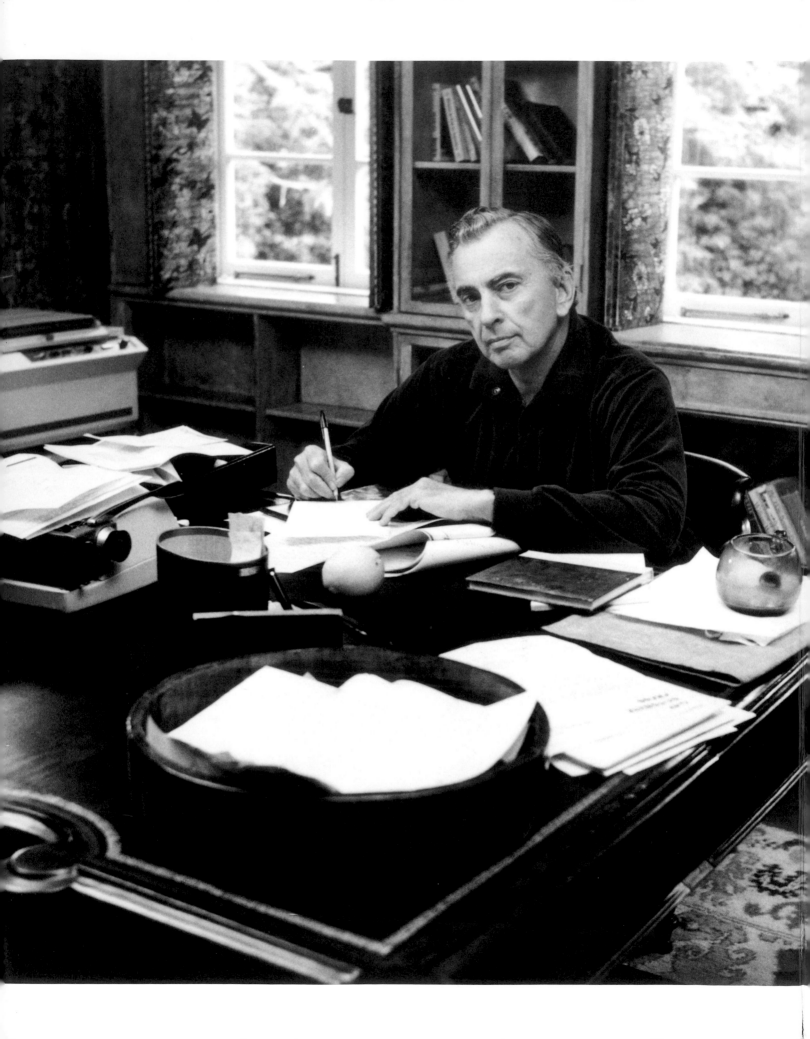

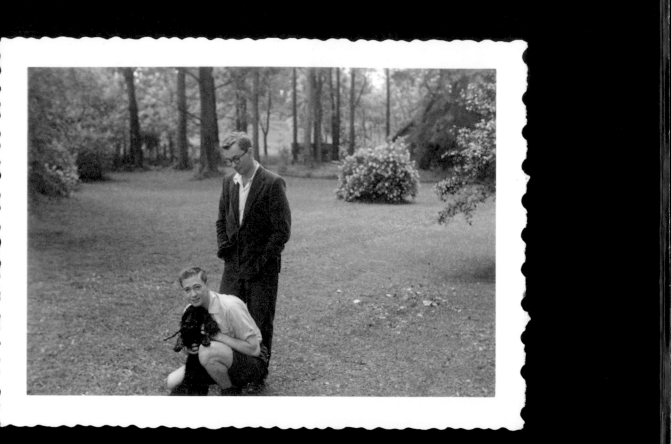

During the fifty-four years that Howard Russell Auster and I shared a life, he took a great many photographs of our friends and acquaintances and occasions, with an eye to eventually making his own book based on his photographs and those years. Upon his death several years ago, he left me his photographs and papers. I have now gone through them, and as a memorial to him, I am now publishing them, with some notes describing the various occasions that we took part in, as well as a number of pictures from my life and times, now becoming, with time's passage, literally historic. Or, as Wolf Blitzer of CNN so wisely reminds us in his reports to the nation, one picture is worth a thousand Blitzers, or something along those lines.

Howard and I at Edgewater in the early fifties.

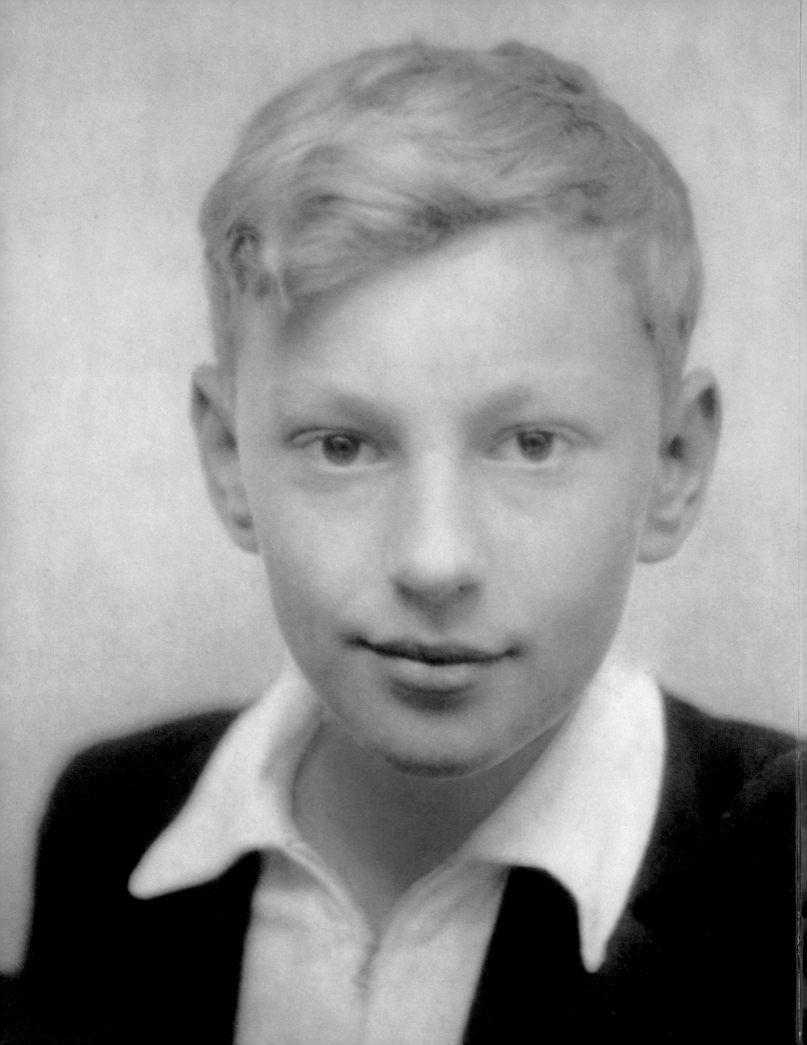

Many years ago an English critic observed to me what a pity it was that the United States had not gone through with an original idea of some of the founding fathers to give eminent families or citizens titles, as they would have been given had they remained on the British Isles, from which most of us had come at that time. The title suggested was margrave, but it never caught on in the absence of a king. George Washington virtuously turned down the title of king on the grounds that having freed the thirteen colonies from the maladministration of King George III, it would be ridiculous for General Washington to then set himself up as King George I. More to the point, had he done so, he had no son, and the laws of succession in a country already in the grips of political factions like Tammany Hall would have created chaos in any matter involving the succession from one reign to another. I said to my British critic, "It is true that we don't

Here I am at
age thirteen.

have titles, except administrative ones as set forth in the Constitution: a full group of senators, in imitation of ancient Rome, and a president, something unique in Anglo-Saxon affairs, as well as Teutonic. How then to cut the Gordian knot? Evolution of our institutions made it quite clear how power was going to be allocated in lieu of a titled aristocracy; we would have, instead, our clearly recognizable-to-others names. And so, to be called John Adams was a far greater thing than to be known as the Duke of Quincy."

Hence, at fourteen, I rid myself of my baptismal Christian name, which was Eugene Luther Vidal, and assumed the family name, Gore, of my maternal grandfather, who organized Oklahoma as the forty-sixth state within the Union and became that state's first senator and so moved to Washington, D.C., where, in due course, thirty years later, he died. His state lives on with a thriving, highly polluted city called Gore, where there also is, I think, a lake and a river and this and that. So, in a way, if you go through any of the U.S. states, particularly in the Mid- and Southwest, you'll find out from the names of towns and cities who the founders were. Each has his legend, often highly exaggerated, but none has his title.

I suspect that Saint Albans, a Washington, D.C. monosexual school, gave us boys as good an education as was available, but I had already been partially educated in my grandfather's library in Rock Creek Park, and here, indeed, is a photograph of Senator T. P. Gore standing in front of some of the twenty thousand books he had collected that were ruined for him by a lady tenant, entirely ignorant of books of any kind, unfortunately, who was inspired to dust all twenty thousand. After this hygienic work had been done, she rearranged all the books, not as he had done, by subject, but by color. So there were red sections and blue sections and absolute chaos. I think his spirit was broken as he realized that never again would he be able to find anything in the attic library, which he had collected with such care.

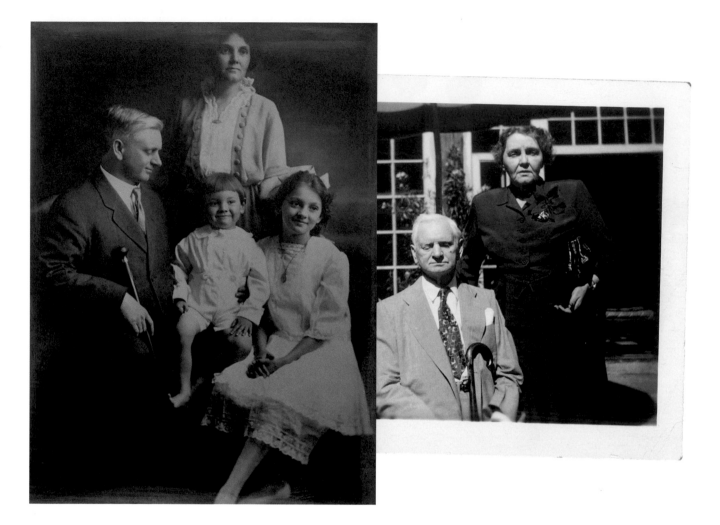

I have forgotten to mention that Mr. Gore, by the age of ten, was blind in both eyes as the result of two separate accidents. Yet he had a great navigational sense, and since he had once known the location of each of his books, before they had been made beautiful by his tenant, he would tell me or his secretary to go to the northwest corner of the library, "tenth shelf to the right, fourth book down." That was how he got some control over his precious library. Although never a fat man, he had a huge belly, hard as a rock. My grandmother, Nina Kay Gore, always said that she couldn't wait for him to be dead so that she could have the stomach opened and see what was inside. Here she is standing behind him in front of the Rock Creek house. And here again is a photograph of Mr. Gore, his son Thomas, and my incorrigible mother, Nina. Mrs. Gore stands back of her, with a look of slight disbelief at what she has brought into the world. Later, when the troubles got worse in the family, she'd always say, "When Nina enters a room it is like an evil spirit." There were always storm clouds over the Gore household.

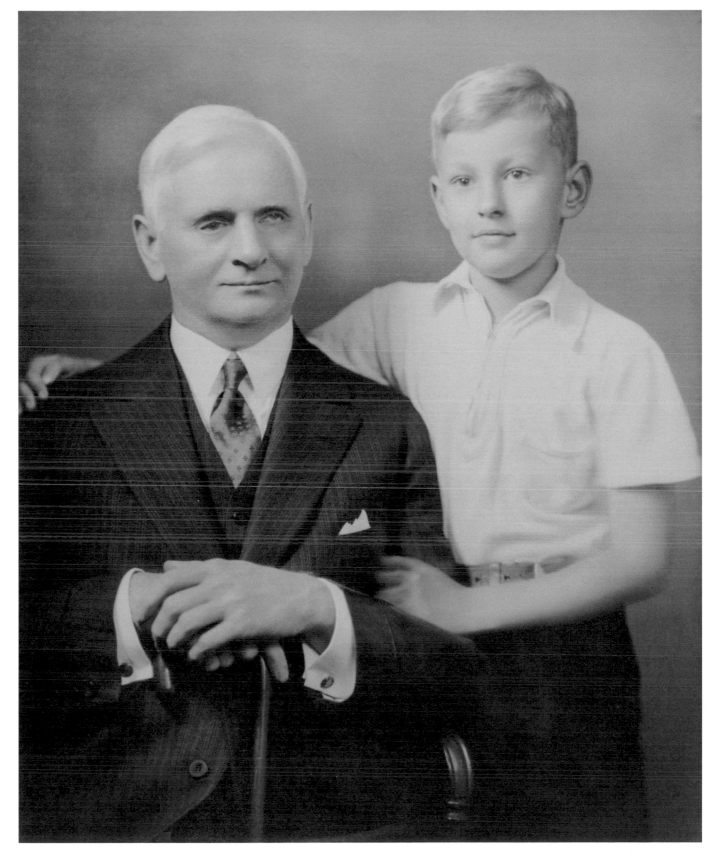

Senator Gore and I in the thirties.

Mr. Gore

Oklahoma

On the floor of the attic there were thousands of newspapers and clippings, never put in any order by any of the Gores or any of the secretaries. One that I found describes the Senator's trial in Oklahoma City, where he had been the victim of what has been called "the badger game." The newspaper is obviously pro-Gore. In this case the badger game was launched by oilmen trying to get their hands on Indian-owned oil fields. The great defender in the Senate of Indian rights was Mr. Gore. He promptly saw to it that an act of Congress that would have awarded to these oilmen rights to Indian-oil land did not pass. The oilmen vowed vengeance against the Senator. So began the badger game. A lady who said she was a constituent rang him at his office and asked if he could meet her at a hotel to discuss an important matter, which proved to be a West Point appointment for her son. The Senator was always available to constituents, so he and his male secretary, at her request, met her at the hotel. The lady asked the Senator to come upstairs with her to a parlor, as the mezzanine was crowded. The "parlor" was actually part of her private suite, and when the blind Senator entered the room, two men followed and the woman began tearing at her clothes. She shouted that she had been attacked. The male "witnesses" to this terrible "crime" asked for money. The Senator called for his secretary who, fortunately, was not far away. The resulting scandal was huge, and my grandmother's highly focused political sense noted later that whenever things looked good for the family, something like this would happen. Rather sensibly, Senator Gore suspected that no jury would believe that an elderly blind man could be led into a room in a strange hotel and then assault a woman unknown to him. He stood his ground. It was a stormy trial, and there was great support for him, as you can see from the clipping preserved in the dust of the floor in the library attic with such loving care by my grandmother, no legendary housekeeper herself. At a noisy trial a jury found Gore innocent, and the criminals were mildly punished.

A BALD-FACED FRAME-UP DECLARES SENATOR GORE DENYING BOND CHARGES

Led to Room He Thought Parlor; Proved to Be Bedroom Infested By Political Enemies Bent His Ruin; Banker Tells of Offer to Drop Suit For Money.

T. P. GORE

A candidate for the U. S. Senate, seeking to replace Senator T. P. Gore, recently spoke in your community.

We ask you to remember that Gore performs more than he promises. Others promise more than they can perform.

Don't trade a TRUE friend for a new friend. Don't swap parachutes in mid air.

WE WANT GORE ONCE MORE
WAR NO MORE

Senator Gore says today as he said in 1917:
"I will never rob the cradle to gorge the dogs of war."

GORE VOLUNTEERS
Chas. L. Wilson, Mgr.

Write us! - - - Join us!

1020 Petroleum Bldg.,
Oklahoma City, Okla.

My father, Eugene Luther Vidal, called Gene, was a natural athlete, although he was once a sickly boy in a place and period in which the Vidals and many other families without money tended to die of tuberculosis. It was suspected that he might become a victim. So his father, whom he did not like, built a jungle gym for him in back of their house in Madison, South Dakota, where he could work out, which he did. (The town and the Vidals have been celebrated by a friend of Hemingway, Robert McAlmon, author of *Village*, a book revered by me as it depicts my father as a young man.)

From Madison, Gene moved on to the University of South Dakota, where he excelled at track and, more important, he was hailed as an All-America quarterback by Grantland Rice, the arbiter of these matters in the press. It was after he led a triumphant South Dakota team to victory that the congressman from his district asked him if he would like to be appointed to West Point. Cautiously, Gene asked where West Point was. He was not thrilled by the distance from Madison, but he accepted the appointment and proceeded to become the most famous college athlete in the history of West Point, as well as a silver medalist in the Olympic Games at Antwerp. My mother fell in love with my father from newspaper images of him and, drawn to stars, saw to it that she could meet the famous athlete at Childs restaurant in New York, where the West Point athletes were hanging out that season. They were married at St. Margaret's Episcopal Church in D.C. when she was only eighteen and he thirty. From the beginning they were ill-matched. He was of a serene nature and she was of a fiery one. She loved to have dramatic rows with people, which neither he nor the rest of us appreciated. Although a member of the new U.S. Army Air Corps and one of the first pilots trained by General "Hap" Arnold, my father abruptly resigned from the military on the grounds that the peace-time army offered no allure. By this time I had been born, and Gene became involved in the formation of a number of commercial airlines, among them what would be later known as TWA, Eastern, and Northeast. (Interestingly, Warren Buffett, the other day on TV, discussing the vagaries of capitalism, noted, accurately, that although airline stocks were the hottest ticket, as it were, in the twenties and thirties, no one ever made a penny of profit from any of

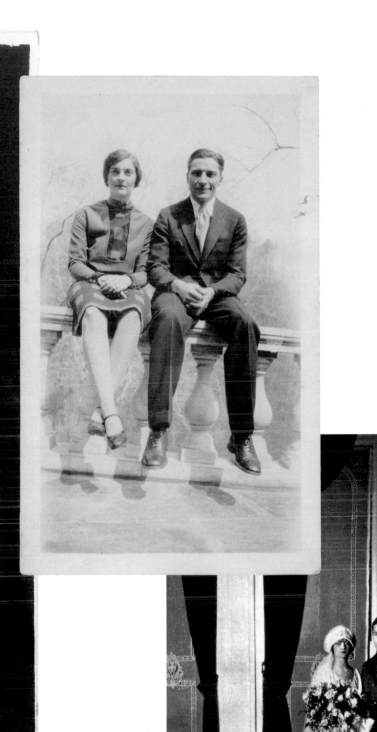

them other than through merger.) Thus, my parents had no place to live, and they moved in with my grandparents, and I was put in a bureau drawer in the house at Rock Creek Park. Apparently, I spent a highly useful meditative year in that drawer. Gene was loved by his in-laws, but less so by his wife, who was already looking for adventure in New York City.

In due course, Nina met a wealthy neighbor, John Hay Whitney, pictured below right, known as Jock. He was first married to Liz Altemus, pictured beside him, a famous horsewoman and breeder, who had decided that Gene Vidal was exactly what she wanted for a new husband. But Gene had other plans, and when he eventually married his second wife, Kit, Liz, who had the skills of a Pinkerton detective, found the newlyweds, and then proceeded to ring every hour on the hour and entertain them with boisterous chat about raising and breeding horses in Warrenton, Virginia. Finally, Liz faded away, as so many people do in this saga.

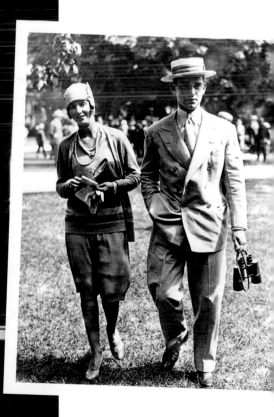

In those days, touring Broadway plays often picked, for bit parts, daughters of notables in the towns where they played. Opposite Nina is in a playbill of Washington's National Theatre, with second-to-last billing as the "Second Female Guest." Pictures of her reveal a magnetic total star, if only in her own wild Madame Bovary imagination. She might be billed next to last in *Sign of the Leopard,* but in real life she was an all-out furious protagonist with three distinguished husbands. In the end she was Nina Gore Vidal Auchincloss Olds, as well as a final celebration: friend of Clark Gable. In other words, it was matrimony that she was interested in, not idle Broadway make-believe. I should note that she failed a Paramount screen test because of the prominence of her manly moustache.

As the years passed Nina became more and more delusional about herself. Like Greta Garbo, she always referred to herself as a male: "I am the sort of guy who would give the shirt off his back for a pal." As far as I know, she never did, but she made much of the fact that she was a man's woman, presumably because she could drink like a man. This was during that sad period when the nation was surviving, as best it could, the prohibition of all alcohol, giving a great boost to crime and various alcohol-related illnesses, as demonstrated by F. Scott Fitzgerald and his family, and highly celebrated by the great bootlegger Joseph P. Kennedy, whose children are soon to enter this narrative.

Daughter of Former Senator Gore Weds Army Officer at Washington

Mrs. Eugene Luther V...
riage last week in Washing...
engineering corps, was M...
and Mrs. Thomas P. Gore...
Margaret's Episcopal chur...

BEGINNING TUESDAY EVENING, DECEMBER 10, 1928
MATINEES WEDNESDAY AND SATURDAY

LEE SHUBERT and EDGAR WALLACE
PRESENT

FIRST AMERICAN PRODUCTION OF AN
EDGAR WALLACE PLAY

"SIGN OF THE LEOPARD"
BY EDGAR WALLACE
STAGED BY CAMPBELL GULLAN
SETTINGS BY ROLLO WAYNE

CAST
(IN THE ORDER OF THEIR APPEARANCE)

FIELD......................................COLIN HUNTER
FIRST SUB-EDITOR......................HENRY JAMIESON
SECOND SUB-EDITOR.....................KENNETH DAVIS
THIRD SUB-EDITOR......................HARRY GORDON

PROGRAM CONTINUED ON SECOND PAGE FOLLOWING

PROGRAM CONTINUED

TAPE BOY....................................
LILLEY......................................HOWARD STEVENS
BILLMAN.....................................KENNETH LAWTON
ELECTRICIAN.................................JAMES KENNEDY
CARR..GEORGE HARTLEY
HALFORD...................................C. HAVILAND CHAPPELL
COLLIE......................................OTTO TURNBY
MR. BUTLER................................CAMPBELL GULLAN
MILLIE......................................AGNEW HORINE
TILLMAN.....................................ELSA SHELLEY
CAPTAIN LESLIE..............................JAMES JOLLEY
SUTTON......................................WARREN WILLIAM
BERYL.......................................MURRAY KINNELL
FENTON......................................FLORA SHEFFIELD
SGT. WEAVER.................................THURSTON HALL
TAYLOR......................................PERRY NORMAN
BILL ANNERLEY...............................FLORENCE TURNER
FEMALE GUEST................................RALPH J. LOCKE
SECOND FEMALE GUEST.........................SARA ALLEN
LORD FRENBURN...............................NINA GORE
..DONALD HARGRAVES

PROGRAM CONTINUED ON NEXT PAGE

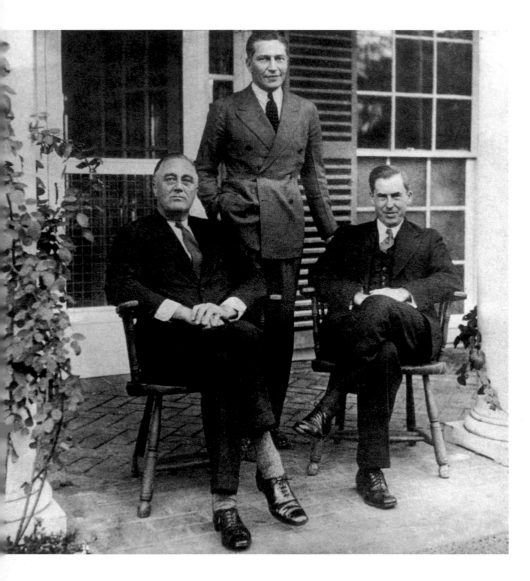

In 1933, after FDR was elected president, Gene was summoned to FDR's Warm Springs, Georgia, retreat. A polio victim, FDR was always hopeful that he would be able to regain the use of his legs, which he was, tragically, never able to do. Gene was flattered that FDR had responded to the analysis of Lindbergh, Earhart, and Vidal that the winner of any upcoming war would be the side with dominant air power. Upon the president's election, the first two appointments he seems to have made were with Gene Vidal for director of Air Commerce, and Henry Wallace, a practically hereditary for secretary of Agriculture. Here they are sitting outdoors because, as Gene remembers, all the downstairs rooms were packed high with telegrams and letters of congratulation for the new president, which Mrs. Roosevelt waded through, occasionally commenting through the screen door, "Why, here is a note from cousin Gladys."

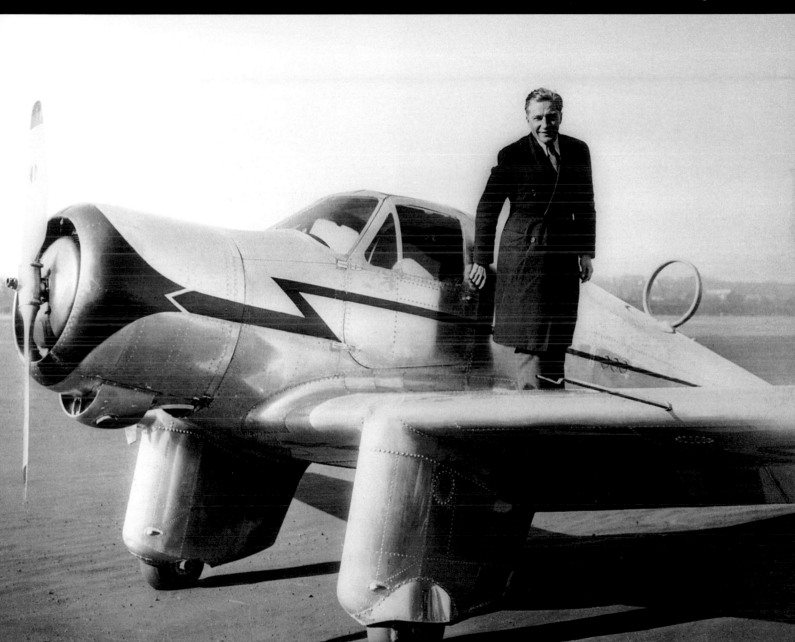

The director of Air Commerce with an airplane.

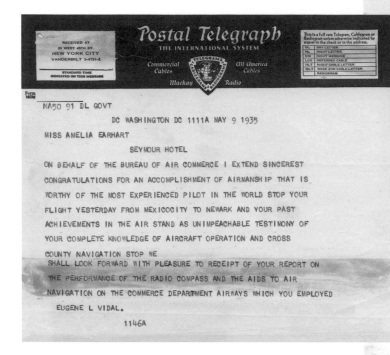

NA50 91 DL GOVT

DC WASHINGTON DC 1111A MAY 9 1935

MISS AMELIA EARHART

SEYMOUR HOTEL

ON BEHALF OF THE BUREAU OF AIR COMMERCE I EXTEND SINCEREST
CONGRATULATIONS FOR AN ACCOMPLISHMENT OF AIRMANSHIP THAT IS
WORTHY OF THE MOST EXPERIENCED PILOT IN THE WORLD STOP YOUR
FLIGHT YESTERDAY FROM MEXICOCITY TO NEWARK AND YOUR PAST
ACHIEVEMENTS IN THE AIR STAND AS UNIMPEACHABLE TESTIMONY OF
YOUR COMPLETE KNOWLEDGE OF AIRCRAFT OPERATION AND CROSS
COUNTY NAVIGATION STOP WE
SHALL LOOK FORWARD WITH PLEASURE TO RECEIPT OF YOUR REPORT ON
THE PERFORMANCE OF THE RADIO COMPASS AND THE AIDS TO AIR
NAVIGATION ON THE COMMERCE DEPARTMENT AIRWAYS WHICH YOU EMPLOYED
EUGENE L VIDAL.
1146A

N ina was a born lobbyist and liked to claim as her work anyone's appointment to anything, but in this case she actually had very little success in that department. FDR picked Gene because he was already well known in the airline business as the founder and promoter of a half dozen airlines, and he had also had great success in getting the two most famous fliers in the world, Charles Lindbergh and Amelia Earhart, to publicize air travel to a country leery of transportation above the clouds. If anyone was responsible for Gene's appointment as director of Air Commerce, it was Amelia, who saw to it that Gene and Mrs. Roosevelt became friends, which meant that in due course, the president heard all about him.

To make what was to become a sort of threesome all the more difficult, Eleanor had fallen in love with Amelia and was constantly proposing that she, the first lady of the land, make visits all over the U.S. with Amelia at the controls. Amelia found this passion somewhat embarrassing, as she admired Mrs. Roosevelt and had no romantic yearnings. That story ended when it came time for my father to withdraw from the Department of Air Commerce, due to a lot of criticism from a Senate committee about the number of airplane crashes on what they call, nowadays, "his watch." So, he quit. The president and Mrs. R. were sorry to see him go, but going through some letters in the Roosevelt collection at Hyde Park, I found a letter from Mrs. Roosevelt about my father's job, suggesting that perhaps Amelia would make a good director of Air Commerce, at a moment when my father was having great difficulties. Suddenly the lines were crisscrossing. Years later I would ask Mrs. Roosevelt what had been happening. She remarked, defensively, that my father *was* leaving office and why shouldn't Amelia take over? She had asked Gene if he would be pleased about Amelia being appointed, and he said that he would be, but he did wonder what was going on, since the Roosevelts had been swearing loyalty to him. Sometimes it is not a good idea to read letters in a presidential library if they are about yourself or your father.

Here is some of the press about Gene's appointment, as well as a congratulatory handshake from Amelia at Glen

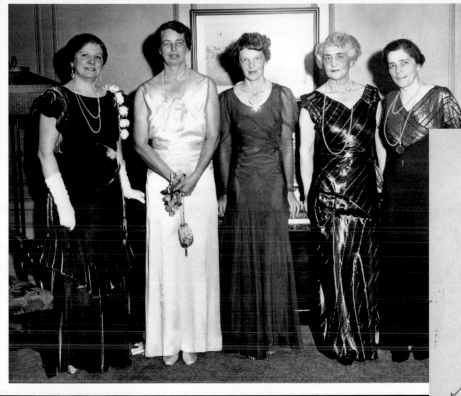

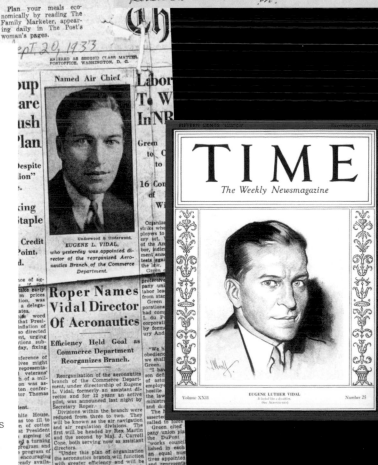

January 18, 1933

My dear Miss Earhart:-

I am enclosing my student
pilot permit. Dr. Smith seemed to
feel that I was all right.

The question now comes as
to whether I can induce my husband
to let me take lessons. I will
let you know if I am successful
with him. I haven't had a chance
even to talk to him about it.

Very cordially yours,

Eleanor Roosevelt
(Mrs. Franklin D. Roosevelt)

Miss Amelia Earhart
Rye
New York

I have talked with Franklin & he won't let me now but perhaps later I can persuade him! E.R.

Echo Amusement Park. My father, who was afraid of heights, but not planes, did not want to follow Amelia down in a mechanical parachute ride. He finally did it, although she had won their battle of chicken.

Included is an image of what I always thought of as the fatal copy of *Time* magazine, which Gene saw on sale on his way home from the Department of Air Commerce. Upon arrival at the not-too-happy home, he showed it to Nina, who threw it in his face. This, I think, says everything about their relationship and her problems. She wanted to drag everyone down to the level of "Second Female Guest" in *Sign of the Leopard*. Unfortunately for her, he was the leopard, and the marriage began to end at that moment. Many years later, as Nina became irritated with me, I appeared on the cover of *Time*, which she used as a provocation to write a letter to the magazine about her problems with my father and me. *Time* captioned her letter "A Mother's Love." The end of both Gene's and my relationship with Nina began with the cover of *Time* magazine.

The Rock Creek Park house, built of yellow Maryland stone. Nearby there were two or three acres of woods and a clearwater spring with salamanders in it where I played blissfully day after day, accompanied by a family of chickens, an idyllic time ruined by my grandmother saying at the table, "Eat your chicken." I pointed out the dining room window, where the chickens were watching us eat other chickens, and I spat the chicken out of my mouth and for years never ate chicken, although Mrs. Gore often tried to trick me, once mincing breast of chicken with spinach, which she called "gazaboo" and tried to spoon into my mouth, only to have me spit it out. I was heard to say, "It may be gazaboo to you, but it's chicken to me!" I won that round.

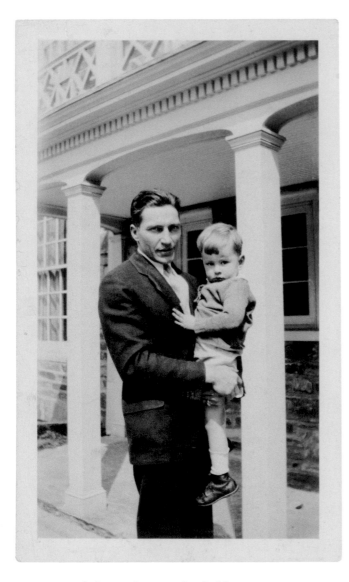 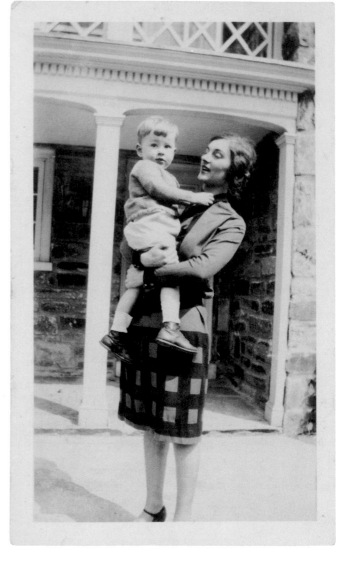

My father and my mother holding me in
front of Senator Gore's Rock Creek house.

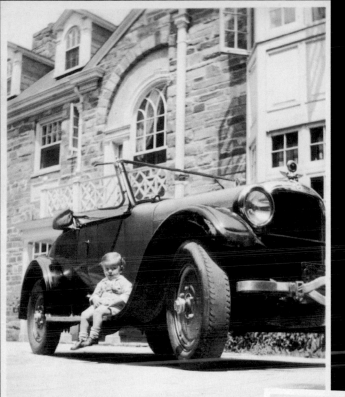

With Gene's convertible.

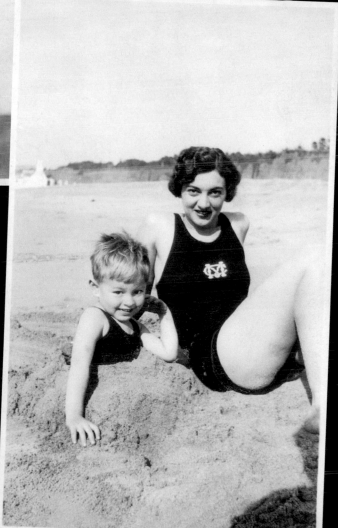

With Nina at Rehoboth Beach,
Delaware, in the late twenties.

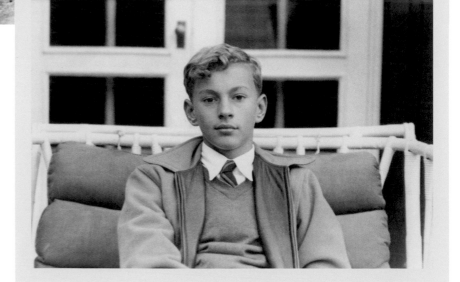

Around 1936 Nina and Gene were divorced. She was now free to marry Jock Whitney, who decided to pass on this increase in the matrimonial stakes, while my father married his second wife, Kit, who remained with him until the end; after the troubles of his first marriage he had come into a serene domestic harbor. At the TH Ranch in Reno, Nevada, where Nina had taken me to observe her getting a Nevada divorce from Gene, she welcomed a visitor, a portly man, who proved to be Hugh Dudley Auchincloss, a broker in Washington, D.C., and he became her second husband.

I was taken along to Hughdie's (as he was called) estate on the Potomac heights, called Merrywood, a real misnomer. Pictured above is Merrywood in the snow.

Merrywood: The Merrys themselves! As you can see, the Gores are heavily featured in the front row: Mr. Auchincloss, to the far left, once identified himself in an autobiographical paragraph as twice related to the U.S. Senate. First with T. P. Gore and second with J. F. Kennedy, who married Hughdie's stepdaughter Jackie. It is so very rare that the very rich achieve their ambitions.

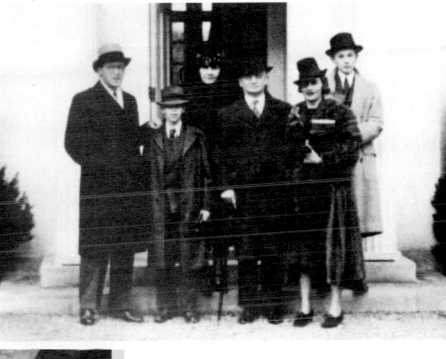

With half sister Nina Gore Auchincloss at Newport, Rhode Island. She went on to become the mother of screenwriter and director Burr Steers.

With my stepbrother on Bailey's Beach at Newport, Rhode Island, where a year or two later I would win a sand-modeling contest, for which I had made a head of Abraham Lincoln.

With Nina. She was always planning where to send me. With luck, I often ended up, to my delight, with the Gores, reading to my grandfather.

The Auchincloss boat; me peering out. Hughdie was not tightfisted when it came to spending; he had inherited from his mother a great deal of Standard Oil stock, money that my mother felt was rightfully hers, but then she felt that way about all the money on earth.

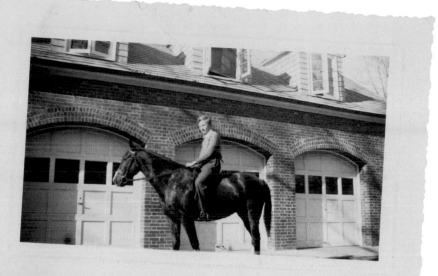

At Merrywood, riding a horse.

A scuffle on the diving board.

There has been vast confusion of thought within the industry regarding the interest of the Department of Commerce in the private airplane market and the policies behind the development of the low-priced airplane. In response to our request, Eugene L. Vidal, originator of the plan, has prepared an official and authoritative expression on a much misunderstood subject.

Eugene L. Vidal

Low-Priced Airplane

By Eugene L. Vidal
Director of Aeronautics, U. S. Department of Commerce

PRIVATE FLYING, measured in terms of active pilots, planes, and their use is on the decline. After fifteen years or so of the building of planes for miscellaneous flying, there are less than 7,000 licensed airplanes in this country of 120,000,000 people.

It might be well to assume that there may be something wrong with the product which we now are attempting to sell, that the market exists for something different. It also might be well to overlook entirely the attitude of the pilots who already have learned to fly (who would like to have a faster plane) and concentrate on the average American citizen who may not be an aviation enthusiast. Also it might be well to cease planning planes which the industry feels that the future pilot should have and plan one which would appeal to the United States citizen even though it may not be as desirable to every pilot and designer.

The most important detail of an airplane, as of any other manufactured product, is its price. Granted an airplane should be safe, no matter how safe it may be, it cannot be sold in numbers if it is too expensive. It is useless to make a plane safe if it won't be purchased, and thus won't be flown. The majority of Americans buy automobiles which sell for less than $1,000 and are inexpensive to operate and maintain. They are quite accustomed to the price range between $500 and $1,000, and it goes without saying that an airplane for that price, sold on the installment plan, would have a popular appeal.

The automobile driver—and he is our customer—has become accustomed to other details of an automobile, its appearance, material, control, etc. A car made out of fabric couldn't possibly sell in these days. The metal machine is durable and strong. So should the plane be.

Metal construction is desirable [for] many other viewpoints. Produc[tion] methods originated for the automo[bile]

industries can be adapted to airplane manufacturing. Many of the parts can be stamped out of sheet metal, and others can be machined in large quantities. Technique of assembly and of maintenance and repair as developed for automobiles will suggest methods for volume-production airplanes, and these practices will have the advantages of ready adaptability and proved worth as to fundamental principles.

In appearance, the aircraft must be attractive, and in as many of its small details as possible should remind the car driver of his automobile. Appearance involves another important consideration. The volume production airplane certainly should look like an airplane, and not be a radical departure from what the average person expects to see along the airways. If a low-wing airplane becomes the large-scale production type, it will have the advantage of looking like the transport craft with which airline travelers already are familiar. To the casual eye the small airplane would appear as a scaled-down reproduction of the airliners which now are flying, or will shortly be introduced on many of the scheduled passenger routes. And that is just what it would be, except that the small airplane would be far simpler, with fewer instruments, with fewer parts likely to require replacement, and with little professional training and skill necessary to fly it.

How many dials?

Without this simplicity there cannot be a successful low-priced airplane. A multiplicity of instruments would increase cost, and a complicated array of dials would discourage prospects from purchasing aircraft and learning to fly. On a transport craft which must adhere to definite schedules, flying at night and in weather which makes air navigation

plies in all matters of design. [If] part can be eliminated, it mean[s] elimination of several thousand pie[ces in] production, and many thousands [of op-] erations in assembly. This can [be ac-] complished with all proper regar[d for] safety. We may bear in [mind that the] airplane is not intended [to appeal pri-] marily to persons who al[ready fly,] although many licensed p[ilots have indi-] cated that they will be i[nterested.] If the market were to [be found among] pilots of the present d[ay, speed] would be a primary obj[ective. But the] craft contemplated is [designed to] enable other persons to [enjoy the plea-] sures and conveniences [of flight, and] will therefore be possibl[e to] sacrifice in speed for la[rger volume in] order to keep down the [cost.]

Volume production w[ould result in] automatic lowering of [its cost.] With a vast increase in [the number of] airplanes produced, the [price] will be lowered. The t[housands of ad-] ditional airplane owners [would create a market] for accessories, insuranc[e, hangar] placements, repairs and [service. This] will make possible a red[uction in cost] for such products and s[ervices. Manu-] facturers of the more e[xpensive planes] will benefit by the dro[p in price.]

All of these factors [were con-] sidered when the low[-priced airplane] project was announced. [There-] fore any definite steps c[ould be taken to] make such an airplane, [it was] necessary to have some [idea as to] whether or not it actually could [be sold,] and the project therefore began [with a] survey of the potential market.

Although the production type [of] plane is meant to appeal more [to the] average man th[a]n to the person [who al-] ready flies, those already license[d are] our best contacts for obtaining [such] information, because they repr[esent]

Gene getting me ready to take off and land the Hammond Flivver plane. My moment of glory, in 1936, was recorded by Pathé newsreel just before I took off from Bolling Field. It was my father's dream that he could make a plane so cheap and easy to fly that even a kid could handle it. He had no intimation until the very end of his life of just how crowded the skies would become. Finally, he simply sighed, "One dream that *can't* come true."

The man or woman who can pass the private pilot's physical test can safely fly the flivver plane

Harry Haenigsen

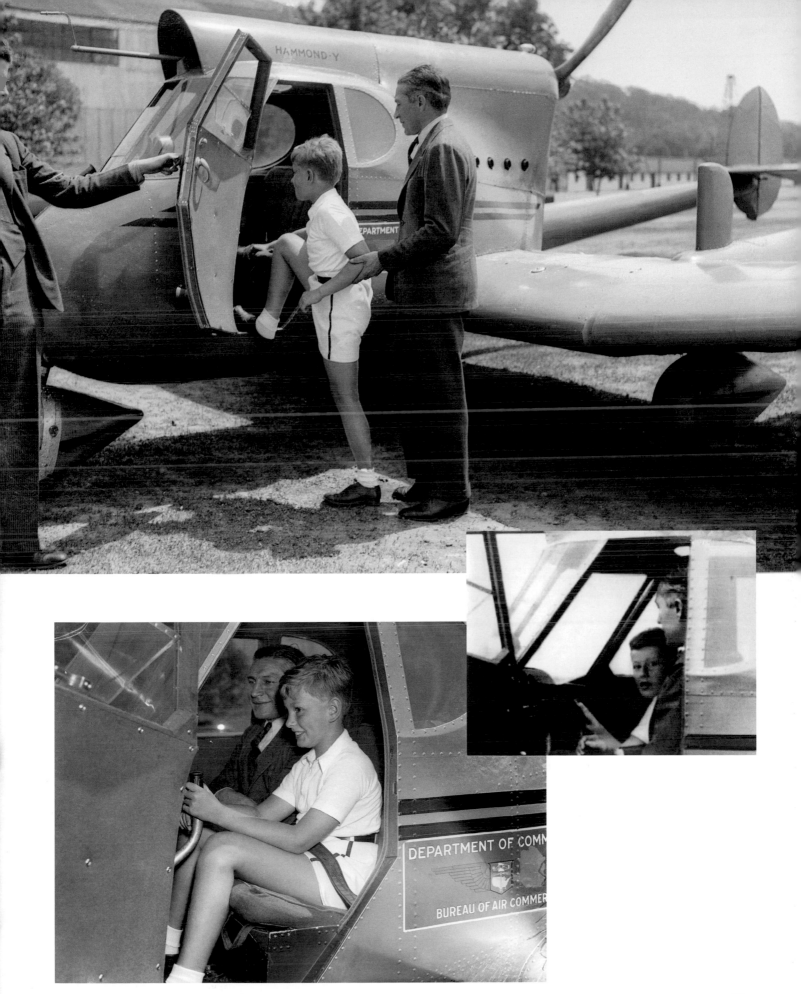

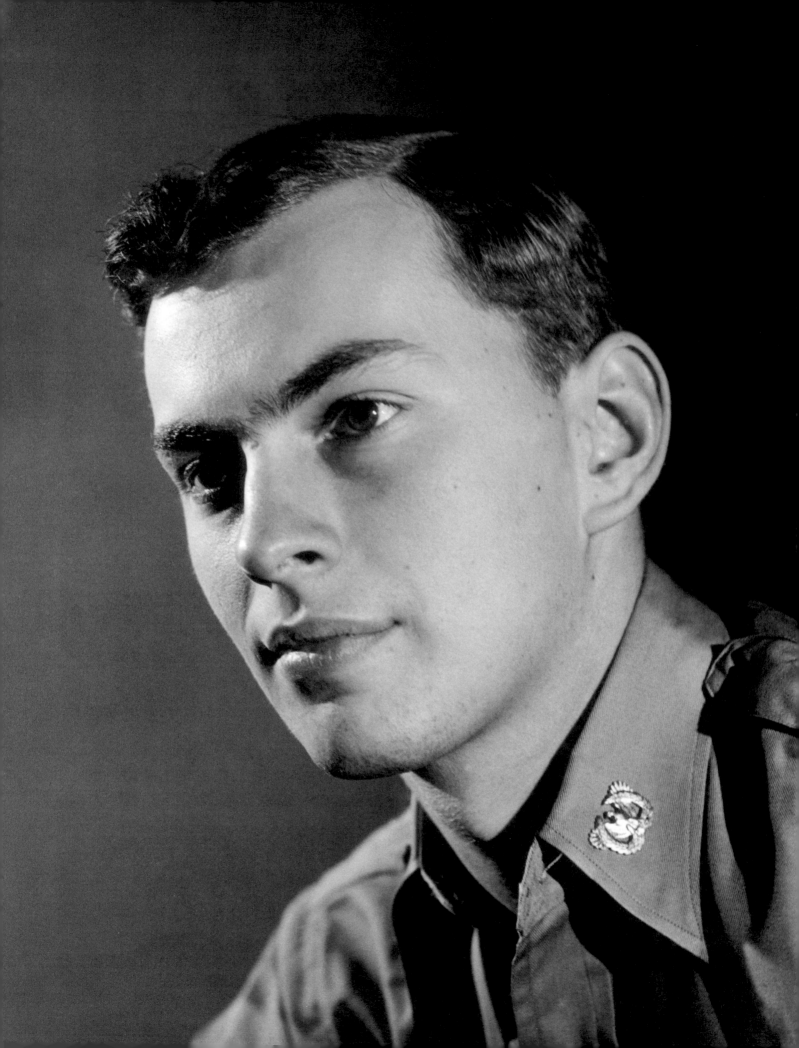

My grandfather was busy warning the Senate and the nation of the coming events of 1917, which would turn into World War I, so necessary for Woodrow Wilson's dream of glory for himself and, presumably, the nation. Though a blind man, Senator Gore was very sharp-eyed about presidents who were getting out of the constitutional box into which they had been put by the framers of the Constitution, and although he had pretty much gotten Woodrow Wilson elected in the first term, he decided not to support him for a second term, as he was convinced, correctly, that Wilson was dedicated to getting us into a European war, which had nothing to do with our national interests. And so it came to pass: There was a great slaughter of young Americans and nothing gained for the United States except that Mr. Wilson was able to parade around Europe, as he insisted on recarving that ancient continent to allow for his improvements, of

Here is Warrant Officer Junior Grade Vidal, first mate of the *FS-35*, taken, I think, at Dutch Harbor circa 1944.

which two were really fatal for peace: one, the dissolution of the Ottoman Empire, and, the other, more fatally, the breakup of the Austro-Hungarian Empire, where one of its wisest inhabitants, Sigmund Freud, rewarded Mr. Wilson with a vicious psychoanalysis based upon the evidence of his character and deeds. When the Senator and Dr. Freud could agree on anything, you must feel that they had somehow struck a gold rush of truth. Latter-day imperialists in the United States praise to the skies Mr. Wilson because of his "foresight" in wanting a League of Nations, as though that was anything but an afterthought for his clumsy imperial maneuverings, whose result for practically every country in the Western Hemisphere was great geographical and cultural suffering, as the map of the world was being drawn up in the image of a schoolteacher from Bryn Mawr. As war clouds again gathered in the early 1940s, there was a vigorous isolationist movement in the United States after the botch that Wilson had made of international politics; wise stewards of the old republic had become extremely wary of provincial American presidents redrawing the map of anything. Much of the chaos created by Wilson's map-drawing in western Europe led to Hitler's early adventures in the Rhineland and the Sudetenland, as well as middle Europa in general, and, finally, his all-out fatal decision for a drive on Russia. The Senator watched, appalled, as he also did at the rise of President Franklin Roosevelt, seeing him as a continuation of Wilsonian international politics

and an inventor of great troubles for us all around a world which we had not previously experienced in full.

When I was a schoolboy at Exeter, the largest political student group was Bundles for Britain, an attempt to save England not only from Hitler but from many unpleasant contingencies, going back to the separation of our colonies from an aging British Empire. As a busybody for the America First Committee, I was in touch with some very interesting Americans, including an old family friend, Alice Roosevelt Longworth, no admirer of her cousin Franklin but devoted to the somewhat horrifying politics of her father, Theodore Rex, as the Adams family called him, somewhat more kindly than Henry James, who referred to him as "the very embodiment of noise."

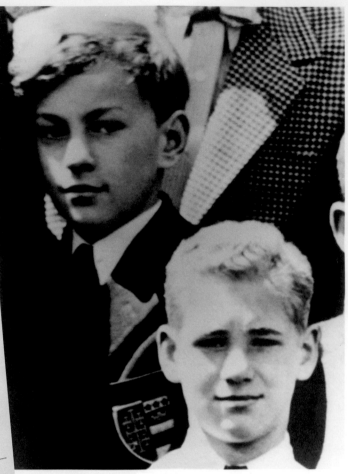

In the mid-1930s, Nina and Gene were divorced and Nina got custody of me. I definitely made her uneasy as I watched her maneuvering her way through her next marriage. Although I was in school at Saint Albans, a boy's school in Washington that I quite liked, she insisted that I board at the school, which boys only did whose families were elsewhere for some reason or another, and, thus, she got rid of me. The only good side to that was, in the interest of reciprocity, I had the occasion to be rid of her. Here I am with Jimmie Trimble, another boy who was missing a father and whose mother felt that he might be better off in the dormitory at Saint Albans. He was the most famous pitcher in Saint Albans history. We made common cause from the beginning and, best of all, we were allowed to go to Merrywood on weekends, where we explored the Potomac, whose sound I begin to hear again as I contemplate those days. And so, that is how I ended *The City and the Pillar,* with a river.

Later my restless mother felt that I should be taken out of Saint Albans, the only reason for which I can divine was that I liked the school and therefore I must leave it. Years later, Mr. True, the headmaster of the lower school, confided to me that he thought my mother was one of the stupidest women he'd ever dealt with. I confessed to agreeing with him. When Saint Albans complained that I was not doing my homework, she replied, "I don't know what's wrong. He simply locks himself in his room and reads and writes." Yes, I had begun my first novel.

How is a novelist born? I suspect there is a different story for each novelist. In my case, I never stopped reading, and whenever I read something I liked, I had a tendency to start writing my own novel in competition with the one I had enjoyed. So that is one way it can begin.

Photograph of bearer

This passport, properly visaed, is valid for travel in all countries unless otherwise specified. _____

This passport, unless limited to a shorter period, is valid for two years from its date of issue and may be renewed for an additional period of two years.

Limitations

This passport is not valid for travel to or in any foreign state in connection with entrance into or service in foreign military or naval forces.

4

5

I the undersigned, Secretary of State of the United States of America, hereby request all whom it may concern to permit safely and freely to pass, and in case of need to give all lawful aid and protection to

EUGENE L. VIDAL

a citizen of the United States.

The bearer is accompanied by his

Wife, XXX

Minor children, XXX

XXX

Given under my hand and the seal of the Department of State at Washington.

JUNE 13TH 1939

2

Description of bearer

Height 5 feet 8 inches

Hair BLONDE

Eyes BROWN

Distinguishing marks or features

SCAR BETWEEN EYE-BROWS

XXX

Place of birth WEST POINT, NEW YORK

Date of birth OCT. 3, 1925

Occupation STUDENT

XXX

XXX

Signature of bearer.

This passport is not valid unless signed by the person to whom it has been issued.

3

Here is a picture of me with a camera and five other boys from Saint Albans, each with cameras, too. We are all about thirteen or fourteen. Chaperoned by two masters, our European tour was certainly an eye opener to me. There are also pictures done in my usual artful Cartier-Bresson way of the Fourteenth of July celebration in Paris, 1939. My camera is trained on the Grand Palais, on whose steps I stood as Premier Daladier and the other rulers of France passed by in a parade to celebrate what I was certain would be an absolute victory of France over Germany. (We had already visited the Maginot Line, which we were assured was impregnable, and so it was; so much so that the Germans wisely went around it—my first experience of true warfare in the field.)

In Rome, Nina, the shadow secretary of State, interrupted our visit to instruct Ambassador William Phillips that the Germans were on the march and would soon be arriving and it was time to ship us all north to London. So there was an exciting train trip up the Italian peninsula surrounded by guards in black shirts representing the fascist dictator Mussolini; this was about as much adventure as I really wanted.

Once in England a group of us were hurried aboard a British ship, the *Antonia,* whose sister ship, the *Athenia,* had just been sunk by the Germans off the Irish coast. We wondered if we would be drowned too, though in a seemingly orderly fashion the passengers from the *Athenia* had for the most part survived. But for the first two weeks of our trip across the Atlantic I practiced holding my breath to see what it was like to drown.

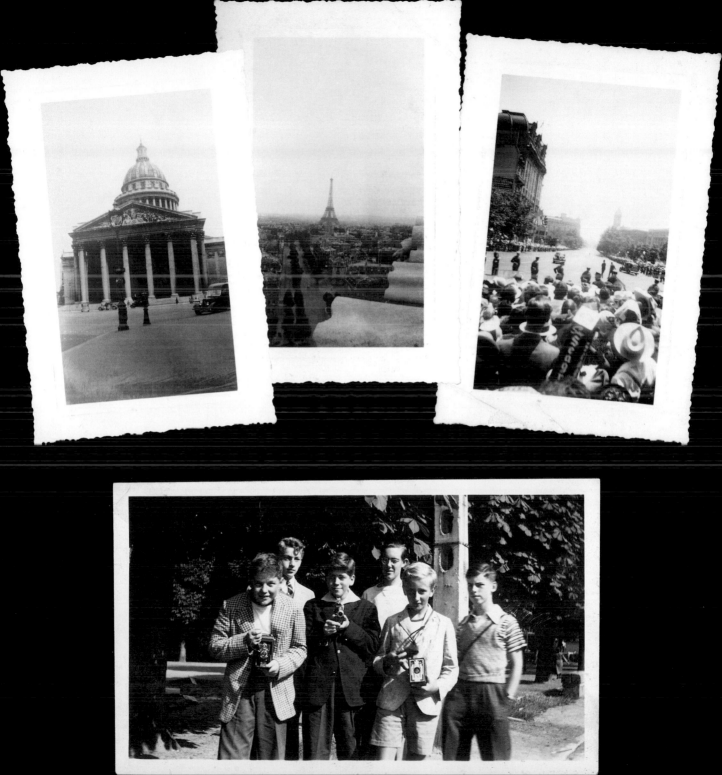

During this period it was my mother's strategy as she conducted her marital campaign against her second husband, Mr. Hugh Dudley Auchincloss, that I must be sent to ever more expensive schools farther and farther away, which my poor father could hardly afford, as he was no longer director of Air Commerce. One such dreadful school was the Los Alamos Ranch School in the hills above Santa Fe. Each boy had his own horse; mine was aptly called Two Bits. Here is a picture of the happy schoolboys on their particular mesa, called Otowi. In the front row is Wilson Hurley, son of Patrick J. Hurley, an

Oklahoma protégé of Senator Gore, later to be made a Republican secretary of War. Even later, from 1944 to '45, as ambassador to China, he made a mess of matters at a delicate time. I can be observed in the second row, on the far left, wondering where to find firearms in order to shoot my way off the mesa. I have written elsewhere about A. J. Connell, a vigorous pederast and disciple of Theodore Roosevelt, as well as founder of the school. In due course the ranch school was taken over by the Manhattan Project in order to produce the atomic bomb, which would secure happiness for everyone on earth, or so we were assured.

WILLIAM BURROUGHS
C O M M U N I C A T I O N S

December 7, 1995
(mailed Feb. 5)

Gore Vidal
La Rondinaia
Ravello
84010 ITALY

Dear Gore Vidal,

Have just read your memoirs, with clicks and buzzes as memories intersect like a pinball machine. Remember the school song?

> Far away and high on the mesa's crest
> Here's the life that all of us love the best:
> Los Alamos …
>
> Winter days as we skim o'er the ice and snow
> Summer days when the balsam breezes blow …

Jokes about the "balsam breezes" as icy spring winds sweep the "mesa's crest" are not well received.

And let no gibbon think he can get away with jokes about the school song just because A.J. is not on the scene. He has his network of snitches and he is *always* on the scene. No lock on any gibbon's door. At any time, your door flies open and there stands the unspeakable A.J., his eyes probing the room … hopefully …

"I've caught them *at it!*" he told me, "each one jacking the other off. Boys are just little *animals.*"

(As you probably have reason to know, he called the boys "gibbons" and "tailless apes", and it was his Kafkian function to see that they remained in that state.)

Gore Vidal — 7 Dec 95 (5 Feb) — p. 2

I consulted my Oracle: "Who was A.J.?"

Click-buzz: "He was a very minor prison official."

Not surprising that, finding oneself in a prison manned by such officials, one should be attracted to transcendental files and escape routes. In my case, General Semantics, psychoanalysis, hallucinogenic drugs (junk is not in the category of escape, just a pain-killer that makes prison conditions endurable), Scientology, EST, a seminar with Robert Monroe (who wrote *Journeys Out of the Body*), Lakota shamanism, spirits stomping around the room, gourds flying through the air … I love that sort of thing.

"And one by one, back in the closet lays …"

For me, the file that hacks to wholeness is the original Ishmaelian, Hassan-i-Sabbah, the Old Man of the Mountain, Master of the Assassins … "Call me Ishmael" …

Sincerely,

William S. Burroughs
William Seward Burroughs

P.S. No resemblance intended between the A.J. at Los Alamos, and the "A.J." in *Naked Lunch*. Also, a small correction: my last bequest from the "adding machine fortune" was ten thousand dollars, which I received thirty years ago, and very welcome at the time. It's just as well I am not rich from inherited money, otherwise *Naked Lunch* would not have been written — only thing gets homo-sap up off his ass is a foot up it.

P.P.S. How is the white cat? I am a dedicated cat lover.

(encl. *My Education: A Book of Dreams* with California copy)

A few years before my term at Los Alamos, a disturbed rich boy from St. Louis, I think it was, called William Burroughs, had been there. I can see in many ways from his later writing that the school and A. J. Connell's exuberant pederasty gave rise to many of his own fantasies. After he read my memoir *Palimpsest*, in which I described the school, I got the following letter from him, where he was plainly in his "golly gee" phase of contentment, perhaps brought on by unnatural substances. Burroughs had a great theater in his mind, and I think that Los Alamos fitted in perfectly with his wildest imaginings. But further deponent sayeth not.

Here are some letters from me to Senator and Mrs. Gore. World War II was about to begin and Senator Gore was famous for having opposed World War I. I was reading some of his speeches to the Senate back in 1916 and '17 and finding out a great deal about his career. Perhaps viewing me as a future politician, I think he wondered if somebody as addicted to the Constitution as he was could ever have a good time in electoral politics in what, after all, were as clearly to me as to him the last days of the republic. Later, I was to work out what a master we had had in FDR; though unappreciated by the Senator and me at the time, had it not been for President Roosevelt we might have had a long period of anarchy

LOS ALAMOS RANCH SCHOOL
OTOWI, NEW MEXICO

Dear Dot

Thanks a lot for the picture,I think I'll start collecting pictures of all the family,if you have one extra of Da do you think you could send it to me?

A few days ago we had a terrible blizzard with snow,thunder and lightening inside of an hour their was fifteen inches of snow.

Yesterday we had our last day of skiing.The snow was slushy and slow.In a few days there probably won't be a snow flake.

I've just finished reading a book called"The Strangest Friendship in History".There was a lot in it about Da and this description of the Sunrise Conference that Mr.Wilson called together. Could you ask Da to write me just what the Gore-McLemore Resolution was all about.

Not much has been happening the only outside school reading I've done has been Shakespeare up to now I've never read one of his plays so I'm starting now.

Give my best to Da.

Love

3/9/40

Nov 22, 1942

Dear Dot and Da

Hope you are both well, and well fed in the famine ridden city. I am comfortably cold, which seems to increase my literary output, for I have written six short stories and am half way through a play that might be amusing in an overly modern kind of way. The REVIEW to which you kindly subscribed will contain at least one of my stories, a cartoon, and perhaps a poem if I can dig one up from my collection for the occasion.

I will be delighted to hear with all the expletives, your reaction to the defeat of the moon gazers in the last election. Do you know the new Oklahoma Senator at all, and if so is he an improvement on the silver-tongued brass headed Senator eject.? I wrote a long and satirical article on the N?H. election for the newspapers round about here. I will send it if I can find a copy. All my predictions came true. I think, after talking with him twice, that Styles Bridges is a congenital idiot. Am I right? He does more steady double talking than any man I've ever seen. If I couldn't make a better speech than he I'd never think of another election again. I asked him a great many embarassing questions before the Republican rally. He squirmed, and not too artfully; especially when I asked about the 18 to 19 year old draft, and his stand upon it. I can see now why you aren't in the Senate. It surprises me that the people had enough sense to keep you for as long as they did.When I start running I am going to call spades spades, fools fools, new dealers jack asses, and I shall be beaten by a comfortable majority. How much truth can the people stand without choking?

I would like to get started on my U.of Okla. plan immediately. It would be a good idea I think to get connected some way with a state before I wend my way into the fields of war. I am sick unto death of either gypsying about the country, or living in that gay, fascinating, sterile vacuum,Washington. Virginia is too solidly Virginian; at least in Oklahoma I could inherit some support,and with the winds blowing the way they are now perhaps I could get elected in time. But the wind'll have to keep on blowing for quite a while; I wish that I were either five or twenty five. I am now too young to run, and too old not to fight. Do you think you might write the President of the U. of Okla. about my getting in; I think there's a chance I could leave here for college as early as February. I have sufficient credits. Would like to know what you think, in the near future, about it all.

Gave a speech the other day on the post war world(hollow mockery that it is) but I received the biggest ovation that I have yet received; they,it seems,liked my ending which was:"this is our world, which we shall in a few years guide to our liking. Wars and leadership are not for the old, but for the young who have spirit if not the wisdom of the old. And this world tempered by the fires of wars shall be ours, for you and I,and all of us together,we are history." It is nice to tell people what they want to believe.

Hope to hear from you soon on a) the election. b)Oklahoma c)the University. d)and most important yourselves. Hope you are all thriving. Yr. most humble servt.

Gore Vidal

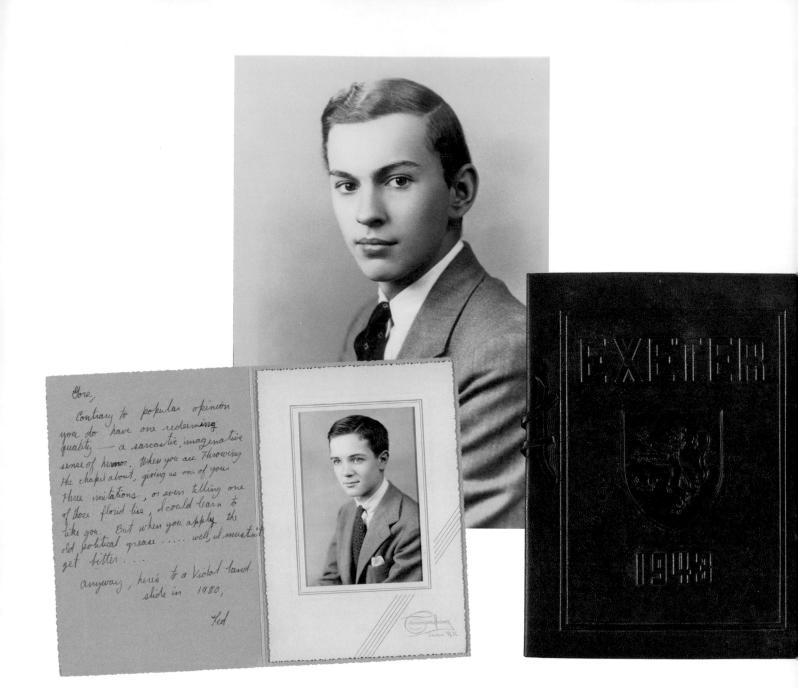

Exeter proved to be the perfect school for me because it most closely resembled the great world itself, with many of the same hazards and pitfalls. Exeter liked to say that there were no rules until you broke them; I thought at the time that this was fine sophistry which somewhat protected them, if not us. But there were two or three masters there whom I liked very much, which is how I suspect anyone gets educated at such a school. I was president of the Golden Branch Debating Society, which went back several generations in Exeter history; here I am addressing the membership.

Of the masters whom I really liked, one was Henry Phillips, a teacher of Greek. I, who had been drowned in Latin, to my regret, for something like four years of Julius Caesar's campaign biography, written by himself, a hardly inspiring text, would have been much better off had I studied Greek with Henry. Another was a teacher long since gone by the time I was graduating, and that was Thomas Riggs, who, as an undergraduate at Princeton, had gained national attention through his founding of the VFW (Veterans of Future Wars). Our cry was, "We want the pension now, before we've been wounded or killed." He was a gorgeous young iconoclast and many of us identified with him far more than we did with a whole series of masters of the high semicolonic.

THE SENATE

Vidal, Litle, Heinrichs, R. Lange, Augsbury, Bowden, Anderman, Lewis, Dubilier
Murphy, M. Kelly, R. O. Brown, Evans, Mr. Thomas, Vail, Archibald, Marx, G. H. Moses, Aldis
Cater, Davis, C. K. Cobb, R. C. Zollner, W. Lange, Wallace, Wheelock, Normile, R. S. Zollner

Gene Vidal Box 326
 You have been elected to membership in
the P.E.A.Senate. If possible, attend the
next meeting, Sunday, Oct. 6, 1940, in the
Debating Room of Phillips Hall.

 Luther Hill

While stationed in Colorado Springs, the commanding general of the Second Air Force, Robert Olds, my mother's third husband, died of a mysterious blood disease. I wrote a poem in his memory, and she appeared to be delighted.

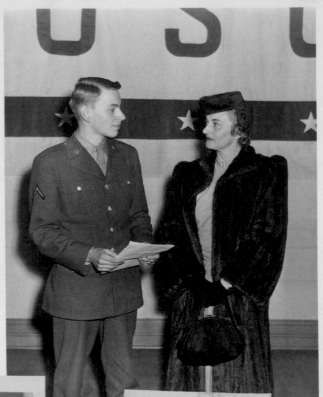

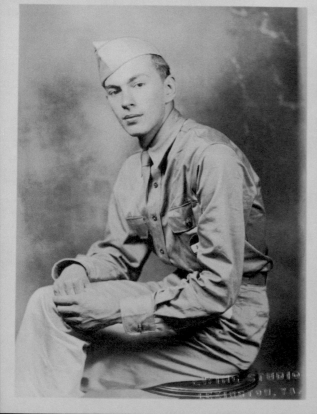

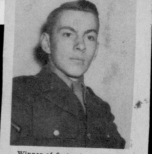

WINS POETRY CONTEST

Winner of first prize of $25 in the poetry contest conducted by the Soldiers' Council of the USO was Pfc. Gore Vidal, above, of the 72nd Fighter Wing. Lt. Rita M. O'Malley, ANC, of the Peterson Field Station Hospital, finished fourth. There were 85 entries. Vidal's poem, "For Bob", appears below.

FOR BOB
By Pfc. Gore Vidal

They say that even eagles die.
Some die in flight, but oftener I
Am told they'll die on a stone-sharp
 cliff
Alone, where those who've watched
 them fly
Can't see them earth-trapped and
 remember,
And remember.

When he died it was, like most, not
 in flight,
Though he'd have had it so—
One can't choose—for out of spite
The jealous wind seeing he was
 faster,
Far faster than the wind.
Raced him till he tired and coldly
 then
Blew his life away, thus pleased
 the wind
Lay quiet—yet some remember
 when
He raced the sky and beat the wind,
And beat the wind.
And tho he did not fall flaming
Down the clour-ribbed sky, he
 might, dying, know
That racing an envious god and
 shaming
Him, killed, slowly, while dreaming,
While dreaming.

But the race was fair and he had
 won.
He had burnt the sky from the
 moon to the sun.
Though even eagles die,
They say that even eagles die.

("Bob" is the late Major General Robert Olds.)

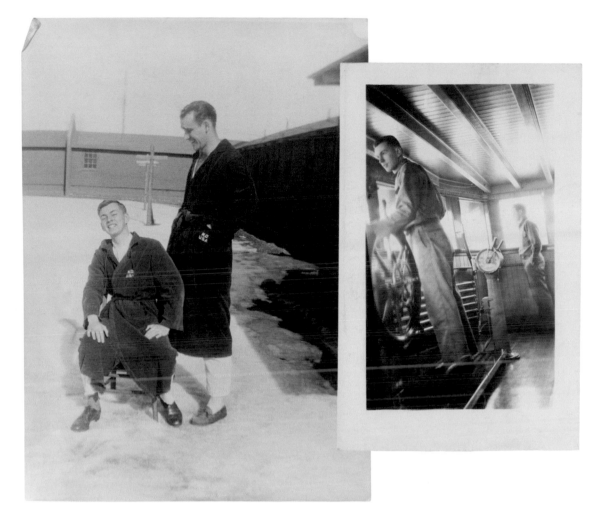

RIGHT My Roosevelt imitation in the snow at the hospital in Fort Richardson, Anchorage, Alaska, with a mildly frozen knee that was, at a later date, doomed to become titanium.

FAR RIGHT At the wheel of the *FS-35*. At my back is Jim Stone, who was skipper of the freight supply ship and, unlike me, a real seaman.

In June 1943 I had graduated from Phillips Exeter, where I had done a lot of reading and writing on my own. Then our ever-sly, if not, indeed, treacherous military had the bright idea of luring every male high school graduate with good marks to enlist in something called the Army Specialized Training Program (ASTP). Should they sign up they would not be thrown into the bowels of the military, but would be trained in languages and learn other useful frills. Unfortunately, the genius of the Army of the United States quickly decided that, having all my life failed mathematics, I would be most useful as an engineer. Happily and deliberately, I flunked out of the Virginia Military Institute, where I'd been sent by ASTP, and I became a member of the crew of a crash boat on Lake Pontchartrain. Our mission was to pick out of the water those "flyboys" from Harding Field at Baton Rouge who had fallen into the water during training.

What happened to us ASTPers? Almost to a man, or boy, we were used up in clumsy operations like Iwo Jima, where my Saint Albans friend Jimmie Trimble was killed in an operation that military historians later deemed an unnecessary part of the "brilliant" island-hopping campaign thought up by the naval command. Jimmie was killed due to inefficient and inaccurate intelligence when the U.S. Navy neglected to find out that the Japanese were already underground on the island. And so, after the Marines landed on a dark night, the Japanese came out and killed a great many of them. Several of my Exeter classmates were also killed in the Ardennes, among them, Lewis Sibley, a marvelous poet. Recently I received a letter from the actor Anthony Hopkins, who, at the time, was a schoolboy in Wales; he remembered getting to know some of my classmates who were about to be shipped across the Channel to fight in Europe. Sibley had been delayed in departing because without his glasses he was nearly blind, and his glasses had been broken. By the time he got a new pair he was just able to walk into some German bullets. And so ended the very short career of what would have been a unique American poet.

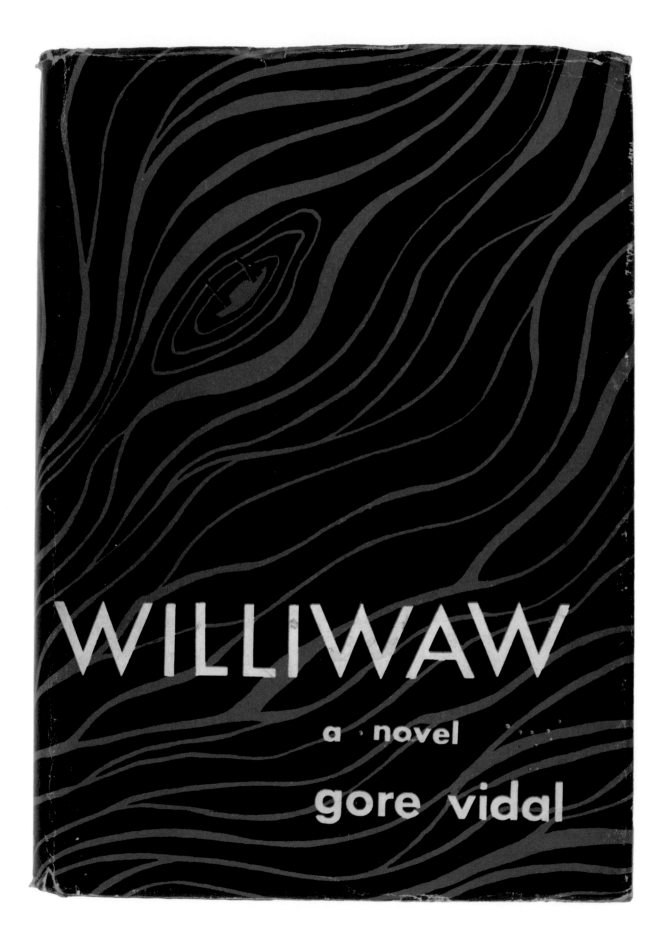

During my time in hospital, I wrote the long-hand draft of my first novel, *Williwaw*, which was published in 1946 by E. P. Dutton, who remained my publisher for the next seven or eight novels. As the war was ending there was at first a mysterious reluctance on the part of mainstream publishers to publish novels set during the war, until a very brilliant novel, now forgotten, *The Gallery*, by John Horne Burns, came out. I think *Williwaw* was probably the second war novel to be much noticed, followed by Mailer's first novel, *The Naked and the Dead*. And then the deluge came.

A Big Blow Hits Aleutian Waters

IT IS SELDOM that a young man of only 20 years develops a talent as decisively as has Gore Vidal, who turned writer after his discharge from the Army to produce a first novel that is far above the average in style, story and drama.

"Williwaw" (Dutton) is Vidal's contribution to the literature of World War II, and the title is a familiar word to those men who served in the cold, treacherous, woman-starved islands of the Aleutian chain.

DRAMA, and hard, fine writing are Vidal's gift, as well as a razor-sharp ability to depict character. His story is one he knows well, for he writes of an Army Transportation Corps crew of an FS boat working up and down the Aleutians. Vidal served as a warrant officer skippering such a boat.

Evans is the skipper of the novel's boat. He is young in years but old in the ways of the sea. His crew is varied, but those closest to him are Martin, the executive officer, Bervick, the second mate and Duval, chief engineer.

The boat is ordered to transport a major, a lieutenant and a chaplain to another island of the chain. The trip should take about 72 hours. However, the boat meets bad weather right from the start and finally is caught in a dreaded williwaw. To make matters worse, Bervick and Duval are feuding over a girl in Big Harbor.

VIDAL'S descriptions of the storm and the tightness of waiting for it are exceptionally well done. And his self-important little major will bring laughs to many men who learned to know that type of officer so well.

Gore Vidal....

Born at West Point, Gore Vidal, one of the most important younger novelists in America, has had a unique literary career. A grandson of blind Senator Gore, he was educated first in Washington, D. C. and finally at the Phillips Exeter Academy in New Hampshire. A month after graduation he enlisted in the Army, serving from 1943 to 1946. He was first mate of an Army F.S. ship in the Aleutians and it was here, at 19, that he wrote his first published novel *Williwaw*, which Mark Schorer in the *Kenyon Review* described: "*Williwaw* was an accomplished narrative of action, somewhat in the manner of Stephen Crane, which depended on vivid pictorialization, on pace and suspense, on the force, the baldness, even, with which it depicted the primitive emotion of its characters."

After discharge from the Army Mr. Vidal worked for a time as Associate Editor in a publishing house. In 1947 his second novel, *In a Yellow Wood* was published. From the Chicago *Tribune*: "Superb . . . one of the outstanding writers of our time." And in *The Saturday Review of Literature* Nathan L. Rothman wrote: "*A product of concentrated workmanship, a rigid and painstaking selection of details plus a delicacy of understatement that reaps its delicacy of overtone.*"

Life magazine described Mr. Vidal's work in its article "Young Writers," and his talents were discussed at greater length in the *Harper's Magazine* article "The New Generation of Writers." His books have been translated into French, Norwegian, Danish, Dutch, etc. In 1948 his brilliant controversial novel *The City and The Pillar* was published and became a national best seller. Of it Christopher Isherwood wrote: "One of the best novels of its kind yet published in English."

Mr. Vidal has contributed articles and poetry to *Town and Country*, *Harper's Bazaar* and the little magazines. Now, in his fourth novel, he establishes himself as one of the foremost novelists of his generation.

E. P. Dutton & Co., Inc.
300 FOURTH AVENUE, NEW YORK 10, N. Y.

Photo by Bellamy

May, 1946

Gentlemen:

I should like very much to bring
to your attention the work of Gore Vidal,
a new writer. His first novel WILLIWAW is
to be published June 17 by E.P. Dutton & Co.

I feel that, as a novelist and
poet, he is striking close to that source
of emotional power from which comes all
great art. WILLIWAW, a story of conflict
and the sea, is written with the simplicity
of a legend.

This book is a beginning work and
I know that others as rich will follow.

Most sincerely,

Anaïs Nin

Anais Nin

s each other
time that y
which sounde
sit, in luxu
d it gets ho
phone given
waiting for
e poetry re
n working a
x end with R
I would li
or announci
till get ven
ing made an
e for Xmas.
lar, all re
alking with
have all a w
ls..Yes, I d
e, and you would love my apartment.
d the final decision I will leave
to him for some day he will tire of being loved as a father. Cheri, how I
wish you would continue with analysis, so valuable for you as a writer.
You can call me up now: Klondike 2 2259.

Je t'embrasse

Anaïs

Cheri: You should know by now
that I will never desert you, That
we are more closely bound than
marriage (c'est terrible! pire que
marié!) that I know whatever
pain your pleasures may cause me is
not voluntary, on your part, that
I may run away from it for but
not from you. I can't escape you—
My conflict now is that the legend
I intended to protect you, your secret,
is harming me by estranging those
who might give me what I lack
and can't live without: passion. I lost
John, and what will happen when
Bill returns if he hears what John
heard or reads your novels? When
you return we will talk about this.
As to your being my protégée, that
we can easily remedy. How could your
masculine writing stem from my very
feminine writing? (Woman was created out
of a man's rib—) Only stupid people could
make such a statement. There is no
influence between us but polarity—

coming back
finished?
tween Book 1
written Book II
and so rich
— that I await
cause of
t —
ding more

Lawrence.

Your letters are like Japanese
paintings. I see

Gore
writing

mountain lake

and some hazy artists.

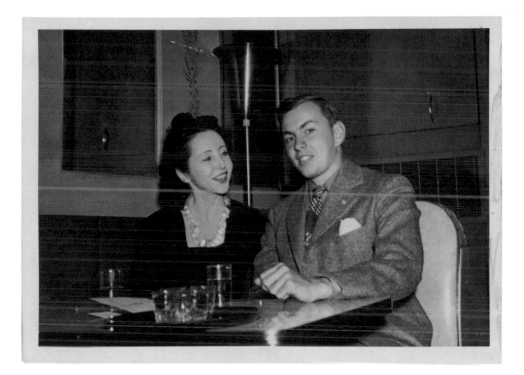

By the time I was back in New York, where my father lived, I had a job with Dutton as a reader of manuscripts, and I met the famous avant-garde American/French writer Anaïs Nin, twenty-two years my senior and the same age, I noticed, as my mother, not a happy coincidence. Anaïs was married to a long-suffering engraver who had loyally seen her through her long affair in France with Henry Miller. One of the letters reproduced here from our copious correspondence suggests I seem to have taken Henry's place. She writes, "We are more closely bound than marriage," and, in rather better French than mine, adds, "This is terrible, worse than marriage."

Regardless, Henry Miller wrote me a thank-you letter on the eve of my departure for Europe, when, at his request, I gave him dollars for an equivalent sum of francs that he had told his French publisher to set aside for me. In his letter, he warned me not to waste my life editing at Dutton's; happily, there was never any chance of that.

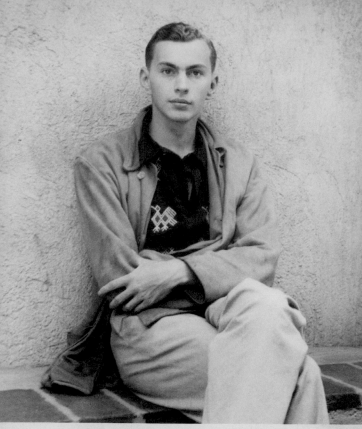

Writing furiously in Guatemala in 1946, '47, and '48, I noticed that I was getting thinner and thinner, until I was diagnosed with acute "jaundice," as they called it in those days, and turned dark yellow. I joined Anaïs in Acapulco and she nursed me through a nearly terminal illness.

This is the church of El Carmen in Antigua Guatemala. To the right of the facade of the church one can see the ruin of a convent that I bought for two thousand dollars in the mid-1940s and owned for a number of years. It was here that I wrote *The City and the Pillar*, which was to give me so much trouble and freedom as well.

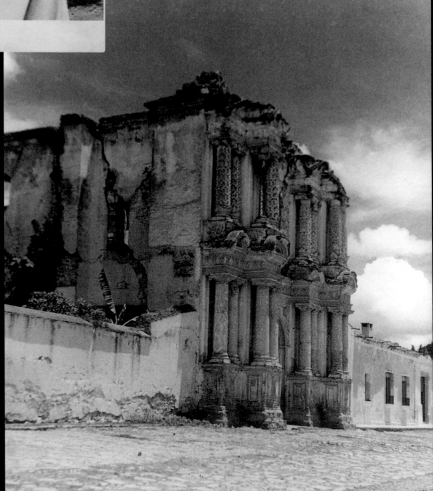

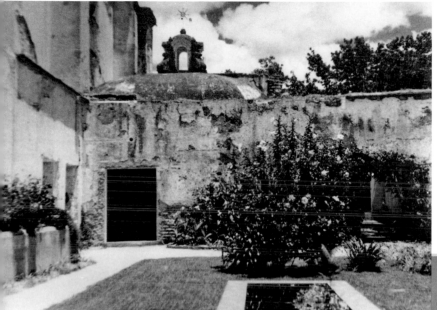

This is the patio of the convent, including my private chapel with a dome. A few sticks of furniture made up the entire furnishing of that very pleasant house, which I rented out for many years to foreigners while I chose to live in Italy.

The president of the Guatemalan National Assembly was a young man called Mario Monteforte Toledo, an ambitious politician and friend of Arévalo, the president of the republic. He used to come up to Antigua to see a girlfriend as an escape from his duties presiding over the Assembly, and we would have long discussions about the United States and imperialism and all the subjects that young men interested in politics are interested in. It was he who told me that the CIA was going to overthrow President Arévalo and run the country in the interest of the United Fruit Company. Loyally, I said this was not possible—the United States, having won two great wars in Europe and in the Pacific, would hardly stoop to destabilize a small country of no great value like Guatemala. He said, well, that is what you are doing. And that is how I first discovered American imperialism in action. I wrote a novel that was supported by my knowledge of what was going on in Guatemala at the time; the book was published as *Dark Green, Bright Red* and was considered, later, to be prophetic of what our rulers intended to do in that part of the world, destroying as much as possible the infrastructure of various sad nations. But by then, Europe had opened up and I was ready to leave Guatemala and go "home," which meant Rome and all the rest.

Although the war ended in 1945, I was not able to return to Europe until '48, when I made a long visit to London and Rome. Here I am on the deck of a Dutch ship, en route. On the far right I am standing in the garden of my English publisher John Lehman's house in Egerton Crescent, London, with Christopher Isherwood and Lehman's ballet-dancer friend Alexis Racine. I was very soon back in Italy, and here we are not far from the American Academy on the Janiculum Hill. Seated at the left is the novelist-poet Frederic Prokosch and next to him the art collector Henry McIlhenny, and next to him, Tennessee Williams, whom I had just met. Also pictured is the composer Samuel Barber. That was the year that Tennessee bought a jeep, left over from the war, and we drove down to Naples through the ruins, a memento of the long battle against the Germans by the American and British armies in the previous year, from Anzio to Rome. Tennessee was great company but an eccentric driver, who would announce, from time to time, "I am for all practical purposes blind in one eye." We survived.

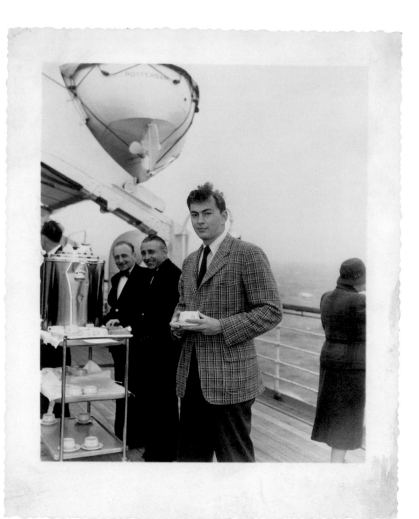

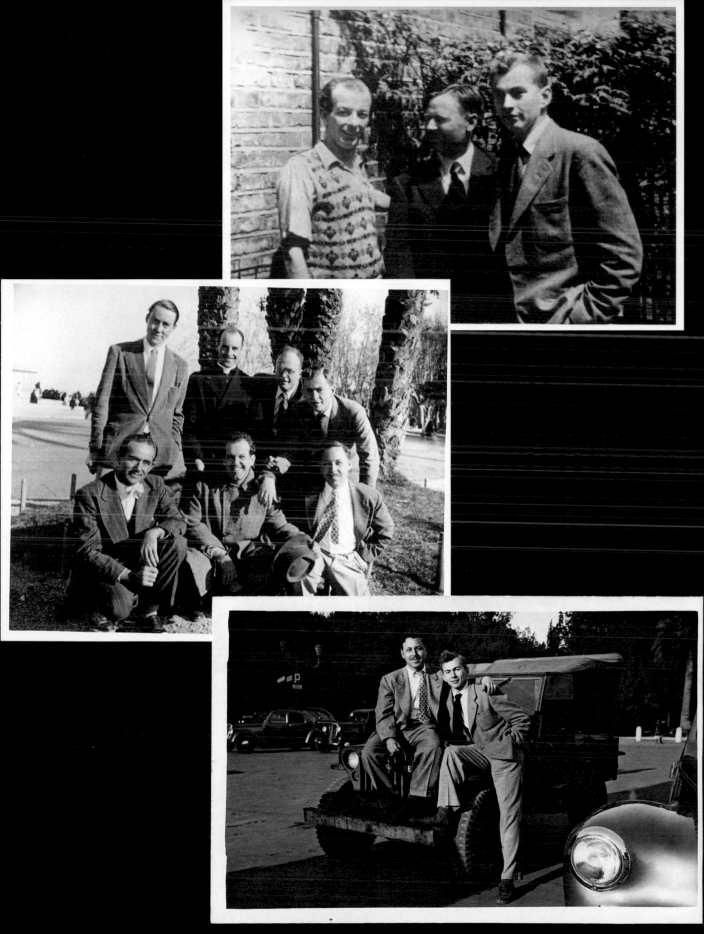

I was out of the prison of the army and I could go anywhere I wanted to, which you couldn't if you were still a soldier. So I traveled quite a bit, landing often at beaches as distant from one another as Deauville and Daytona, sometimes in the company of dancers with cars, like John Kriza, as I did not yet drive. It was a very free and open outdoor style of life.

Harold Lang in Bermuda.

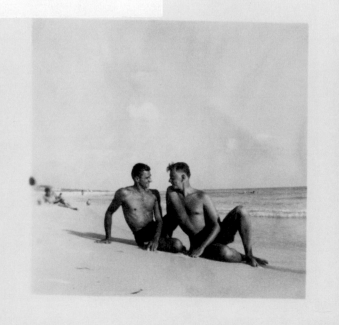

In France with Paul Avril
on the beach at Deauville.

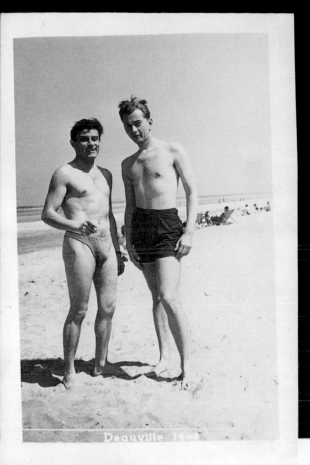

Deauville 1946

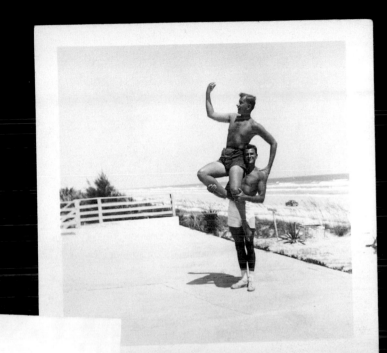

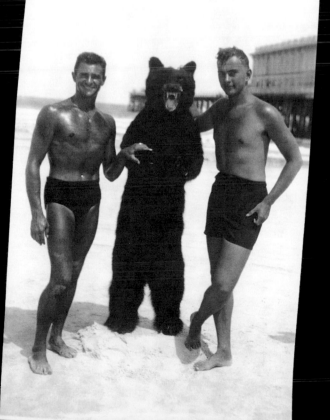

This time with John Kriza on a beach in Florida, where we are being received by a bear. Kriza was charming and later married an Asian ballerina.

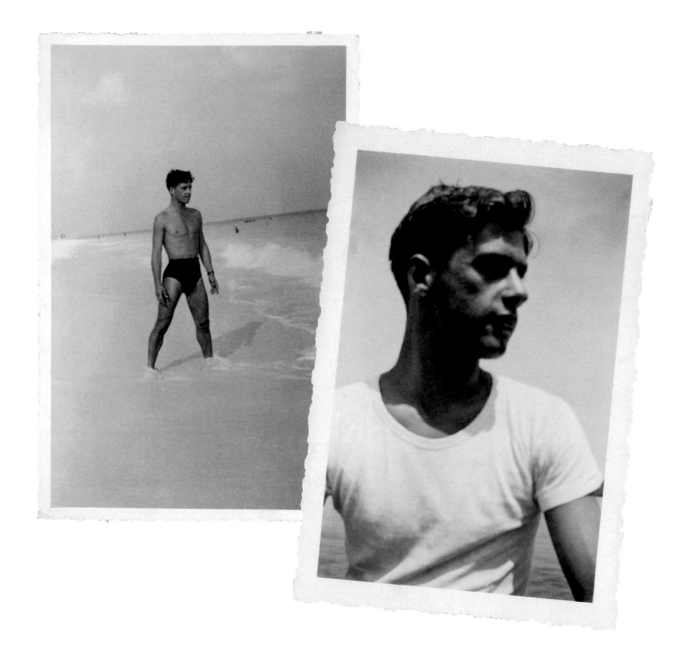

The dancer Harold Lang in Bermuda. The most famous American ballet dancer of his time, he starred in a revival of *Pal Joey*. My interest in ballet was more medical than aesthetic; once I was let out of the last army hospital in Van Nuys, California, I turned down a pension for life, which I was offered as I was lame in one leg. So back in New York, busy writing yet another book, I spent a year taking ballet class, which proved to be not only good for the legs but very good for my appreciation of an art I had known nothing about.

Harold never married and often lived up to his nickname, the Beast of the Ballet. But he was a charming companion. The last time I saw him was at the University of California, Davis, where he had put together a ballet company and had taken over a number of functions as minister of culture for the school. There were rumors that he died of AIDS, as this was the height of that epidemic, but he didn't. Dedication to whiskey had taken its toll.

Harold and I
holding up a wall.

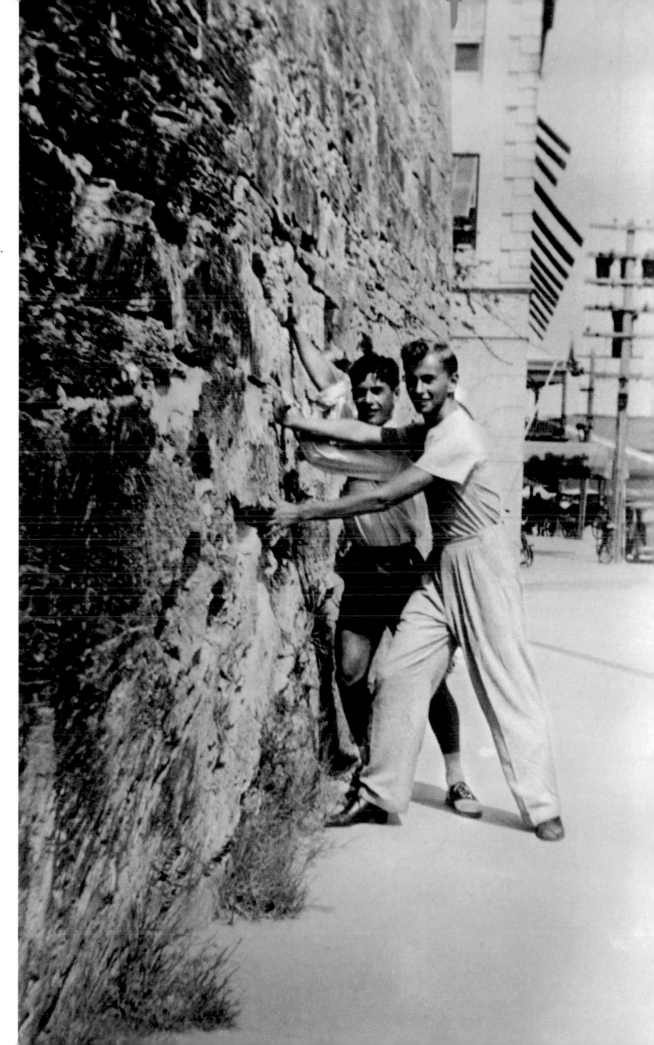

Otto Fenn took pictures for various fashion magazines and he was in great demand for his photographs of people like me. So he took a batch of pictures, some rather good.

To the amazement of the publisher, *The City and the Pillar* was an instant best seller all around the country, and then, gradually, France, Italy, Germany, and other countries checked in. The latest has been Turkey. I got a great deal of fan mail, something like a thousand letters, as well as a marvelous letter from Dr. Alfred C. Kinsey himself congratulating me on my "work in the field."

The first great writer whom I ever dared send a book of mine to was the one who had had the greatest influence on me, Thomas Mann, who was during much of the war years living in California. Here he is at about the time he was reading *The City and the Pillar*, which he describes, page by page, in his diaries, published some years later. It was most heartening to hear something from perhaps the only writer in the world I respected and read much of. In fact, *Joseph and His Brothers* taught me how to deal with history in a novel; it was a foundation for any writer predisposed to the so-called novel of ideas, which Mann would later crown his own career with, in the absolute triumph of *Doctor Faustus*.

THOMAS MANN

January 3, 1948

Mr. Goer Vidal
c o E.P. Dutton & Co. Inc.
300 Fourth Avenue
New York 10, N.Y.

Dear Mr. Vidal:

It was extremely kind of you to send me your new work "The City and the Pillar" with your personal inscription. Your novel, which has afforded me a noble entertainment, is a valuable addition to my English library. The interesting book has my most sincere wishes for the success it deserves.

With kindest regards,

Cordially yours

Thomas Mann.

The Best Sellers

An analysis based on reports from leading book sellers in 22 cities, showing the sales rating of 16 leading fiction and general titles, and their relative standing over the past 3 weeks.

Fiction

Feb. 22	Feb. 29	March 7	This Week	
6	4	1	1	Eagle in the Sky. *Mason*
2	3	3	2	Raintree County. *Lockridge*
1	1	4	3	House Divided. *Williams*
3	2	2	4	East Side, West Side. *Davenport*
		16	5	The Ides of March. *Wilder*
4	5	5	6	Came a Cavalier. *Keyes*
5	6	6	7	A Light in the Window. *Rinehart*
			8	The Great Ones. *Ingersoll*
8	9	9	9	The Bishop's Mantle. *Turnbull*
	7	10	10	The City and the Pillar. *Vidal*
14	14	8	11	Red Plush. *McCrone*
7	11	11	12	Other Voices, Other Rooms. *Capote*
		13	13	Earthbound. *Reymond*
13	12	12	14	The Garretson Chronicle. *Brace*
11		7	15	That Winter. *Miller*
	15		16	Cry, the Beloved Country. *Paton*

General

Feb. 22	Feb. 29	March 7	This Week	
1	1	1	1	Peace of Mind. *Liebman*
3	3	2	2	Information Please Almanac 1948. *Ed. by Kieran*
2	2	3	3	Inside U. S. A. *Gunther*
5	5	4	4	Sexual Behavior in the Human Male. *Kinsey et al.*
6	7	8	5	A Study of History. *Toynbee*
9	9	6	6	The Proper Bostonians. *Amory*
4	4	9	7	Speaking Frankly. *Byrnes*
10	6	5	8	The Meaning of Treason. *West*
		11	9	I Saw Poland Betrayed. *Lane*
13	8	7	10	The Great Rehearsal. *Van Doren*
8	12	10	11	Human Destiny. *du Nouy*
	14	16	12	Your Income Tax. *Lasser*
7	10	13	13	The American Past. *Butterfield*
			14	The Last Billionaire. *Richards*
11	11		15	I Remember Distinctly. *Rogers and Allen*
16	13	12	16	War as I Knew It. *Patton*

T. P. GORE
ATTORNEY AND COUNSELOR AT LAW
UNION TRUST BUILDING
WASHINGTON, D. C.

Airmail

March 23, 1948

Mr. Jean Gore Vidal
C/o American Embassy
Rome, Italy

My dear Jean:

Your card was received a few days ago and we were very much pleased to hear from you.
I wish you had written me more about the situation in Italy. This country is all wrought up about Europe, Asia and the whole world. There is a good deal of war talk in the air---atmosphere, I mean.
If I were you I believe I would remain in Italy until after the election on April 20th--unless you think that it is too dangerous? ! ? ! ?
Your mother had figured on going to Florida, but I just learn that she has given that up. The children seem to be well.
I haven't seen your father this year. He was in town a few days ago but we did not happen to get in touch with him.
Tot and I are doing very well. She can now walk without a crutch and without a cane but she is not yet fully recovered. I still do not walk enough to do much good. I have not been to my office since returning to Washington, and that was in December.
I am enclosing herewith the New York Times "Best Seller List" of last Sunday. I thought it might be of interest to you.
Write soon, and believe me, with best wishes, as ever,

T. P. Gore

A note from my grandfather dating from March 1948; he had a new secretary. In the family I was still known as *Gene*, short for *Eugene*, but the secretary writes *Jean*. As you can see, there was talk of war in 1948. Neither I nor my grandfather liked the idea of perpetual war for the United States, but I think we were beginning to understand that this was a condition of the regrettable century we were living in.

These letters have been sitting in university archives for some sixty years, first at the University of Wisconsin and now at Harvard.

Dear Mr. Vidal,

I have just had the great pleasure of reading your book and I have never before enjoyed the theme of a novel as much as I enjoyed "The City and The Pillar".

My only remark after reading your wonderful book was "Oh my god, how does that guy have the intuition and the ability to dissect humans as thoroly and frankly as you did in "The City?".....

You certainly have an unusually acute sense of understanding of the problems that Jim Willard faced. How you are able to fathom out human nature as precisely and clearly is beyond my meagre intellect to comprehend.

You see..... I could be Jim Willard. If you had used my personality as a basis for the character study of Jim Willard you could not have been more accurate.

I would be extremely pleased if you would autograph my copy of your novel. I shall send it to you on receipt of your answer to this note saying that you will autograph the book.

Thanking you

I remain

Yours sincerely

Eino
Eino

June 21st., 1948

MR. GORE VIDAL
c/o E.P.Dutton & Co., Inc.
300 Fourth Ave., N.Y.

Dear Mr.Vidal :-

I just finished reading your THIRD GREAT successful novel "THE CITY AND THE PILLAR".

I am taking the liberty of writing you a Famous Author to comment on same. I can't truthfully say I liked the book, to me it leaves a bitter taste in one's mouth, but I can say you wrote this book with finesse and authority of to-day's unfortunate "Queers".

I did NOT read your book for the same purpose the majority are reading it for-to pry into these Men's souls, etc-NO-I read it to TRY to understand them better. You see I am a Sister of one of these kind of Men, something like your "JIM". My Brother started out at 20 yrs.of age to Study to be a METHODIST MINISTER. At this School he met a Student like your BOB. From then on he gaveup ministry and my life of WORRY, humiliation etc. began.I have often felt that I could write a book about the Men you wrote about, only I would INCLUDE their Families.My Brother was associated with boys and Men from the BEST of Families. Our City has a population of over 80,000 People and in regards to this type of person, they are NOT understandable, nor do they accept them- they CONDEM them.Me-I PITY them-I never censor them. I even found out from our Family Physican there is not medical cure for them.As my Brother often explained to me-"they live in a DIFFERENT World", and your Book explains that.

My OLD FASHIONED-WONDERFUL-CHRISTIAN Mother who died last October still hoping her BABY(41) a BACHELOR would CHANGE, died with a broken heart. Leaving me to TRY to understand him- to keep on loving him and to comfort him when he gets despondent. He has TRIED to fall in love with BLONDE girls- but-like in your Novel- this seems impossible. For twelve years he was madly in love with ONE Handsome Man, so handsome he could have been a Movie Actor had he chosen to be, a very likeable chap, our Family liked him very much but, two years ago he and my Brother parted. Since then my Brother SEARCHES for another DICK.And since my Mother's death- he goes from BAR to BAR, that is, high class Bars.My Brother likes odd clothes, such as cardigan jackets, dark red or green with shoes to match-exotic perfumes, exciting places to work and live in. That is why- I got him located in WASHINGTON D.C. because in larger Cities like that he can be with and among HIS kind of People and not be talked about. I felt more SAFE when my Brother went with ONE at a time- now he writes about-"NICKIE"- "LENNY"- "TERRY" etc. and it FRIGHTEN'S me- he still broods over the one he lost- DICK. The part of your Novel that FRIGHTENED me was the ending whrre JIM chokes BOB- I live in FEAR that my Brother will become too LONELY- too DESPONDENT without his BEST FRIEND- our Mother-who died recently- and I'm always afraid that he may some-day take his own life, as an escape. I am the only one my Brother confides in- my older Brother is a successfull- happily arried Man-has been for 35 years-he never tried to understand my Brother-but-I did. Even so- there is so much I can't understand. To me, its NOT not normal living-its FRIGHTNING. I never discuss this topic with any-oe here,I have tried to give these narrow minded People explanations but they even went so far as to codem me and I assure you I live a NORMAL-DECENT life. Forgive me for writing you this,but any-one who wrote "THE CITY AND THE PILLAR" must UNDERSTAND this subject,if there's anything you can and care to write me personally about it,I would be eternally grateful. Best regards and continued success-

Kay

Friday, February 23, 1951

Dear Mr. Vidal,

I have just finished your novel "The City and the Pillar" and want to commend you for the fine literary skill which you display in this work as well as in "The Season of Comfort", which I had read previously. Especially remarkable is the deep insight and understanding with which you treat the subject of homosexuality. Your portrayal of Jim Willard in "The City and the Pillar" was a masterpiece and touched me deeply, because for the first time I have found a character, although he is fictional, to whom I feel myself very similar. Basically I have the same problems as Jim. I am 21 years of age and within the past few years have realized that I have homosexual tendencies, although I am quite sure that my friends and family would be greatly surprised, even "shocked" if they knew it.

Although I go out on dates with girls (because of social pressures) at regular intervals and am considered very personable, I have thus far been not at all sexually attracted to them. Rather, for reasons I find hard to explain to myself, I find that I am very greatly sexually attracted to the many of the fellows I come into contact with both at college and other places. I am very much aroused, excited, but very ill-at-ease in a male atmosphere, especially go without fear of being recognized & exposed, and would no doubt find another with my problem. I would be forever grateful to you if you would send me the addresses of a few of these places, those which you consider of a "higher class". Once + for all I feel I must go through with it and find out definitely, although I am quite sure I am a homosexual,— I feel I must release this immense tension and great mental strain which I feel.

I would greatly appreciate your doing this vital favor for me as soon as possible, at your very earliest convenience. Please let me know where I can go in New York City to get what some unknown driving force is compelling me to seek, the same force that Jim Willard felt.

Very sincerely and gratefully,
Paul Edwards

January 31, 1948

Mr. Gore Vidal
c/o Dutton & Co.
New York, N. Y.

Dear Mr. Vidal:

The idiotic review of your book, THE CITY AND THE
PILLAR, in the N. Y. Times induced me to buy it at once.
It was obvious that the critic was acting under some
compulsion, probably his rage against his own repressed
desires.

I am fairly familiar with the literature of sex
deviations from the ancients to our own day. I am, or
rather was a friend of Magnus Hirschfeld, Havelock Ellis,
Freud, and have the honor of being on friendly terms with
Prof. Kinsey, whose extraordinary book on SEXUAL BEHAVIOR
IN THE HUMAN MALE justifies everything you say in your book.
The first edition of 25,000, I understand, was sold out on
the day of publication.

I myself, during the five years when I was Mr Roosevelt's
guest in divers Federal penitentiaries, had the opportunity
to study many intermediate types and to write a novel in
which I depict the sex life in prison, which incidentally
does not differ very much from the sex life outside. I
also wrote a number of lyric portraits of various types
that interested me. Have you read MY FIRST 2000 YEARS,
SALOME, and THE INVINCIBLE ADAM, or MY FLESH AND BLOOD
published by Liveright which is a collection of my poems,
and in which I attempt to analyze myself?

Your book is infinitely superior, both in literary
quality and in psychological acumen to the SLING AND THE
ARROW, and THE FALL OF VALOUR. The latter especially
strikes me as rather crude for a variety of reasons, which
sometime when you are in New York we can talk over at lunch
or dinner. I live rather humbly on the top floor of a
brownstone house near Central Park West.

I congratulate you once more on your literary
accomplishment and indomitable courage.

Sincerely yours,

from the bottom of my
heart. I agree with much
of the philosophy expressed
and find a list of new

+ some

some.

for
cess

my truly,
S. Marlor

My dear Mr. Vidal,

Just a note to express
my appreciation to you
for presenting to the general
public a picture of the
homosexual as a human
being in The City and The
Pillar. I think it is
one of the finest novels
on the subject and shows
great insight, sincerity, and
sympathy into physiological
and psychological functioning
of the homosexual.

As a homosexual
I want to thank you

with an American chap and besides I did not know you wrote
the book. Anyhow, if you wil
like to meet you, if you will
spending my holidays in Augu
of a friend of mine but I sh
during the other months. Can
to give, an interview to a m
do not understand the meanin
intended as pure and friendl
Italy? Silly as this request
realise, can you send me you
It will be deeply cherished
appreciation your book.

When spring is in
and everything speaks of lov
to be alone, very often misu
too often left to my terribl

Thank you again,
understanding of "us homosex
deserve somebody on this ear
only with dirt!

If you will ever a
you will make me enormously

May you have, if p
which I lack and all the luc

Enclose my photo g

STRICTLY PERSONAL

Dear Mr. Vidal,

I have just finished to read your book "The City
and the pillar" and since I definitely belong to the
homosexual world, may I thank you for your deep under-
standing which I have sincerely appreciated.

Too often and too easily, especially here in
Italy, "homosexuals" are misunderstood for vicious people
who are something between "females" and "degenerated
persons". I am proud to say that I have always been a man,
in the full meaning of the word, but I have never loved
or felt any phisical attraction for a woman. I do not
know what a woman looks like when stripped, I have no wish
whatsoever of knowing particulars of her anatomy. I love
a man and I am a man, that's all. This caused me in the
past and at present quite a lot of trouble firstly with
myself, secondly with the "normal" world, starting from
my parents with whom I live. They simply "do not admit"
such thing. But after having read your books I know
that also in the United States "such thing" exists and
at least by you it is understood, I am compelled to live
alone, alone with my terrible longing for love, real
life, for appreciation not only of my mind but also of
my love-making, which I cannot find in "normal" men
since when my feeling are not reciprocated I simply feel
disgust for the "other party". Not because I wish to tell
you my personal experience, but because it is indeed
so sweet to open my heart, may I tell you that since when
I was 18 (I am 38 now) I am in love with a man, a fellow
thoroughly normal, who, of course, does not reciprocate
my love. But he is always close to me, he understands me
a little bit, and, firstly, we have no phisical contact
whatsoever as we never had. I like him and love him because
he shares my life, because my home is his home, because
I can tell him the truth, always. In the meantime, and my
friend, is perfectly aware of this, I had other men,
including several Americans. But he is always there, deeply
rooted in my heart and blood, a dream that will never
come true (unfortunately). This is my life, unhappy as
a life can be. There is no possibility, in Italy, to just
go away from home, you must stuck to it, so much so because
I am the only son. And so, day by day, hour by hour, I live
my lonesome and unpleasant life, recently lit by your book.
I know that you have been to Italy last year, in Venice,
just when I was there! But then, yes, I was too busy

65

ere are some of the books that I've published post-*Williwaw*. *The City and the Pillar* was successful around the world, and I lived off the income from that book for a long time. Most of these books were published by E. P. Dutton, whose chief editor was Nicholas Wreden, a great and loyal friend during those occasionally stormy times for me and some of my books.

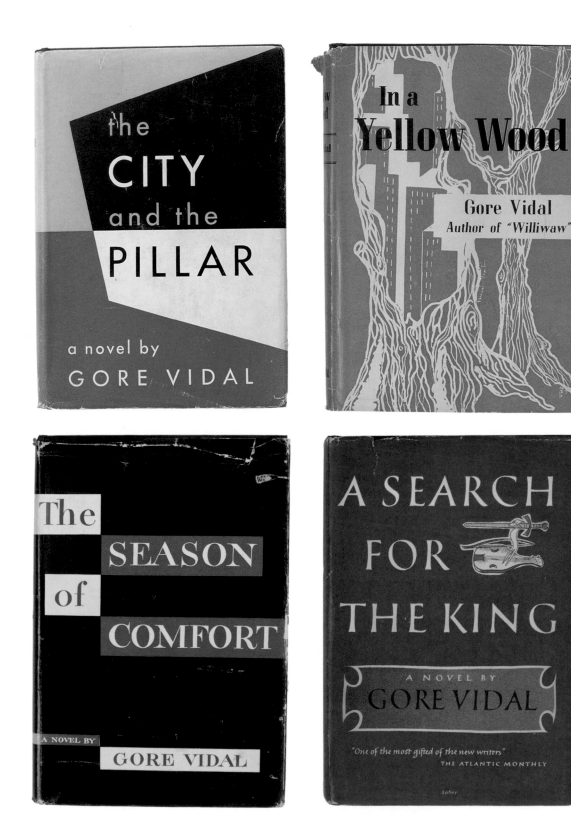

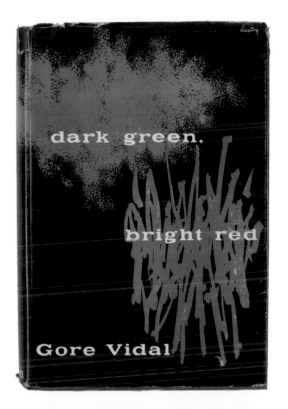

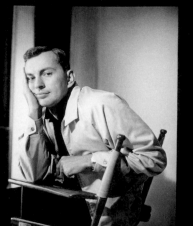

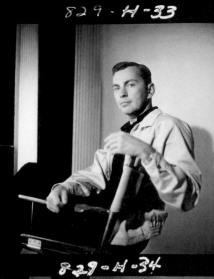

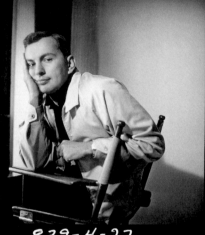

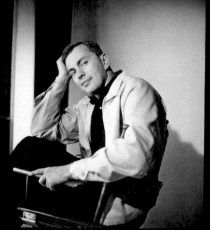

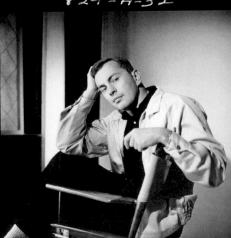

M y time at E. P. Dutton was pleasant. I read many fairly hopeless manuscripts. I did persuade Dutton to publish Anaïs Nin's *Ladders to Fire*, but I failed to get them to publish *Cry Holy* (later published as *Go Tell It on the Mountain*) by the African-American writer James Baldwin. Mr. Macrae, the publisher, explained to me his rejection of *Cry Holy*. "You know, I'm from Virginia. So I *can't* publish this book." Baldwin went elsewhere and flourished. But racism was very much alive and well in mainstream publishing back then. So was sexism. This meant that my third novel, *The City and the Pillar*, although a success in Europe and even in most of the United States, went unmentioned in *The New York Times*, which refused to review it or even accept advertising for it.

The permanent daily book reviewer for the *Times*, Orville Prescott, had warned Nick Wreden that despite his favorable review of me as a war novelist, he simply could

Here I am posing for one of many photographers who were suddenly interested in photographing me while I was still under eighty.

not allow any book of mine to be reviewed in the daily *New York Times*. And so I vanished from the scene and wrote a number of novels under pseudonyms. The most popular was Edgar Box, a mystery writer who is still read today. The Hearst newspapers, always hostile to FDR and his director of Air Commerce, now included me in this blacklist. One of their journalists started a rumor that a vast publicity campaign for me was being paid for by my father, who was, at that time, practically penniless. Although this "news" was totally untrue, it started a persistent rumor that I had inherited a fortune and meant to buy my way to the top. The only thing that was unusual about me was that I could write a novel in eight days, which I had to do until 1964, when I published *Julian,* a book that everyone reviewed, including Orville Prescott, who came out of a well-earned retirement to attack me. I should note that I have always been amazed to find that, curiously, very few schoolteachers or journalists believe this story, one that is so easily checked by referencing *The New York Times* itself, when at least once a year they list books that they have reviewed. Looking back I am quite relieved. That a newspaper notorious for its dullness and hostility to excellence of any kind, other than thievery, would choose to blacklist me was in a way a blessing. I shall not note the long list of truly bad writers that the *Times* embraced. But then a mediocre newspaper must be consistent. The mediocre are a curious tribe, ever loyal to their own peculiar ethos. In any case, there was a short

period between 1945 and 1950 when the United States was blessedly at peace and attacking no one, or hardly anyone, and it looked as if a sudden burst in all the arts might yet give us a golden age, of a sort, which our leaden culture could never really deal with. And that is why I like Mr. Bissinger's photo (pp. 74–75), as it was a visualization of a potential golden age when we were no longer attacking other nations and it looked as if we had begun to create a civilization soon to be lost on far-flung battlefields in Korea and Vietnam.

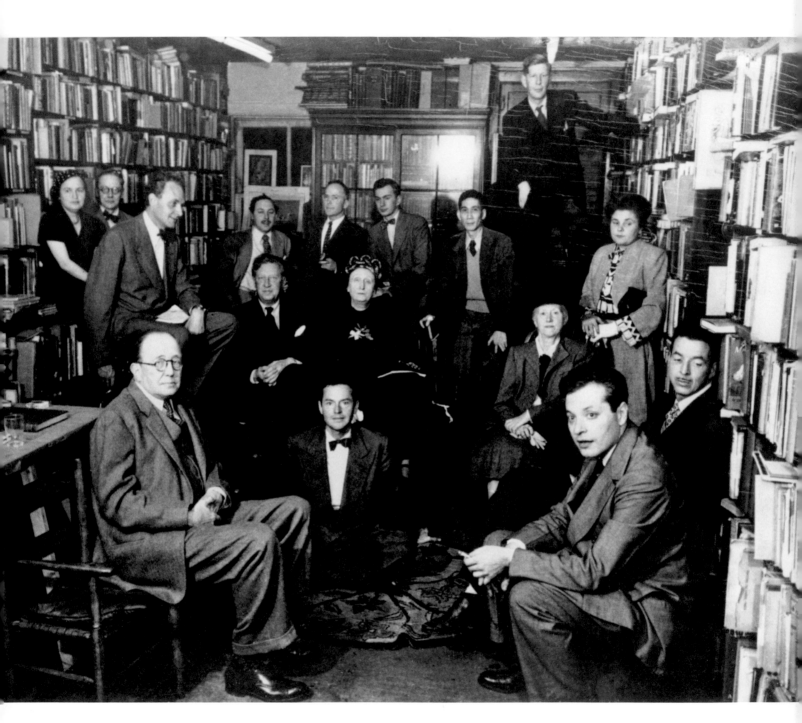

A famous photograph taken in the Gotham Book Mart by *Life* magazine. I was then, I thought, erroneously, a poet. So I have been included among a group of very grand poets including W. H. Auden, Elizabeth Bishop, Stephen Spender, and Osbert and Edith Sitwell.

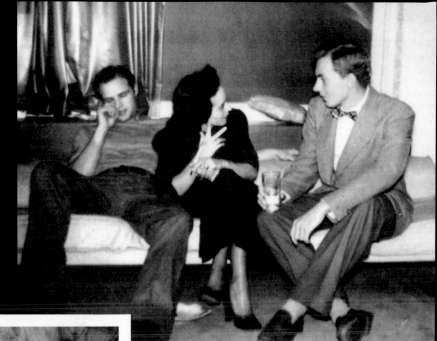

A snapshot of Marlon Brando, who was having his golden success that season as an actor on Broadway in Tennessee Williams's *A Streetcar Named Desire*. I have no idea where we are or who the lady sitting between us is. But I seem to be watching Marlon pick his nose with great interest.

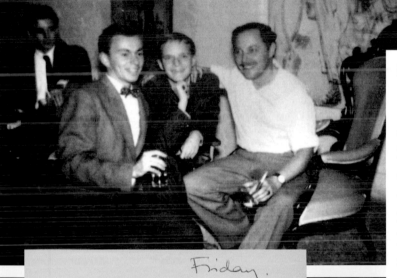

Tennessee Williams, Truman Capote, and me, three writers whose bad reviews in those days (I wonder why?) could have shut down the bronze doors of literature itself but somehow we all survived. Capote's name was often linked with mine, on the grounds, I suppose, that each had published a "degenerate" novel. Later the press liked to write that Mailer and I were constantly feuding, which was hardly the case, as we usually got on quite well.

Friday.

Dear Gore—
Your suggestions for "Ambush" worked like a charm. I am not only grateful for the nice & shrewd criticism — I am still flattered at such a considerate and generous gesture, & I feel very much in your debt. I hope, some time, my own critical faculty might be of some use to you — if ever it is, please consider my warmest coöperation a fait accompli. I have put through the changes (all except a drawing last curtain) and I've told Duggan to start contacting Harold Clurman.
If I may coin a cliché, you are very "right-hearted".
Kindest regards
Noël C.

Here is a letter to me from Noël Coward, whom I had lunch with in London earlier that year. A reader used to Coward's calligraphy says it has to do with thanking me for an interpretation of a play called *Ambush* he'd asked me about. It would be redundant for me to say that I found him a most delightful person to know and saw him two or three times in my life and found each encounter charming.

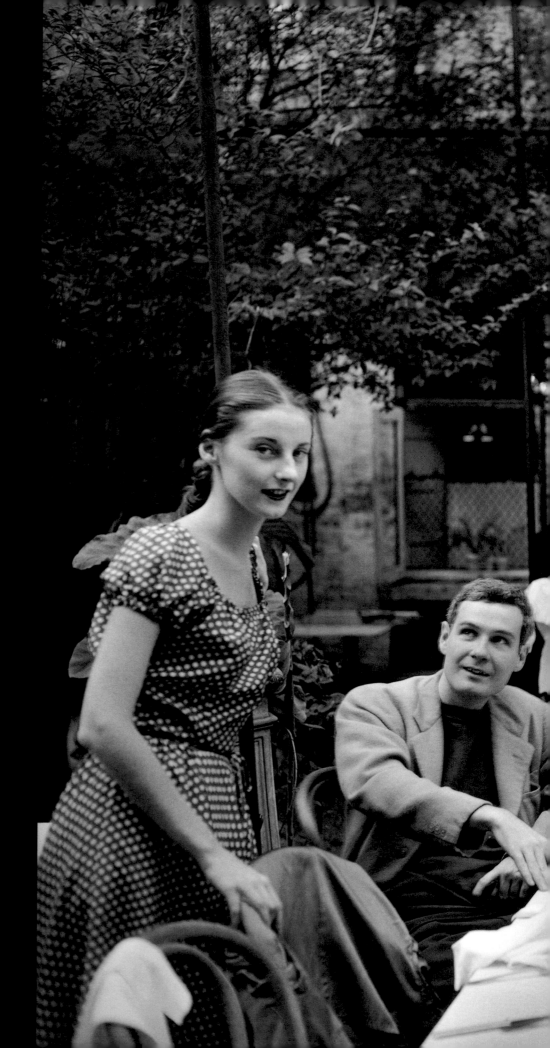

Karl Bissinger's beautiful photograph taken for *Flair* magazine in the garden of Johnny Nicholson's restaurant in Manhattan. On the left is Tanaquil Le Clercq, a young ballerina whom Balanchine married; later she was struck down by polio. Seated at the head of the table is the painter Buffie Johnson, then Tennessee Williams, and then me.

Sometimes when people ask, "What were the 1940s like?" I refer them to this photograph. For me the 1940s were mostly the war, but when that ended I did not realize that we were about to embark on an imperial mission that involved attacking nations around the world and reordering their politics as I had witnessed during my time in Guatemala. When Bissinger snapped this picture we were not to be at war until Korea began, but from then on we have been at war for no reasons ever made clear to us. One feels that the people in the Bissinger photograph are serious about the arts, and we felt that our time had come. In any case, Korea preceded Vietnam, and since then all sorts of artificial monsters have been invented for us by interested financial parties. As we had—and have—no intellectual class to fall back on to explain to us what was really happening, there was only Norman Mailer to remind us, through his own rendering of Matthew Arnold's great poem "Dover Beach," of what the "war" was indeed about: *And here we are as on a darkling plain / Swept with confused alarms of struggle and flight / Where ignorant armies clash by night.* The night continues.

74

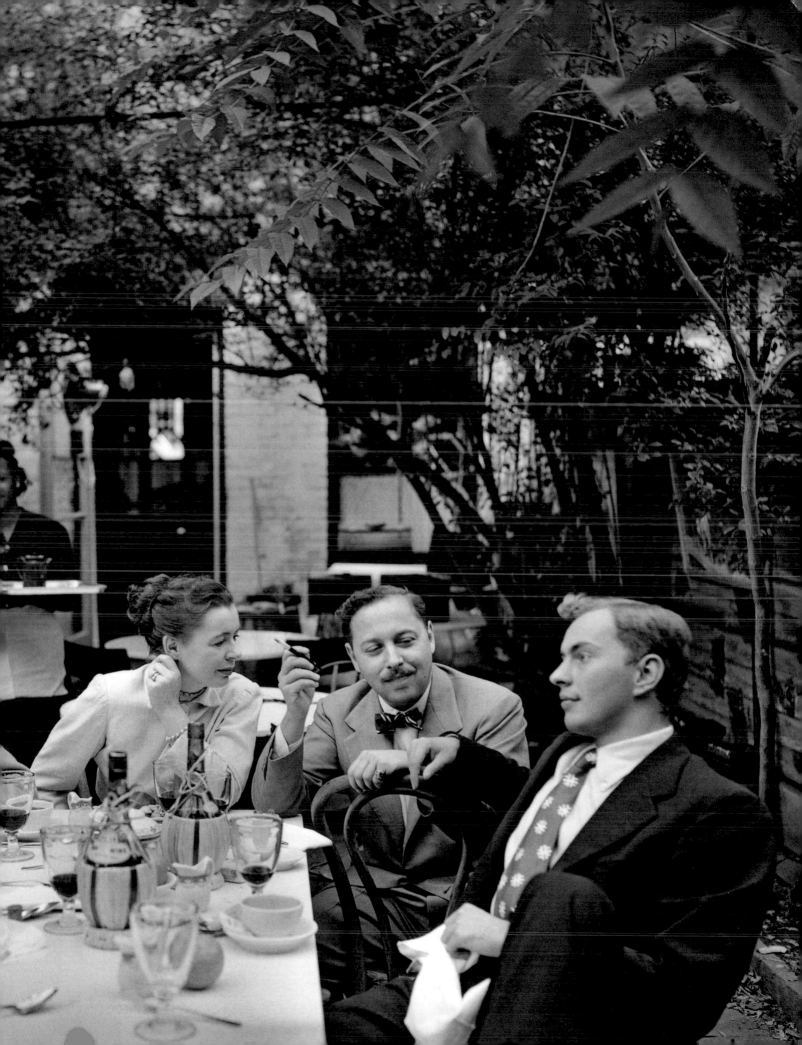

It was during this time that I met Howard Auster, seen here as a child with his parents in the Bronx. We had met once in New York City and I had asked him to come up to Edgewater, the house on the Hudson, and he did. And some fifty-four years later we were still together. Here are some of his notes to me. He had put himself, with no help from his parents, through NYU and tried to get a job with a couple of advertising agencies, but he was rejected because he was Jewish. Since he had no desire to become a holy roller Christian, I told him to change the *r* at the end of *Auster* to an *n*. He did, and was accepted by an important advertising firm, BBD&O. Then, more and more, he helped me with my business life, and when I went to Europe for work or whatever, he came along. He charmed most people. He was at home everywhere. And I trusted his judgment about people far more than I did my own.

Dear Gore,
Tinker misses you so much. He thinks of you all the time and wonders how you're enjoying yourself and how the book is coming along.
He wishes desperately that he were there with you or you back home. He finds people dull and life more uninteresting than it ever was. I don't think he trusts you very much either, because he always has those silly suspicions of your being spirited away from him by some bad bogieman. But then when he thinks of how beautiful you're going to look when you get back from Florida with wonderful gold hair and a "gorgeous" tan (the bound slave in pastels), he doesn't mind too much and reconsiders and feels guilty and knows that you need a vacation badly. But then again he thinks of how ugly hill seers, all pale and crab-looking—standing beside you when you get back and again wishes more desperately that he were there with you.

Up at Edgewater, my Greek Revival house on the Hudson River, which I had bought for very little.

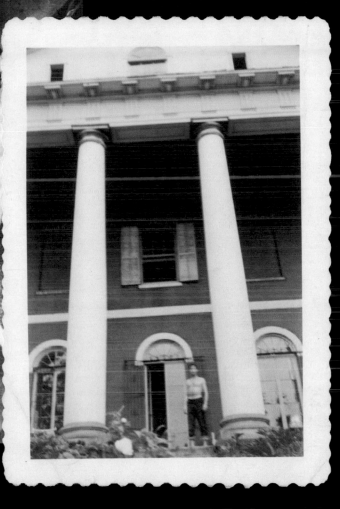

The facade of the house that faced the river, and Howard poised against a mass of wisteria.

Feb. I, 1951

Dear Gore,

Your letter arrived just as I was beginning to wonder why I hadn't received one. You never fail me, do you?

You're so lucky to be in Key West now. We're having terrible snow and rain storms with temperature's in the teens. It's so depressing that it just intensifies the personal feeling of depression that I have.

Life at home stinks. It's worse since you've been gone. You were such a pleasant escape - so ple asant and influe ncing that now I feel like caviar in a can of sardines. My parents really are gruesomeand as you would say "so yentey". They're now on a new word kick-"morg , meaning , lingering, idling, wasting time,(that's what I take it to mean,anyway.

I haven't gone out since you left, mainly because I have to save money. I brought back that $35 typewriter that I boughtbecause the ribbon wouldpop up like a jack in the boxevery time I'd hit one of t he keys. I bought a new Underwood Champion f or $100.I will have to pay it off at about the rate of $10 a week for seven weeks.

A new job with more money would help , but nothing so wonderful seems to be in the offing. Those two other things never worked out and Ted tells me that he doesn't know when and if anything will develop with Orr. So I'm back where I started from- no job, no you, no money. As soon as I'm out of debt I'M going to Quit my job and look for something else.It's too difficult to look for a job on your lunch hour(which is what I've been doing to no avail.) By the time you an wear an ad it's been taken by someone else, who not working was able to get there earlier.

Tennessee's new show has been getting an awful lot of advance publicity and the"word" is that it will be as successful in New Y ork as it was in C hicago. There was another article on Tenn. in last weeks Times. about the humor and comedy in the new play. while reading it, I got the same react ion that I get when I read your work or ar- ticles about you. I see the man completely detached from his artistic personality(the subject matter has nothing to do with the reaction). I suppose I've associated the artist with the profesor for too long a time be cause I can't imagine the professor as being a man among men excent whe n he sheds his professor'al robes and puts on a sports jacket. It's the same way when I'm with you. when you're Gore- a nice, sweet guy who writes brilliantly and whom(?) I'm very fond of: not Gore Vidal , THE Writer. Does it make se nse? Well, exrlain it to me .

Enough of this nonsense .It's confusing me more as I go on. I've reread it and it makes very little sense and is very easi ly understood.

OH! I'm on a diet. It probably won't be very effective tho'. My appetite has increased since I started . I can't help it

I'm enclosing these pages from the l test issue of "Theatre Arts" just in case you might not have seen it. I thought you might be interested . It's very amusing .

well, it's getting rather late , so I'm going to take my hip-bath-Yes! A hip-bath!-and go"sleep".

Goodnight Gore,

Love

Tinker

77

Dust jackets from the works of Edgar Box and other ghostly figures. For a year or two after my blackout by *The New York Times* I supported myself with pseudonymous work and enjoyed conversations with people who were trying to guess who Edgar Box really was.

About that time I discovered a quicker way of making a living; after all it took me eight days to write a novel. I had a wonderful agent called Harold Franklin at the William Morris Agency and I said, "I think I can write plays for television." He said, "Have you ever seen a TV play?" And I said no. So he thought I might at least watch one before I wrote one. And that is what I did.

A. J. Donelson was the nephew of Andrew Jackson and he
built Edgewater in 1820. In 1826 architect A. J. Davis
added the octagon, later my library, where I am pictured
opposite. After my first TV plays, for which I was paid a few thou-
sand dollars each, I was able to put ten thousand dollars down to
buy Edgewater. I then began to do movies and that way earn more
money, with which I started to fix up the house with the help of the
lady who showed it to me in the first place, Alice Astor Bouverie.

A long shot of the house, surrounded by locust trees.

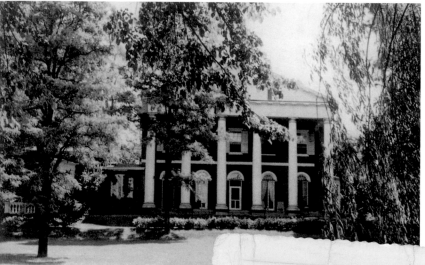

A view from the octagon. The
length of the house, including
pink and green rooms.

Dining & Living Rooms Edgewater

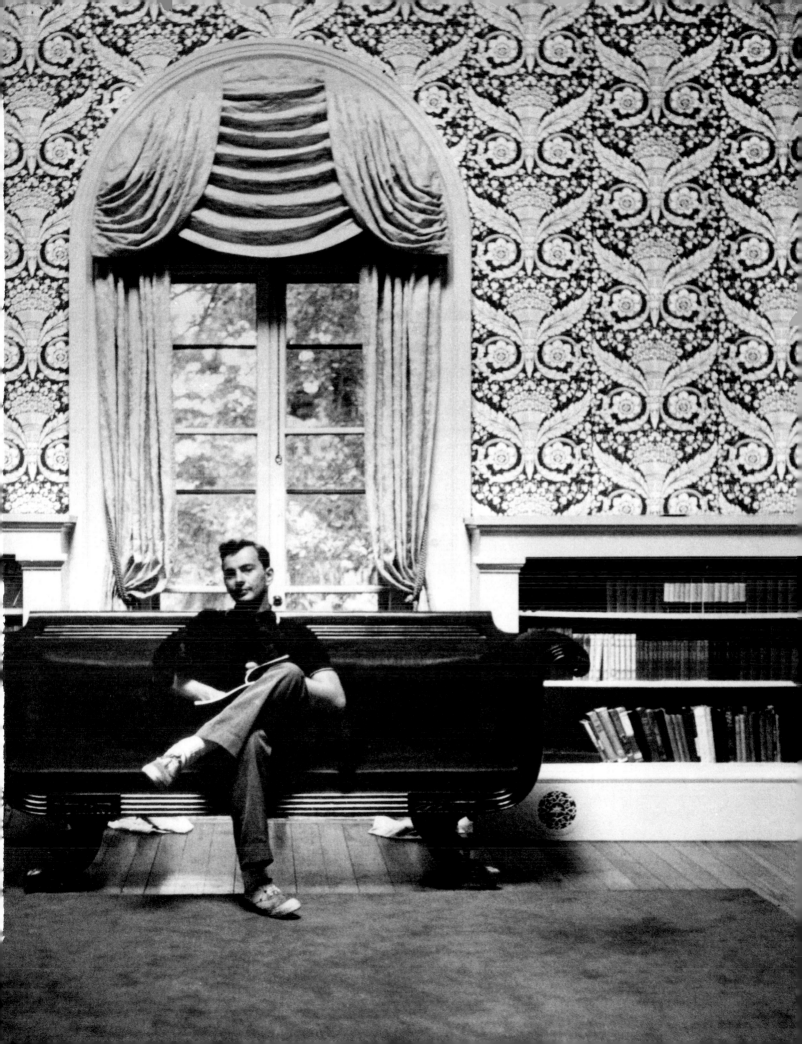

dgewater overlooks the Hudson River, and
although with most of the houses that I have had
in life—liked, lived in, and gave up—I still dream
about Edgewater, always a sign of some ghostly commit-
ment. Here it was that Howard and I lived for most of the
fifties and the beginning of the sixties, by which time I
had been selected by the Democratic Party of the
district to run for Congress.

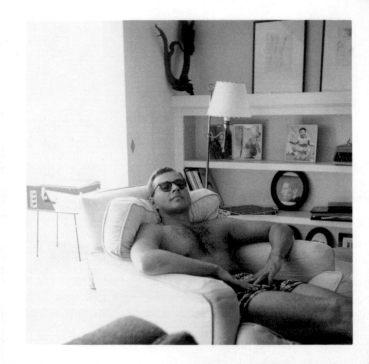

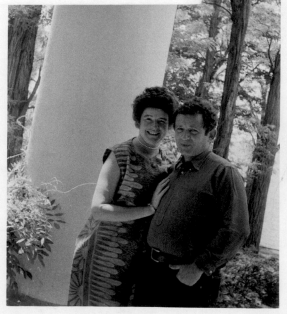

orman Mailer and his
wife Adele, whom he,
somewhat absentmind-
edly, stabbed with a small pen-
knife, which thrilled American
journalism. I invited them both to
come to Edgewater and I assem-
bled all of the literary figures of
the neighborhood, from F. W.
Dupee to Richard Rovere. Saul
Bellow and Ralph Ellison, who
were sharing a house down the
road from me, were also invited.

Here I am with Christopher Fry. We are the two writers who actually wrote the screenplay of the film *Ben-Hur* in Rome for producer Sam Zimbalist and director William Wyler. The literally incredible Screenwriters' Guild denied credit to either of us on the grounds that another writer, unknown to all of us, claimed the script was his. He maintained that he had mailed a copy of the script from Culver City to Zimbalist who, at credit time, was conveniently dead. Years later, I successfully sued the Guild on a similar matter.

By 1957 I was under contract to MGM as a scriptwriter. This meant I was well paid all year round (and if one did not want to do what the studios asked one to do, there was a state called suspension, in which one did not get paid at all, but one could go to Broadway, as I did when my first play opened there). Usually, under the old regime, the major producers at the studio had their pick of the writers; should writer and producer work well together, they stayed together. My producer for several films was Sam Zimbalist, who had come to Hollywood many years before from New York with Alla Nazimova. He had started out as an editor, which is the best training for anyone who wants to make movies. Our first film together was about the Dreyfus case, with José Ferrer directing as well as acting the part of Captain Dreyfus. The film was mostly made in Europe, but for reasons still obscure to me, France banned and still bans it from the theaters of *la patrie*.

Meanwhile, under suspension, I had written a play for Broadway, *Visit to a Small Planet*, which duly opened at the Booth Theatre and ran for many seasons in New York and around the world, largely thanks to a pair of manic comic actors—Cyril Ritchard and Eddie Mayehoff. It was a happy state of affairs that ended with the release of a film of the same name. Incidentally, the higher the profile of the movie, the less chance for its actual creator to be given credit. Over the years attempts have been made to pretend that the movies are an art form, but you cannot have an art form without an artist. The careful muddling of credits makes it almost impossible to figure out who did what on so many films, good and bad.

When I told Zimbalist that I could only give him a month or two as rewriter of the script of *Ben-Hur*, he suggested the charming writer and person Christopher Fry to write the last scenes; I said he'd be quite wonderful. He was as good as we'd all hoped. And so there I was standing under the centerpiece of the stadium at Antioch at the time of the death of Christ. Fry nicely pointed out how apt it was that the two writers should be posing in front of a statue of a weary, if not godlike, figure holding a pen.

In the fifties, under my contract to MGM, I

After Paul Newman had appeared as Billy the Kid in a Philco-Goodyear Television Playhouse play that I had written, Paul, Joanne Woodward, Howard, and I all became friends—so much so that we ended up taking a house belonging to Shirley MacLaine in the Colony, as it was called, in Malibu. It was a glorious time and we held a sort of regular open house, the four of us, never knowing who was going to be there on a given Sunday, as everyone thought that they could come, just by showing up; I would never know if Joanne and Paul had invited them or if Howard had invited them or if I had invited them. Its greatest moment came after lunch on a sunny day, when Hermione Gingold came to the house wearing a great picture hat, high heels, resplendent ornaments in her hair, or somewhere, and she and I took a walk just as a crowd of fat squalid-looking birds flew overhead. She said in her comic voice, "Oh look! They're going to spell out my name!" and we marched off into the sunset.

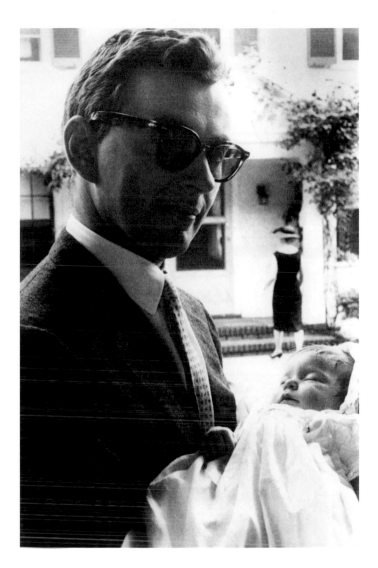

Here I am, godfather to Paul and Joanne's first-born child. Hence my comment, "Always a godfather, but never a god."

1955

1956

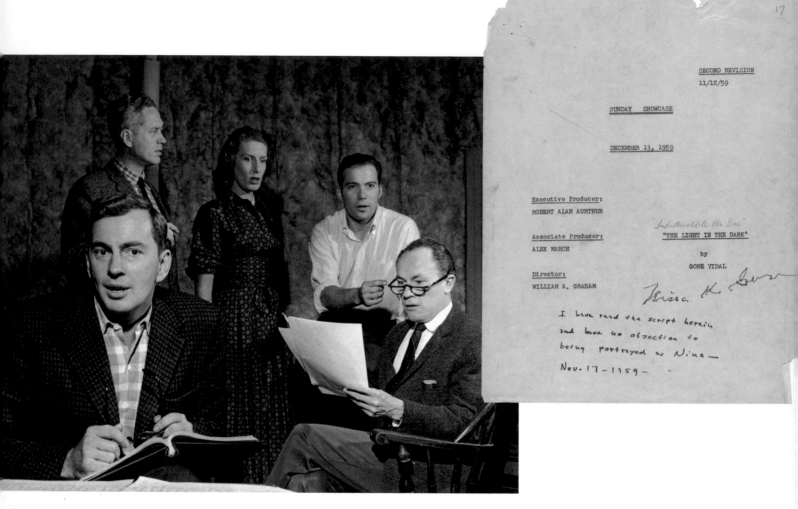

Here I am narrating the beginning of my television play *The Indestructible Mr. Gore,* starring Bill Shatner and Inger Stevens, as well as my favorite actor, E. G. Marshall, comfortably reading his script on air, as he said that it was the sensible thing to do when we lost all power in NBC's Brooklyn studio in the middle of the play; besides, he was playing a lawyer. Live television had come into its own in New York, thanks to all of the remarkably good actors available to us, among them Paul Newman and Joanne Woodward. Later, television made a fatal mistake when they moved production from Manhattan to

Hollywood, on the grounds that they could only get the really great stars in Hollywood. Presumably, they could, but they seldom did.

On the other hand, stars were often born. I recall John Cassavetes, a vague young actor whose self-absorption director Frank Schaffner found difficult to penetrate during rehearsals of my Studio One play *A Man and Two Gods.* When the exasperated Schaffner suggested that Cassavetes should perhaps show more interest in the play, the actor said, "I guess I'm so busy thinking about my next parts that I'm having trouble with this one." Thus, an auteur was born.

Dr. Jekyll and Mr. Hyde (with Michael Rennie in the double role and produced by my old friend Martin Manulis), one of the first teleplays done out of the CBS studios in Hollywood. I was warned of a story told about Somerset Maugham when he was visiting the studios in the previous decade and Spencer Tracy was playing Dr. Jekyll and Mr. Hyde. When Maugham had asked, "Isn't he going to be made up as a monster?" which is what Hollywood usually did when it came to the Hyde scene, he was assured by the director that so great an actor as Tracy was going to make the transformation from Jekyll to Hyde internally, without any help from makeup. At the beginning of Mr. Hyde's great scene, Maugham stormed onto the set with, I think, George Cukor, and asked in a loud voice, "Well, which one is he now?"

The first transplant of one of my plays was an adaptation of Hemingway's *A Farewell to Arms*, with Guy Madison and Diana Lynn. My friendship with Diana ended only with her abrupt death.

Shatner and Stevens in *The Indestructible Mr. Gore*, a story about my grandfather, a blind man who marries a girl with perfect sight, whose parents warn her not to marry him because, "You'll end up in the streets with a tin cup begging, as he will never see again." They were right—he never saw again, but they never needed to beg in the streets, since for some decades he was a United States senator, from the new state of Oklahoma, and a famous lawyer.

Promotional materials for *I Accuse*, a film still not shown in France.

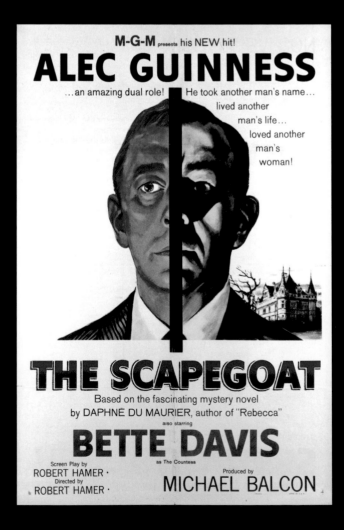

Paul Newman and I decided to use his Warner Bros. contract to make a movie our way, *The Left Handed Gun*, but an overeager producer got rid of our director, Bob Mulligan, and replaced him with a scholarly director called Arthur Penn. At about this time, Zimbalist asked me to make a full-length film out of a forty-five-minute TV "play" by Paddy Chayefsky, reminding me that theft in this business continues after death. *A Catered Affair* had a script entirely written by me. It was one of Bette Davis's last studio films, and it revealed her at the peak of her last phase, while Debbie Reynolds gave a superb ingenue performance. Currently a musical based on my script is playing on Broadway, and the producer rang me to say that they had to use the magical name of Paddy Chayefsky to show from where the script had come. There's a lot of difference between a three-hour film script and a forty-five-minute television script, as I pointed out. But I did not wish them ill and made no fuss.

Incidentally, Bette Davis and I became friends but I did her no great good when I got her cast in *The Scapegoat* with Alec Guinness. Alec was a very complicated man and she had a dreadful time working with him.

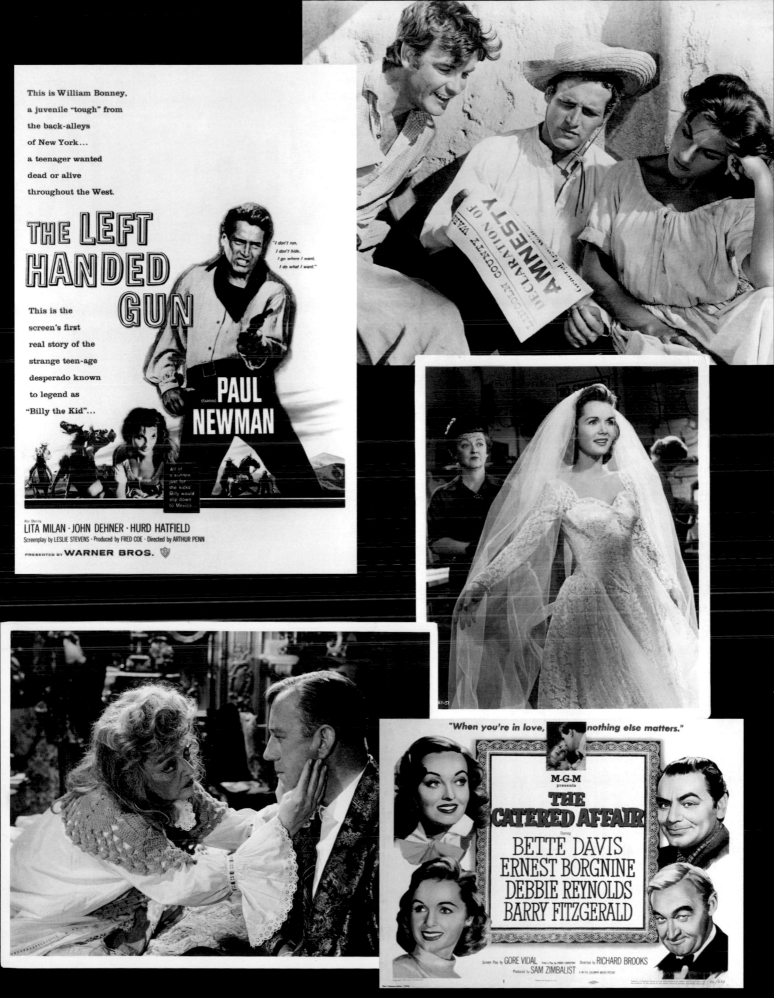

This is William Bonney, a juvenile "tough" from the back-alleys of New York... a teenager wanted dead or alive throughout the West.

THE LEFT HANDED GUN

"I don't run, I don't hide, I go where I want, I do what I want."

This is the screen's first real story of the strange teen-age desperado known to legend as "Billy the Kid"...

All of a sudden just for the kicks Billy would slip down to Mexico...

PAUL NEWMAN

Also Starring LITA MILAN · JOHN DEHNER · HURD HATFIELD
Screenplay by LESLIE STEVENS · Produced by FRED COE · Directed by ARTHUR PENN

PRESENTED BY WARNER BROS.

"When you're in love, nothing else matters."

M·G·M presents

THE CATERED AFFAIR

Starring

BETTE DAVIS
ERNEST BORGNINE
DEBBIE REYNOLDS
BARRY FITZGERALD

Screen Play by GORE VIDAL From a Play by PADDY CHAYEFSKY Directed by RICHARD BROOKS
Produced by SAM ZIMBALIST A METRO-GOLDWYN-MAYER PICTURE

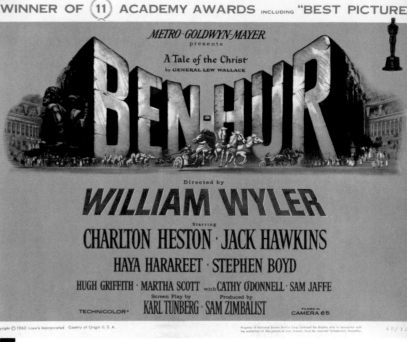

MGM was in great trouble financially and in fact the survival of the studio depended on one film, a remake of *Ben-Hur*. Zimbalist was producing, and he wanted me to write it. I told him that I thought it was simply junk, but it would be fun to make as "accurate" an interpretation of ancient Roman life as possible (I was already at work on the novel *Julian*, set in the fourth century AD). And the film *looks* quite good. Charlton Heston got the lead because Paul Newman had turned down $1 million to play it, on the grounds that he had already performed in a silver cocktail dress in a movie called *The Silver Chalice*. Finally the studio decided, rather sadly, on Heston, who, to be fair, was always a first-rate villain in western movies, and was even used to good effect by Orson Welles himself. Heston was not popular with the people working on the film. They had to do all sorts of extra things for him, putting out a newsletter of his doings in Rome and so forth. I suppose it was one of them who came up with this photograph of Mr. Heston, above, with a guilty expression, fleshing out his part. My agreement with Zimbalist was that I would give a month or two to the script of *Ben-Hur* in Rome with him, and that went very well. The director William Wyler and I would meet in Zimbalist's office with the latest changes in the script; then we would be joined by "Ben-Hur," Mr. Heston himself, and the excellent Irish actor Stephen Boyd, and they would read the scene for us. Not always useful because Heston reverted to some silent-screen acting, tossing his head like Francis X. Bushman. Once, as the "boys" left the office, producer, director, and writer looked at each other sadly, and the writer said, "Chuck does not have much charm." To which the director responded, "And, you can direct your ass off and you still can't give it to him."

Catastrophe struck not long after I left: Zimbalist died of a heart attack. Contrary to auteur legends, in that period at a great studio like MGM, the producer, not the director, was in total control of every aspect of the script and, indeed, of the production. The Screenwriters' Guild had a peculiar method of deciding who had written what in a film, and the decision would be made by three members of the Guild, I think it was. This made it possible for a former officer of the Guild to claim that he had been sending the "final" script to Zimbalist, and so he claimed credit when, actually, every word of the script had been written by me, except for the last part, which was the work of Christopher Fry. Although Wyler made a determined effort to tell the Guild that he, as director, knew for a fact that Fry had written the last scenes, the writer who had nothing at all to do with the script of

Ben-Hur was given full credit, in those days a standard perk of former officers of the Guild. As a result, when awards were handed out, everything from makeup to special effects was praised in the film—everything except the script. The membership had a fairly clear idea of who had done what, but in those old anarchic days thievery in such matters was respected, even admired. During this time I was busy writing *Julian*, and since I disliked *Ben-Hur* to begin with, I didn't understand quite what it meant to ignore the time I had spent in Rome with Zimbalist and have my credit given to a writer who had not been in Rome, and I very much doubted the so-called evidence, seemingly carbon copies of what was allegedly the script written by Fry and me in Rome, copied by the writer in Hollywood. So it was with some pleasure, years later on a similar case of misappropriation of credit, that I sued the Guild, which lost in several courts and ended by appealing to the Supreme Court of California, which found in my favor and, in a sense, said that the rules for establishing credit in our labor union, the Screenwriters' Guild, were in need of repair. The Guild, endlessly resourceful in the presence of crime, has never, as far as I know, acknowledged the ruling of the Supreme Court of California. In due course, studio producers lost their powers, which were then preempted by the directors in their new role as auteur.

A brilliant lawyer, Bert Fields, represented me against the Guild, and when the Supreme Court of California, to whom the Guild had appealed, found in my favor, I did not ask for credit on the film since it was to me a pure example of commercialism. When asked to define *commercialism*, I said, "It is the ability to do well what ought not to be done at all." This lawsuit was my quarter-of-a-million-dollar gift to the membership of the Guild: No longer need they accept as "final" word the judgments of three anonymous hacks. The Guild finessed this by—to this day—refusing to acknowledge the decision of the Supreme Court.

The photo above shows Wyler, Fry, Heston, and me in happier days.

A number of my fellow hacks in Hollywood couldn't understand why, once I was again a successful novelist, playwright, etc., I would work with Sam Spiegel, who was famous for not paying his bills, cheating people out of credits—anything you could do wrong, Sam did it. I remember answering one of the hacks by saying, "Well, I agreed to work with Sam again on the grounds that the first time I didn't believe it. And he was good company." Not trusting Sam, Tennessee came to ask me if I would do *Suddenly Last Summer*. I said I would, but only under the condition that I write the script myself. Next thing

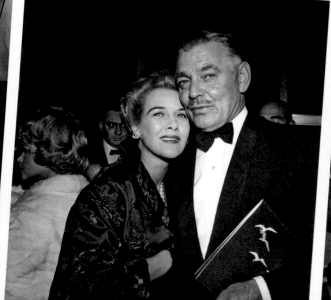

I know, Spiegel has listed beside my name Tennessee Williams himself, who did not contribute one line to the screenplay. But Tennessee was quite happy with the result, which was the most successful film based upon any of his plays. Here are some shots of Sam's opening night party for *Suddenly Last Summer*—he was much better at those parties than any of the movies that went with them, and he was also a master concierge, getting girls transported from one country to another country, one city to another city, and, indeed, from one sex to another—most of his life was involved in transport. *Ars gratia artis*.

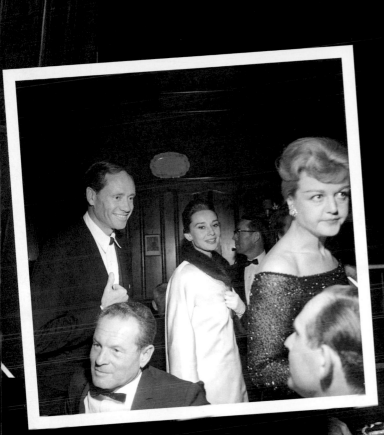

SAM SPIEGEL PRESENTS

ELIZABETH MONTGOMERY KATHARINE
TAYLOR CLIFT HEPBURN

...the *lured* ...the *lored* ...the *lost*

TENNESSEE WILLIAMS
...the *author*

JOSEPH L. MANKIEWICZ
...the *director*

SAM SPIEGEL
...the *producer*

SUDDENLY LAST SUMMER

Based on the play by TENNESSEE WILLIAMS · Written for the screen by GORE VIDAL and TENNESSEE WILLIAMS
Directed by JOSEPH L. MANKIEWICZ · Produced by SAM SPIEGEL · Production Designer—OLIVER MESSEL
A COLUMBIA PICTURES RELEASE

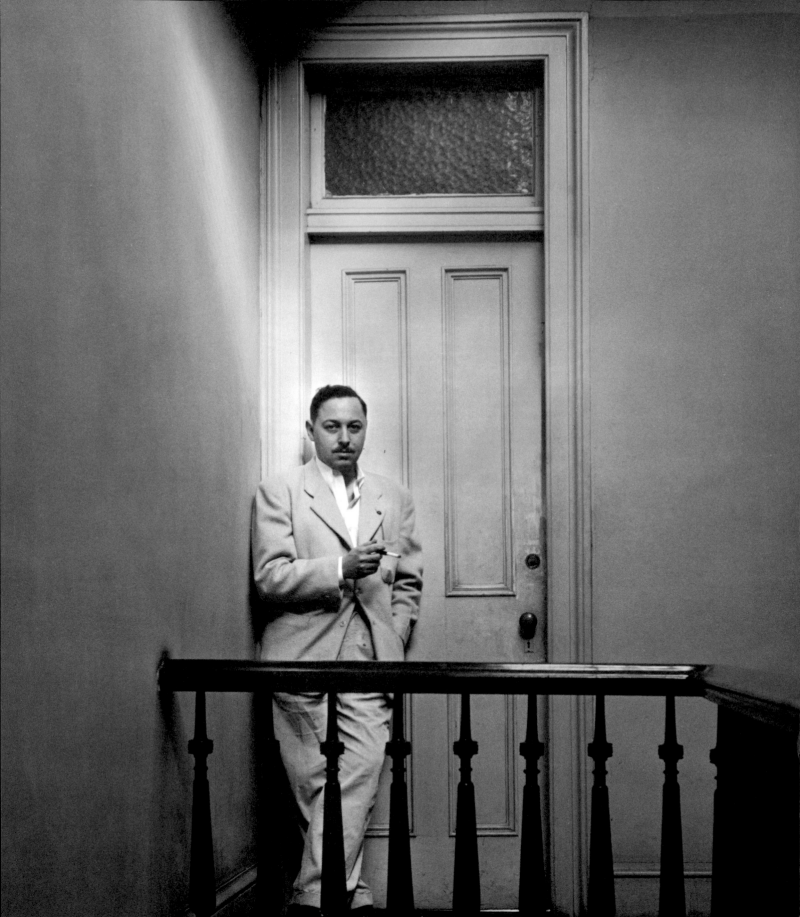

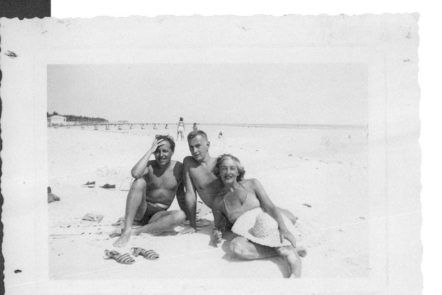

I have always associated my friend Tennessee with beaches, mostly Key West, where he eventually bought a house and settled in. Here is a photograph of him on the beach there. I am in the middle, he is to my right, and Nina, the star of *Sign of the Leopard*, is getting ready for her long shot.

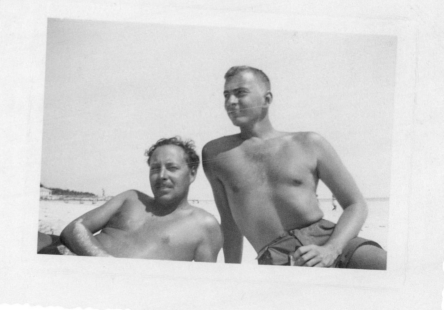

LEFT The Glorious Bird, the name I coined for Tennessee after years of delighting in his references to the flight of birds, so like his own lovely art.

It was Donald Windham who always said when Tennessee has knifed you, he becomes extremely affectionate and effusive. This telegram shows him after he was given shared billing with me for the movie he had made no contribution to beyond the one-act play that, as I pointed out to him, he was given great credit for. Here are some characteristic notes from him to me.

How about this for the dust-jacket of your next novel, Glorious?

Jean
(Roma)

PER VIA AEREA
Mod. 24-R bis

Gore Vidal/
℅ E. P. Dutton Co.
(Publishers)
3ᵈ ave (?)
New York.
U.S.A.

PER VIA AEREA

CLASS OF SERVICE

This is a full-rate
Telegram or Cable-
gram unless its de-
ferred character is in-
dicated by a suitable
symbol above or pre-
ceding the address.

WESTERN UNION

W. P. MARSHALL, PRESIDENT

FX-1201

[48]=

SYMBOLS

DL=Day Letter
NL=Night Letter
LT=Int'l Letter Telegram
VLT=Int'l Victory Ltr.

The filing time shown in the date line on telegrams and day letters is STANDARD TIME at point of origin. Time of receipt is STANDARD TIME at point of destination

NA086 PD=KEY WEST FLO 27 119PME=

=GORE VIDAL=APT 5A 1954 MAR 27 PM 2:01

683 LEXINGTON AVE

=DEAR GORE THIS IS YOUR MOST IMPORTANT BOOK DEEPLY
TOUCHED BY INSCRIPTION WILL BE IN NEW YORK WITH TWO
WEEKS LOVE=

 TENNESSEE=(

THE COMPANY WILL APPRECIATE SUGGESTIONS

To Gore of Rome and Paris
and Red Hook
with affection everywhere,
always,

 Tennessee.

3/1/50

Fruit of Eden!

The first of your letters, the one mailed in packages, was forwarded to New
York. I opened it and started to read it in the theatre when the lights went
down. I never got past the first two sentences and unfortunately I left it
in my program. I hope it has fallen into friendly hands and that it was not
the sort of letter that would expose us to blackmail. The second I did get
here. (We are back in Key West). The high point of my trip to New York was
a week-end at Rhinebeck, arranged and conducted by Polly Bigelow. I became
quite fond of Alice and also her husband who is not without charm. As you
know, they have an indoor swimming pool and all the New York pools had been
closed so it was a God send. I went to plays every night. The Cocktail Party
was fascinating but nevertheless rather dull. The best was Inge s Come Back
Little Sheba. Carson's was done so badly I found it difficult to appreciate,
but there are standees at every performance. Lamkin was in evidence, but
apparently about to leave for Hollywood. with Charlie Feldman, like I had in 1943, but he seemed a bit wistful as though
that were not quite what he had hoped to be in store for him. Audrey had got him a $250. week job
see at all: but he was purportedly present in New York. Truman I did not
Windham-Campbell menage. A very painful dinner, everyone on edge and very
little to eat - the atmosphere full of a mysterious tension which I cannot un-
derstand or explain to myself and very saddening as I felt I had made every
propitiatory gesture. I talked to Audrey about you. She had your letter and
I assured her that she should certainly promote you with the studios if that
was your wish. Hope you've heard from her. You should be able to get a
better deal than Lamkin if you go after it. Polly is planning to
visit us early in March but we are planning a trip to Havana first. He may
occupy the house while we're away and spend a while with us after we get back.
Professionally the trip was rather ambiguous. Audrey is sitting on the new
script like an old hen, either because she doesn t really like it or because
she doesn t want it to fall into the hands of a producer, I don t know which.
I think she and Liebling hope to produce it themselves. I did show it to Kazan.
He wrote a long letter about it, seemed sincerely interested and enthusiastic
about most of it but wanted a different first act. So the work continues. I
am tired to the point of collapse but perhaps the Havana trip will revive me
This literary life, my child, is no bed of thornless roses! Did you know that?
But yesterday the social leaders of the town dropped in to see us. Grandfather
was eating his rice krispies in the diningroom which, as you may remember,
is continuous with the salon. I told him, Grandfather, The Newton Porters are
here! He could not see the other end of the room and thought I was merely making
some remark about them (it was quite early for a call) and he said, Goodness
Gracious, what pests those people are! - An awkward moment ensued, as even at 92
there is a limit to what you can get away with.

Write me about Houston. I presume you're coming back to New Orleans? I may
visit you there this Spring.

 Love -

10.

à Gore Vidal

souvenir amical de

LES ENFANTS TERRIBLES

Jean Cocteau
1948

pour Gore Vidal
avec la sympathie

André Gide

CORYDON

6 juillet 48

Here is a collection of books that I got the authors to sign in 1948 in France and Italy. Although I was never a great autograph collector, for which I was rewarded in my lifetime with an often cramped hand from signing autographs for others, here I got André Gide, Jean Cocteau, and George Santayana, a pretty good haul for a month or two in Paris and Rome.

To Gore
love
Tennessee.

For Gore –
who is *not* one of
the children of the Albatross –
having greater courage
Anaïs

Gore Vidal
from
G Santayana
Rome, April 1, 1948

With congratulations on the
quality of your own work
Alfred C Kinsey
Wardell B. Pomeroy
5·16·49

Cher Gore Vidal
en attendant vos conclusions
sur la page 17
et cordialement
Marcel Duchamp

MARCHAND du SEL
écrits de
MARCEL DUCHAMP

For Gore
with love from Christopher –
this warning.

Paris. April 1948

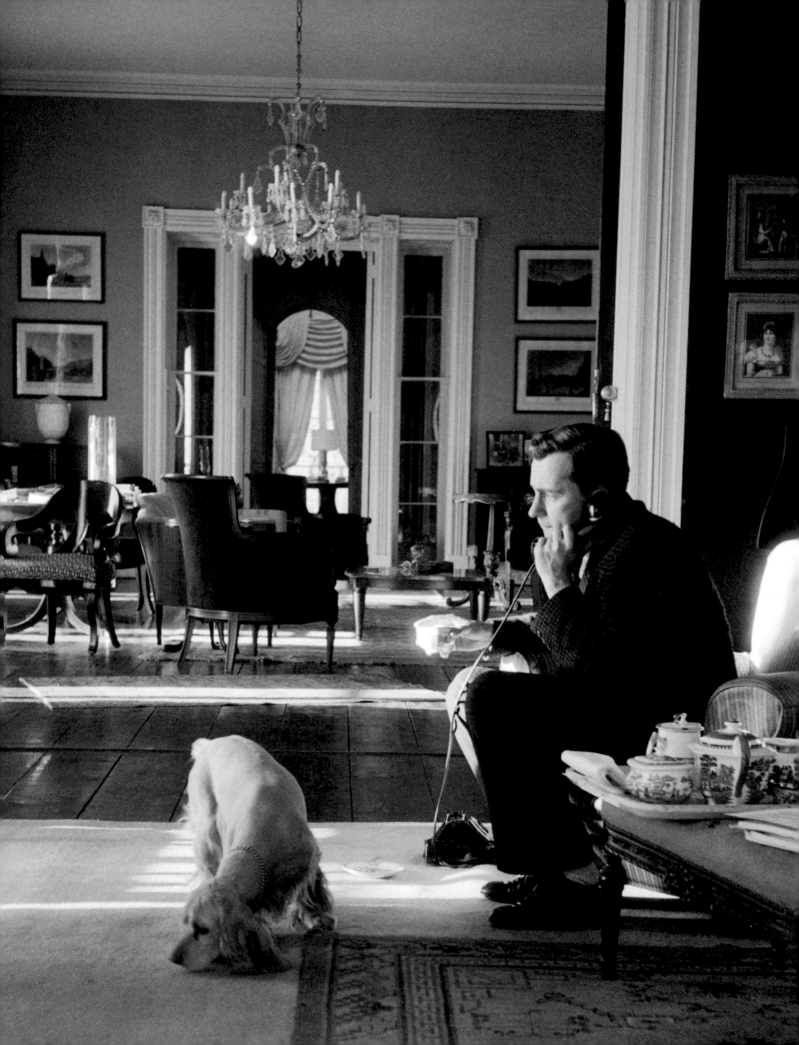

I have just announced my candidacy for Congress from the Twenty-ninth District of upstate New York, and I am now on the telephone speaking to an anonymous caller who is warning me that if I continue to run, a million copies of *The City and the Pillar* will be distributed from Fishkill to Hudson. I was invited to retreat before the worst had happened. Not for nothing had I spent those seasons in Hollywood. I said I might consider withdrawing if instead of 1 million they raised it to 2, as the book had not been doing well since I entered politics.

The decision for me to run was made by the head of the Dutchess County Democratic Party, Judge Hawkins, and he was excited both to have me and my television self working for the local party in a congressional election. It was an exciting and busy time. I had been a delegate to the Democratic Convention at Los Angeles, where Kennedy was nominated. I had also acted as something of

In the Green
Room at
Edgewater
in 1960.

a go-between for Mrs. Roosevelt's headquarters at nearby Val-Kill Cottage and Kennedy himself. One of my biggest problems was Bobby Kennedy, who had been put in charge of the state of New York for the presidential election; with his aggressive non-charm he was antagonizing people right and left, putting me in the unusual position of the honeyed voice of reason. I read here and there about all of my feuds with literary people, even though I can't think of one. On the other hand, with political people, it is far more interesting, because more is at stake. I remember a critic once asking Arthur Schlesinger why the academic quarrels at Harvard, say, were so harsh, and even virulent. To which not Arthur but Kissinger answered, "Because the stakes are so low."

I should say in passing that I quite liked all of this activity in the real world, as opposed to the shrinking world of publishing, and despite a lot of snarling from Bobby Kennedy, which he mistook for encouragement on behalf of Jack. Meanwhile, at the congressional level I was doing my best to promote the candidacy of the senator from Massachusetts, but it was uphill work since an anti-Catholic tendency in the district was becoming difficult to deal with. In the end, we could never really do much about it and Kennedy did badly in the mid–Hudson Valley.

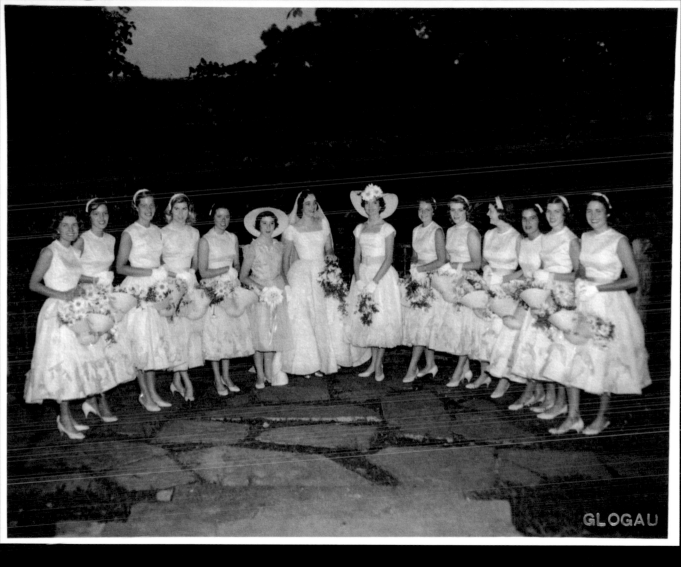

GLOGAU

The lawn at Merrywood in truly merry mood, with
Jackie at the center and my half sister beside her,

The lads of Merrywood. I am at the center of the groomsmen. To my far left is Jack, looking weary. Nearby there is John Warner, soon to be senator from Virginia. Some tables have been put outside on the lawn, where Jack can be seen making up to the diplomatic corps.

GLOGAU

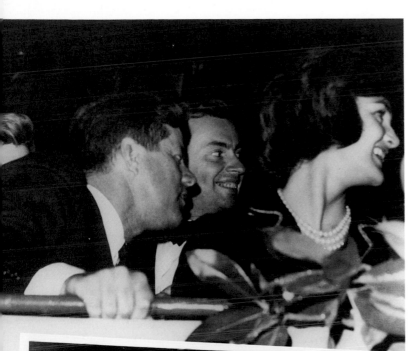

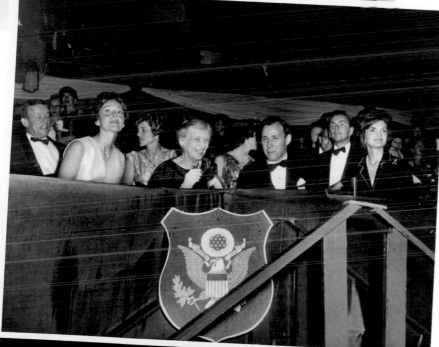

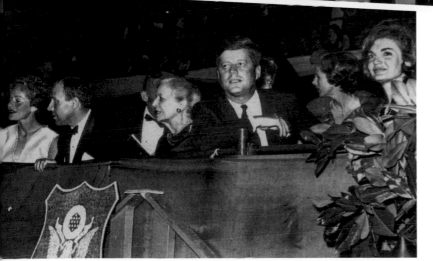

N ow every book, no matter how beautiful the photos, deserves one mystery story. Here is the mystery story for this one. You see a photograph of Jack, newly elected president, and myself, not elected at all, and Jackie presiding over a horse show, to which she has dragged us after a dinner at the White House in the presidential living quarters, where we had a splendid meal of caviar straight from the 21 Club as homage to the new chief. This is the actual photo of the three of us and how we were seated at the horse show. Now for the mystery: Recently, the writer Sally Bedell Smith, in an admiring book about Camelot, revealed a totally different photograph from that evening. Instead of the lineup you have just looked at—Jack, Gore, and Jackie—a new picture has replaced the old picture. The new picture is of Jack, as he was; I am totally cut out of the photo and replaced by Alice Roosevelt Longworth and her black hat (she had actually been seated about five rows behind us in the original picture); and Jackie is kept as she indeed was. I discussed this matter with Ms. Bedell Smith, who could not believe that the Kennedy White House could rearrange a picture for political reasons. But Bobby was eager to prove that it was not possible that I could ever have posed with the Kennedys. This is how the Kennedy White House played ball. As well as the attacks from the Far Right, I was now dealing with the Bobbyites in the White House, which smacked of the old Soviet Union. I tried to tell Ms. Bedell Smith the facts of the case, but she was not going to believe it, could not believe it, and did not believe it. And that is how politics is played in the greatest democracy on earth.

Sam Spiegel had come to Miami on his yacht, where Tennessee and I were to meet to discuss with him the film that I was to write, *Suddenly Last Summer*, based on a one-act Williams play. Jack and Jackie were at Palm Beach, he was not yet president, but he was getting very close, and she and I were talking on the phone about this and that when I said that Tennessee was in Miami, and she asked if we could do something with him, as Jack wanted to meet him as well. We all agreed on lunch, but by then Tennessee and I were down in Key West. By the time I had driven us to Palm Beach and Joe Kennedy's house, it was very late, but the Kennedys took it in stride. They were delighted with Tennessee and he was delighted with them. It was a lovely day; Jackie took these photos. The letter gives the background to the photographs, and to the peculiar stationary of Joseph P. Kennedy, a doting father-in-law, who, when she asked permission to acquire a red Mustang, said, "Kennedys drive Buicks." She paid him back.

JOSEPH P. KENNEDY

Dear Gore —

Admit that I do have the most feminine writing paper —

I send you some rather blurry pictures which may amuse you & Tennessee — He just leans into that gun like some crack shot, with you & Jack standing gawkily by in admiration —

Jack gets back from Boston late the night of the 29th — so I don't think either of us will be able to come to Miami — but if everything changes I'll let you know — We loved seeing you + hope it didn't take too long to recover from your dove, Love Jackie

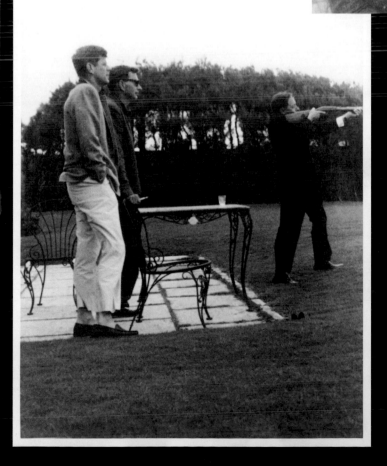

Jack wanted to have a shooting contest. Tennessee, in the first of the photographs, is staring at Jack and muttering to me, "That boy has a nice ass." I replied, "Stop it, that's the next president of the United States." Tennessee said, "No, he's not going to be the next president, because the American people hate with great violence attractiveness in anything, but particularly politicians." Later, I told Jack about the compliment of his ass, and he said, "Why, that's very exciting."

The photo of the three of us posed side by side is one that Jackie thought would be great for a history book. And now you must regard the volume in your hands as Jackie's history book, as well as mine.

The photo at left shows Jack "gawking," in Jackie's words, as Tennessee hits bull's-eye after bull's-eye. Jack was not doing so well, and I pleaded blindness. It was a golden day in a golden era that had begun so well and would end so badly.

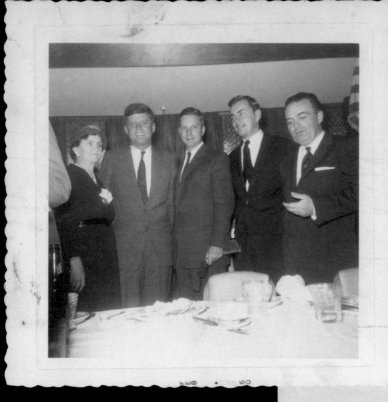

Meanwhile, Jack Kennedy was running hard. I did what I could for him in the district. Brother Bobby suspected me of double-dealing. He was unable to grasp the problems. One of which was that he had no business dealing with politics in New York for Jack. The district was one of the most conservative in the United States. Terrible rumors about Jack and even virtuous me were all abroad. I discussed this with Mrs. Roosevelt. She said, "You know when Franklin first ran for public office up here, the Republicans said he did not have polio, but it was syphilis from not having led the right sort of life that had weakened him." Her advice: Be ready for anything, which, after all, had been my usual state. When it comes to libelous rumors, the American right wing is unparalleled in the things they can think up, demonstrating what strange subconsciousnesses they must have, as they have no conscious minds, at least visible thus far, to the voters.

GORE VIDAL
Barrytown NY

June 12, 1960

Dear Jack:

The enclosed may amuse you. The local paper specializes in dirty pool but suffers from excessive subtlety.

Saturday night I had dinner with Eleanor R., FDR jr, and Walter Reuther at Hyde Park. I expect you have already got reports on what was said but it is my impression Reuther made a strong case (1) for a meeting of the liberal elements in the party before the convention to decide on a united front against exploiting the division between you and Stevenson; (2) the steps by which the Johnson forces might capture Stevenson and nominate him, to no one's delight. Mrs. R. was most interested and, possibly, won over... at least negatively. She ended by musing upon who your running mate might be.

Needless to say, these sessions are always most interesting for what is not said.

I have a hunch she was depressed by Stevenson's waffling (she had an advance copy of his Monday statement of availability).

Meanwhile, my own campaign goes on its busy way. I've made a couple of hundred speeches and am now the best known person in the district, but whether this will mean anything in November is anyone's guess. Kennedy vs. Nixon would be a great help to my own sly ambitions.

I talked to Sorenson about being helpful. I'm not sure there's much I can do. I hardly have time to prepare my own speeches, but if you want me to act as emissary to those liberal establishments to which I have a key (Ascoli, the Nation, PR, etc.), I'll be happy to.

I think at one point, if you have time, you should meet the various contiguous worlds of Norman Mailer, Philip Rahv, Trilling, etc. They view you with suspicion but I have a hunch you could win them around. If you like, I'll set up something along those lines. Their influence is formidable.

Keep well. I should like you to be President.

Best to you both.

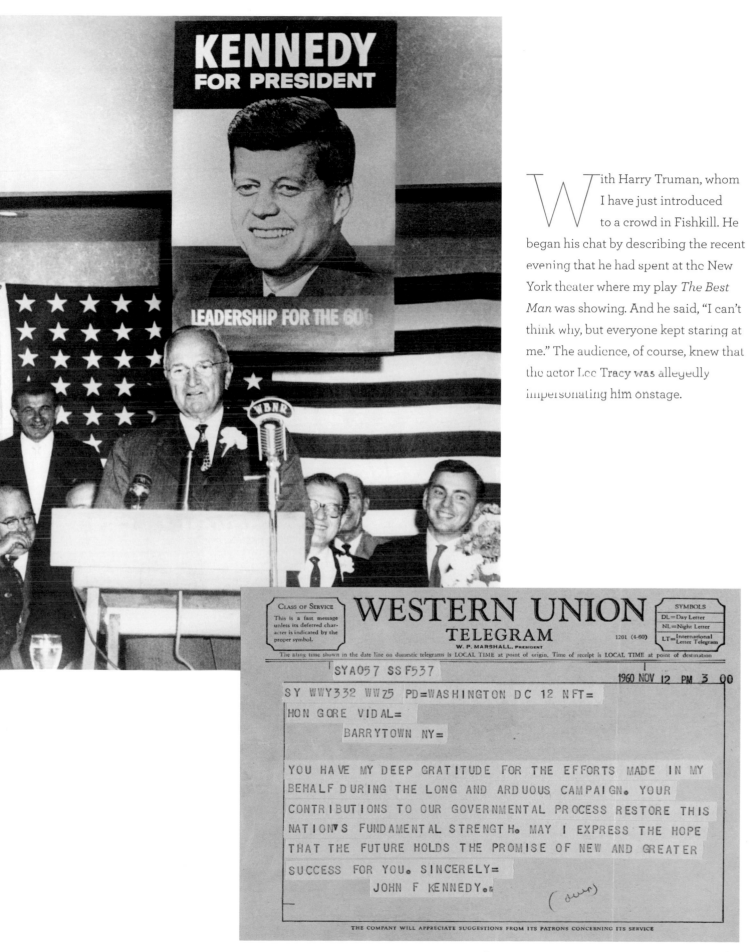

With Harry Truman, whom I have just introduced to a crowd in Fishkill. He began his chat by describing the recent evening that he had spent at the New York theater where my play *The Best Man* was showing. And he said, "I can't think why, but everyone kept staring at me." The audience, of course, knew that the actor Lee Tracy was allegedly impersonating him onstage.

WESTERN UNION
TELEGRAM

1201 (4-60)

W. P. MARSHALL, PRESIDENT

The filing time shown in the date line on domestic telegrams is LOCAL TIME at point of origin. Time of receipt is LOCAL TIME at point of destination

SYA057 SS F537

1960 NOV 12 PM 3 00

SY WWY332 WW 75 PD=WASHINGTON DC 12 NFT=

HON GORE VIDAL=

BARRYTOWN NY=

YOU HAVE MY DEEP GRATITUDE FOR THE EFFORTS MADE IN MY
BEHALF DURING THE LONG AND ARDUOUS CAMPAIGN. YOUR
CONTRIBUTIONS TO OUR GOVERNMENTAL PROCESS RESTORE THIS
NATION'S FUNDAMENTAL STRENGTH. MAY I EXPRESS THE HOPE
THAT THE FUTURE HOLDS THE PROMISE OF NEW AND GREATER
SUCCESS FOR YOU. SINCERELY=

JOHN F KENNEDY.

(over)

THE COMPANY WILL APPRECIATE SUGGESTIONS FROM ITS PATRONS CONCERNING ITS SERVICE

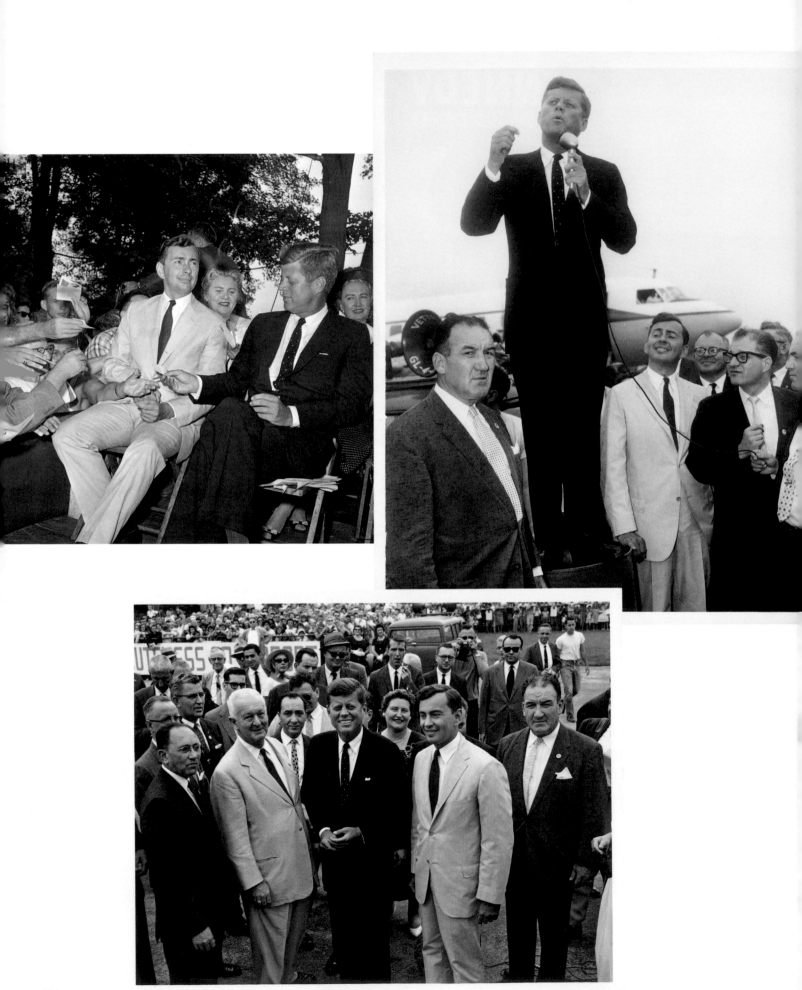

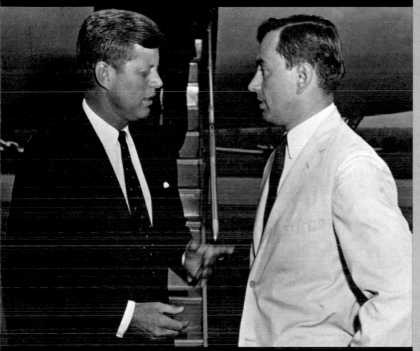

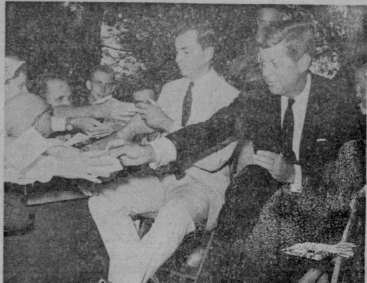

Gore Vidal and Senator John Kennedy at Hyde Park

Why Gore Vidal Must Win!

Gore Vidal, who is running for Congress in our District, has made the point that politically he is an independent. His opponents claim that this is not true, that he merely says it to get the votes of those 20,000 independent-minded Republicans he needs to win. Yet, when Gore Vidal accepted the Democratic and Liberal endorsements for Congress, he made it clear to both these parties that he would not be bound to their platforms, if he thought those platforms went against the interests of the people in the 29th District. Gore Vidal has shown considerable courage and independence in taking issue at several points with the Democratic party's platform, especially on its farm policy where he has opposed price supports and 90% parity.

We, as independent voters, feel that our District is in the unique position of being able to vote for a man who, not only is a world figure as a writer and political analyst, but also, one with no commitments to any political pressure group. He would be *our* Representative, not any one party's Representative. Lately, many of us have been dissatisfied with both political parties, and that is why we think we now have a rare opportunity to be able to vote for a free and forceful figure in American life, one who has already proved his political independence by writing speeches for President Eisenhower as well as for Senator Kennedy. For the first time in our District's history we have the chance to vote not for just another politician, but for *our* Representative.

Independent Voters for Gore Vidal for Congress

Gore Vidal TONIGHT On WRGB-TV (Channel 6) 6:40 p.m.

ome scenes from my campaign in the Twenty-ninth Congressional District of upstate New York. I am seated on the lawn in Hyde Park with Jack Kennedy, each of us counting how many autographs the other had signed. Remember, he was just a senator at the time. Jack, despite his bad back, had flown in to a small airport in Hyde Park for a speech. Opposite and above are a few snapshots of Jack on his way to talk to Mrs. Roosevelt, who did not support him, as she preferred Adlai Stevenson. But it was his hour and the Stevenson candidacy annoyed him. At the convention (see page 122), I voted with the winning majority. The meeting with Mrs. Roosevelt, I am told—I was not there—did not go well. She felt that Jack had been pro-McCarthy, as well as committing other deviations from liberalism.

115

I entered the 1960 congressional race, vowing I would not spend my own money nor would I try to raise money from strangers, because I knew I was ill suited for mendicancy. In the end, using television and such "hosts" as Johnny Carson of *The Tonight Show* and Merv Griffin, I was, indeed, as much everywhere as one could be without spending a fortune of everyone else's money. I had little to complain about in the end, even though the Republican press of the Twenty-ninth District was very strict about never mentioning my campaign. This came to a head when Paul Newman came to town to campaign for me, and despite the huge crowds he drew, the Poughkeepsie newspaper would not mention his presence. At this moment I signaled to the principal businessmen of Poughkeepsie, mostly Jewish and mostly in favor of my candidacy, and when they threatened to withdraw their advertising from the newspaper, only then did I get fair coverage in the *Poughkeepsie Journal*. The mainstream idea that we are chosen for Congress in the court of public opinion is nonsense. Public opinion is hardly consulted. We operate in the biased court of a media paid for by those promoting contrary interests.

But campaigns do go on, and here I am, after Jack has left our area, at a rally in Kingston. In the first row Mr. and Mrs. Newman are seated with a charming actress named Ina Balin and some presumably contented Kingstonians.

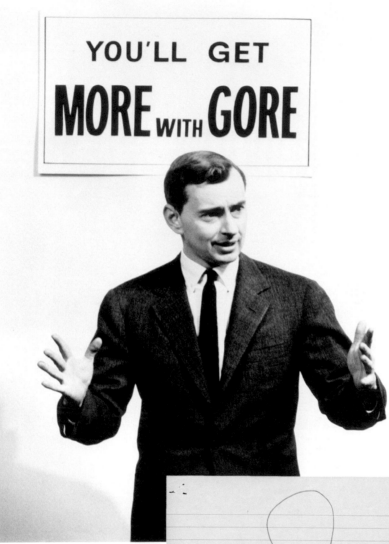

A few words . . .
. . . from Gore Vidal

"I have tried in the last year and a half to meet as many of the 395,000 people in our District as possible. Of the some 20,000 I have met, I was most struck by one thing: People, more and more, are politically independent. 'Habit-voting,' whether Democratic or Republican, is declining. Some think this a bad sign. I think it good. I have campaigned as an independent because I want the freedom to say what I think, to represent honestly a majority of those in this District. I couldn't do this as a doctrinaire Democrat or Republican.

"True representation, finally, is a personal business. Who is the Representative? What does he really think? Will he work for us? These are the questions asked. Well, I have done my best, day after day, to give answers. I am told that I am too independent, that the people don't want to know hard facts. I disagree. I think all of us, as never before, are aware of our responsibility as voters. I think we can accept more honesty than our professional politicians believe we can. If I didn't think that, I would not be a candidate for Congress. Yet I feel that I am not alone. I believe there is a real majority in our District who prefer honesty, independence, and vigor, to the old political stereotypes. In that faith, I have been a candidate, and now that the speeches are nearly over and the time of choice approaches, I turn to you for the first time and ask for your support."

Independent Voters for Gore Vidal for Congress

See Gore Vidal Tonight on WRGB-TV (Channel 6) — 11:15 p.m.

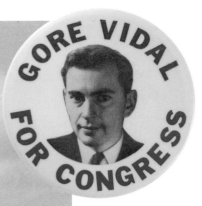

The campaign of 1960. The slogan "You'll get more with Gore" was not mine, since it begged the question, more what? But the picture of the cow and myself tells a lot about my relationship with milk marketing orders, an important subject to the upstate dairy farmers. I am trying to reassure this mother cow that she will get her share of the market orders in due course. The incumbent Republican from the Twenty-ninth District was returned, but the Democratic contender, myself, did quite well in the final vote. I got the most votes of any Democrat since the race of 1910, when FDR was elected a state senator in the Democratic interest.

GORE VIDAL FOR CONGRESS

Vital
Vigorous
Vidal

A MAN WHO CARES.

May 23, 1960

"What does VFV stand for?"
"Vitamins For Vigor? Violets for Veterinaries?"

"No! Vote For Vidal!"
"- X ! X"

n Election Day 1960, I got twenty thousand more votes in the district and county where I lived, Dutchess, than Jack Kennedy did in the presidential election. I never let him forget it. Unfortunately, the kid brother Bobby never forgot it either. "Why don't you ever mention the ticket?" he screamed at me on the eve of Halloween at Saugerties Landing, in Ulster County. I snarled at him, "Because I want to win." Our war had well and truly begun.

6	7	8	9	10	11
E COURT	**Representative in Congress**	**STATE SENATOR**	**MEMBER OF ASSEMBLY**	**COUNTY CLERK**	**CORONER**
	Vote for 1	Vote for 1	Vote for 1	Vote for 1	Vote for 1
6 A Republican	7 A Republican	8 A Republican	9 A Republican	10 A Republican	11 A Republican
ELLIS J. STALEY, JR.	J. ERNEST WHARTON	E. OGDEN BUSH	KENNETH L. WILSON	LAWRENCE D. CRAFT	FRANCIS J. McCARDLE
6 B Democratic	7 B Democratic	8 B Democratic	9 B Democratic	10 B Democratic	11 B Democratic
ELLIS J. STALEY, JR.	GORE VIDAL	JAMES T. McCARDLE	NORMAN KELLAR	JAMES T. EGAN	HARRY C. McNAMARA
6 C Liberal	7 C Liberal	8 C Liberal	9 C Liberal	10 C Liberal	11 C Liberal
ELLIS J. STALEY, JR.	GORE VIDAL	JAMES T. McCARDLE	NORMAN KELLAR	JAMES T. EGAN	HARRY C. McNAMARA

Mrs. Roosevelt at the Democratic Convention at Los Angeles, where she is practically beseeching the Democratic delegates to vote for Adlai Stevenson rather than Jack. I was very conscious of a painful divided loyalty. I was a delegate instructed to vote for Kennedy and, in any case, I did not favor another run for Stevenson. But when Mrs. Roosevelt, a giant of a woman, in every sense, walked out into the glare of the lights and, like some ancient priestess, warned us against turning our backs on Stevenson, I realized that history had made a strange, sudden move and that Jack would not only be nominated but would become president. When she wanted to be, she was extraordinarily eloquent, and so she was that day.

Mrs. Roosevelt
At Home

on Tuesday afternoon
May the eighteenth
at four o'clock

Garden Party

MRS. FRANKLIN D. ROOSEVELT
55 EAST 74TH STREET
NEW YORK CITY 21, N. Y.

March 24, 1961

Dear Mr. Vidal:

I very much enjoyed seeing you the other evening, and I wonder if there is a chance that you might be free to dine with me here informally on the night of April 2nd.? We will have cocktails at 7:30 and I would be delighted if you could join us.

Very cordially yours,

Eleanor Roosevelt

EMOCRATIC NATIONAL CONVENT
1960

After Jack was nominated, Arthur Schlesinger and Ken Galbraith came down to the floor of the convention to observe Jack's speechwriter, Ted Sorenson, who made the sign of the O as he passed us, to emphasize the nomination of Kennedy for which they had worked and, indeed, I suppose I had, too, despite a feeling of disloyalty to what now was my greatest political ally upstate, Mrs. Roosevelt herself. The three of us, Schlesinger, Galbraith, and Vidal, left together and I took them to the Luau, a Polynesian restaurant in Beverly Hills, where we had a wonderful dinner. Galbraith, spotting an ornamental ship's wheel set in front of the restaurant, rushed toward it and grabbed the spokes of the wheel, shouting, "This is the ship of state!" at which time at least two of the spokes broke off. I have saved this ominous message from the Fates for a later day, like this one.

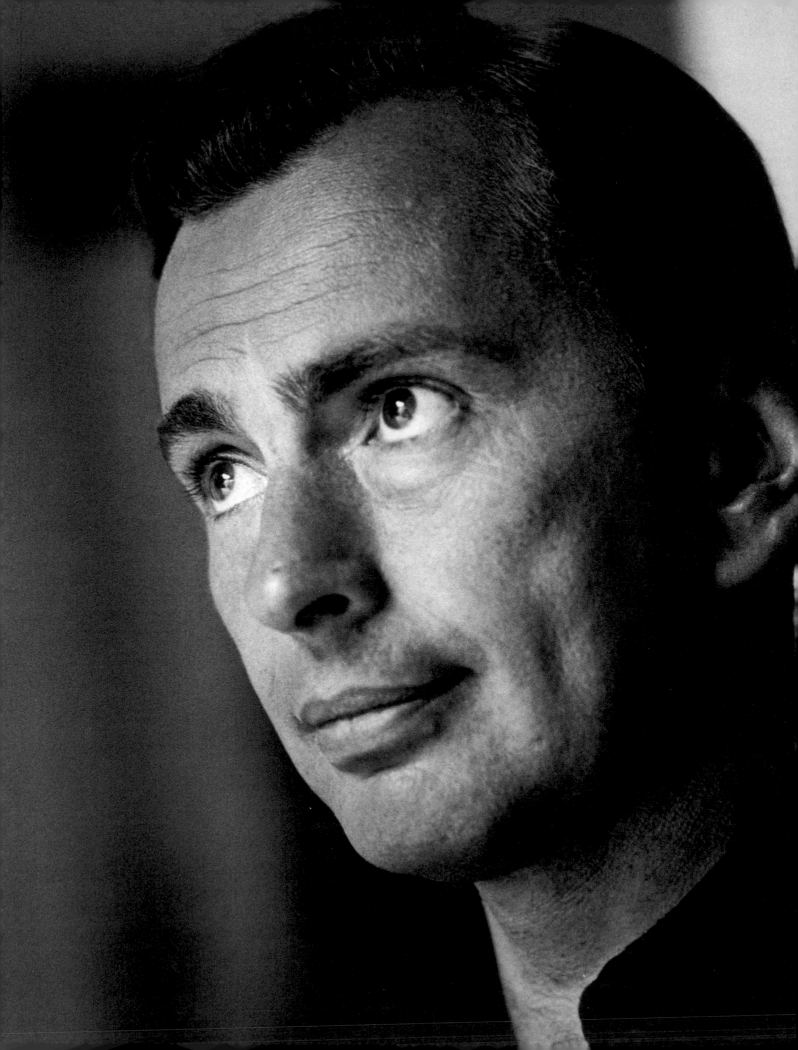

We had a flat, Howard and I, in a brownstone that I had bought on Fifty-eighth Street, where I tried, as best I could, to keep three simultaneous careers going.

From *Summer and Smoke* on, I had watched Tennessee prepare his plays for out of town and then again on Broadway and, watching him, I think I figured out what the secret to playwrighting was and answered the question of Henry James, who was said to have said that playwrighting is not an art but a secret. I think I understood the secret, which is you don't have the space of the novel and you must be quick in your effects. Playwrighting is not prose writing; it is dialogue and closer to life than actual dialogue in life, always a problem for the ambitious playwright. Tennessee was very ambivalent about those of his friends who also became playwrights; he was particularly cruel about Bill Inge, who was an old friend from St. Louis, and only a bit better about me.

Portrait of a working playwright.

Our mutual friend Maria St. Just described Tennessee's response after they had attended a performance of *The Best Man*: "Well," sighed the Bird, "This looks like Gore's year."

I regarded the death of Sam Zimbalist as a fitting end to my career as a screenwriter, and though over the years, every now and then, I would write a script or even doctor one, as in the case of *Is Paris Burning?*, I had returned to prose, where I belonged.

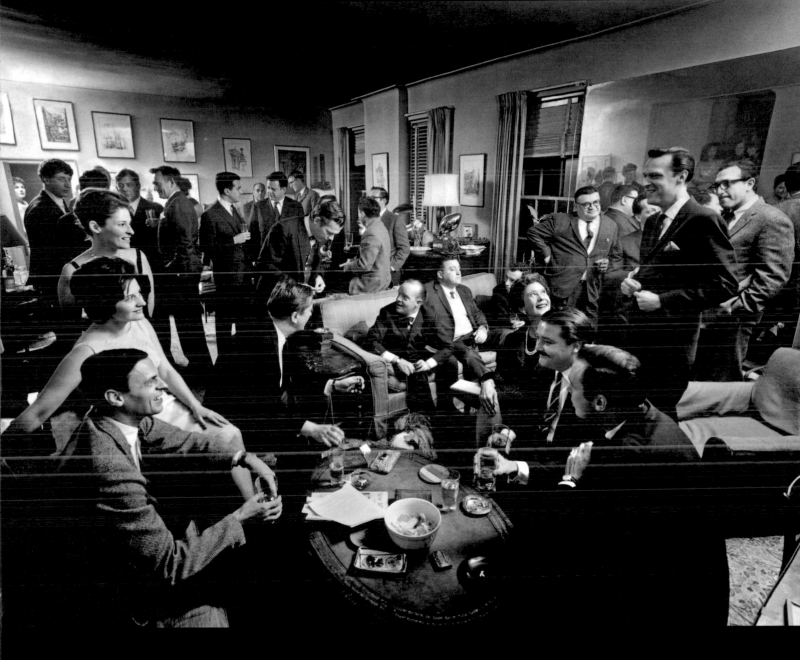

The literary gang, a gang from which my interest in politics very much exempted me that year, at a large party given by George Plimpton, who edited *The Paris Review* for a long time. Most of the people in this picture look familiar to me, but I can't remember who anyone is—a condition of time, I have been assured. George and I were in the same class at Phillips Exeter Academy, but grown up we seldom saw each other.

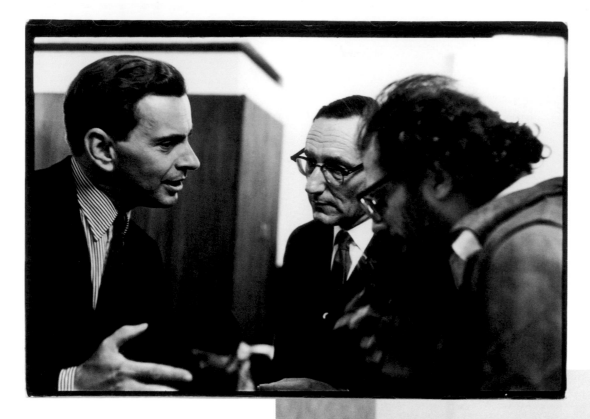

With William Burroughs
and Allen Ginsberg.

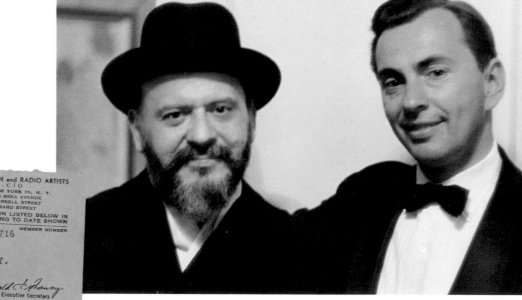

With Mr. Know-it-all, Leo Lerman, a charming, busy man
around Lit and the first editor of the revived *Vanity Fair*.

DINNER GUESTS

	Table NO.		Table NO.
Count Bismarck		Countess Bismarck	
Mr. Stephen Sanford	2	Mrs. Stephen Sanford	1
Mr. William Paley	5	Mrs. William Paley	9
Mr. Sheldon Whitehouse	7	Mrs. Sheldon Whitehouse	1
Mr. Benjamin Kitteridge	3	Mrs. Benjamin Kitteridge	2
Mr. Edward Bohn	3	Mrs. Edward Bohn	7
The Duke of Talleyrand	10	The Duchess of Talleyrand	9
Mr. Suydam Cutting	1	Mrs. Suydam Cutting	3
Mr. T. Markoe Robertson	2	Mrs. T. Markoe Robertson	3
Mr. Henry Phipps	5	Mrs. Henry Phipps	3
Mr. Eric Loden	9	Mrs. Eric Loden	10
Mr. Charles Amory	4	Mrs. Charles Amory	7
Mr. Reed Vreeland	9	Mrs. Reed Vreeland	6
Mr. Wolcott Blair	5	Mrs. Wolcott Blair	9
Mr. James Fosburgh	7	Mrs. James Fosburgh	5
Mr. Edward Condon	3	Mrs. Edward Condon	7
Mr. Winston Frost	5	Mrs. Winston Frost	6
Mr. Igor Cassini		Mrs. Igor Cassini	5
Prince Furstenberg	10	Princess Furstenberg	6
Mr. Lawrence Lowman	6	Mrs. Lawrence Lowman	9
Mr. Dan Caulkins	5	Mrs. Dan Caulkin	7
Mr. J. S. Kelley	5	Mrs. J. S. Kelley	6
Mr. Erwin Watt	7	Countess Crespi	4
Mr. Van Day Truex	10	Miss Margaret Case	5
Mr. Lander Greenway	2	Mrs. Mellon Bruce	8
Mr. Oliver Kessel	4	Mrs. Harold Talbott	3
Mr. John Rutherford	4	Miss Elsa Maxwell	8
Prince Obolensky	4	Mrs. William Breed	4
Mr. William Baldwin	8	Mrs. Ogden Mills	3
Mr. Hershall Williams		Mrs. Harry F. Bingham	2
Mr. Constantine Alajalov	8	Marquise de Portago	2
Count Rasponi	9	Mrs. James Donohue	4
Duca Fulco de Verdura	2	Mrs. William Woodward, Sr.	1
Mr. John Schlumberger		Mrs. Edgar Leonard	2
Prince John Braganza	5	Mrs. Brooke Howe	1
Mr. Theodore Rousseau, Jr.	4	Mrs. W. R. Hearst, Sr.	8
Mr. Harry Brooks	7	Mrs. W. R. Hearst, Jr.	5
Mr. Bryon Foy	2	Princess Lobowicz	3
Mr. John LaFarge		Mrs. Winston Guest	4
Count Vara Adderberg	1	Mrs. T. Inglis Jones	7
Mr. Horace Kelland	9	Mrs. John Fell	6
Mr. Stavos Niarchos	4	Mrs. Michael Phipps	4
Marchese Feraca	1	Princess del Drago	
Baron de Gunzburg	7	Miss Beth Leary	10
Mr. Timothy Vreeland	7	Mrs. John Wilson	10
Mr. Gore Vidal	10	Mrs. D. Messinesi	1
Mr. Winston Thomas	10	Mrs. S. Weldon	10
Mr. Vadin Makaroff	8	Mr. Smauel Reber	8
Marquis de Villaverde	1		8

Here are some pictures taken of me in my period as an extra man, beloved of hostesses. At the top I am in the Rezzonico Palace in Venice with my date, Clare Boothe Luce. We are both busy misquoting Browning in what had once been his study in the palace, then being used for a gala party. At the left I am on the island of Capri with my hostess, once Mrs. Harrison Williams, now Countess Bismarck, with her Capri neighbor, the English singer-actress Gracie Fields. I fear that everyone mentioned in the list of dinner guests pictured here is long since safely dead by now.

From 1957 on I wrote a dozen or so plays for Broadway. The first to be produced starred a marvelous comic actor, Cyril Ritchard, himself a famous perennial in revivals of *Peter Pan*, where he always played Captain Hook. In *Visit to a Small Planet* he played a time-traveling visitor to Earth who wants to observe the American Civil War, since "war is the only thing you do really well down here." Unfortunately for him, he lands not in the 1860s, but in the 1950s. Nevertheless, he has nearly enough time to start a war all of his own, until Sarah Marshall stops him with her own white magic. Cyril and I are pictured here together in rehearsal. A few years later I worked again with Cyril in *Romulus*, by the Swiss playwright Friedrich Dürrenmatt. Cyril, despite being miscast, which was my fault, gave a valiant performance as the last Roman emperor, who has become emperor in order to destroy the Roman Empire, rather the way George W. became president a few years ago to do the same for the United States, with no lofty motive that we can discern. Cyril was a saintly man and a fine clown, at his very best in Regency plays, a form far too advanced for American audiences, thus far. Originally, I wanted the part of Romulus to be played by Paul Scofield, but as so often happens in transatlantic casting, this never came to pass.

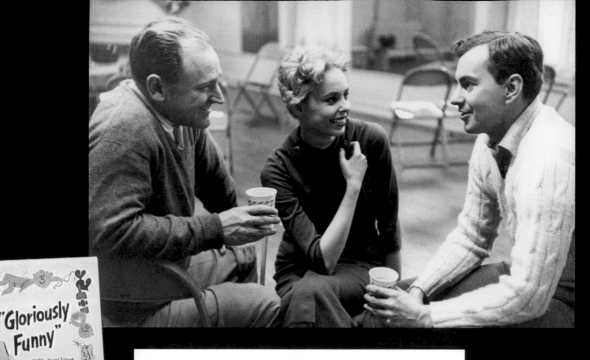

"Gloriously Funny"
— KERR, Herald Tribune

GEORGE AXELROD & CLINTON WILDER PRESENT

CYRIL RITCHARD

A NEW COMEDY BY GORE VIDAL

VISIT TO A SMALL PLANET

with

EDDIE MAYEHOFF

PHILIP COOLIDGE
SARAH MARSHALL • CONRAD JANIS • SIBYL BOWAN • FRANCIS BETHENCOURT

DIRECTED BY MR. RITCHARD

BOOTH THEATRE
45th ST. WEST B'WAY
MATS WED & SAT

Here I am at a rehearsal for *Visit to a Small Planet* with Eddie Mayehoff and Sarah Marshall, daughter of Herbert, and a brilliant actress in high comedy which seems no longer to exist.

Cyril Ritchard, the alien from outer space, is having a comfortable chat with a cat, whom he understands all too well for her own good, as well as finding an excuse to indulge in his sense of intermittent human violence with a disapproving Eddie Mayehoff, very much the military man, whose army specialty is laundry and dry cleaning. Cyril can be seen egging everyone on to behave in a truly human way—that is, violently.

The **PLAYBILL**
for The Booth Theatre

Visit to a Small Planet

CYRIL RITCHARD IN **VISIT TO A SMALL PLANET** WITH **EDDIE MAYEHOFF**

My Benchley, as opposed to his father, the comic writer and actor Robert Benchley, served time with me not just at Exeter but also at MGM. He is giving me the sort of warning that we gave each other when our demerits in the eyes of authority were mounting perilously high, indicating, perhaps, retreat from New England dignity and severity. After school we became friends in Hollywood, where he did not fare quite as well as did his son, the author of *Jaws*.

Hollywood was still, even in our days, in thrall to the practical joke. Benchley and his wife were going East, as so many of us did, on the train. Humphrey Bogart, in a playful mood, sent a large tree in a terra-cotta bowl to the Benchley's Pullman suite as a farewell gift. As the Benchleys entered the train, they were astonished by the living tree in their sitting room, breathing in all the oxygen. There was still some time for Benchley to hang out before the train left, and the next thing we knew the Benchleys had planted the tree in Paul Newman's garden. I got a desperate call from Newman, "Help me with this tree!" It was, by the way, huge. Also, dusk had fallen. So, Paul and I, with shovels, went over to the plot of lawn where Benchley had established the tree, to the horror of the owner. Paul said, "What are we going to do with this?" I was inspired to say, "José Ferrer lives down the street" (which was Roxbury Drive) "and if we're very quiet, he and Rosie will be asleep and we can plant it." Our plan did not work. Ferrer came thundering down onto the lawn to protect his land from our depredations. I have no idea where the Bogart, eventually Newman-Vidal tree is today. I can only hope that it is happy.

Congratulations

1957 FEB 7 PM 12 45

NUO 34 PD=NEWYORK NY 7 1204P= PB

=GORE VIDAL=
 =THE BOOTH THEATRE=

YOU'VE MISSED CHAPEL FOR THE LAST THREE WEEKS AND I AM TIRED
OF COVERING UP FOR YOU=UNLESS YOU ARE IN YOUR SEAT TOMORROW
MORNING YOU GET A DICKEY SLIP=

 =BENCHLEY=

BY WESTERN UNION

The Morosco Theatre was a marvelous—indeed perfect—theater for staging plays. The real estate lords of New York decided it should be torn down and not replaced by another theater. So, we carefully wreck what little civilization we do have.

MOROSCO

THE
BEST
MAN

As the Kennedy era dawned, and I was again becoming political, I made my contribution to the campaign with a play called *The Best Man*, starring Melvyn Douglas, Frank Lovejoy, and Lee Tracy. After much history, and many decades later, the play is still produced every four years when a presidential election is in the offing.

"THE BEST MAN"

From left to right are Melvyn Douglas, Lee Tracy, and Frank Lovejoy. These three gentlemen are passionately engaged in politics in Gore Vidal's play at the Morosco.

IN GORE VIDAL'S POLITICAL PLAY "The Best Man," opening Tuesday at the Colonial Theater, Lee Tracy, an ex-President, gives campaign advice to Melvyn Douglas who seeks nomination while Frank Lovejoy, another aspirant, shows Kathleen Maguire damaging facts on Douglas.

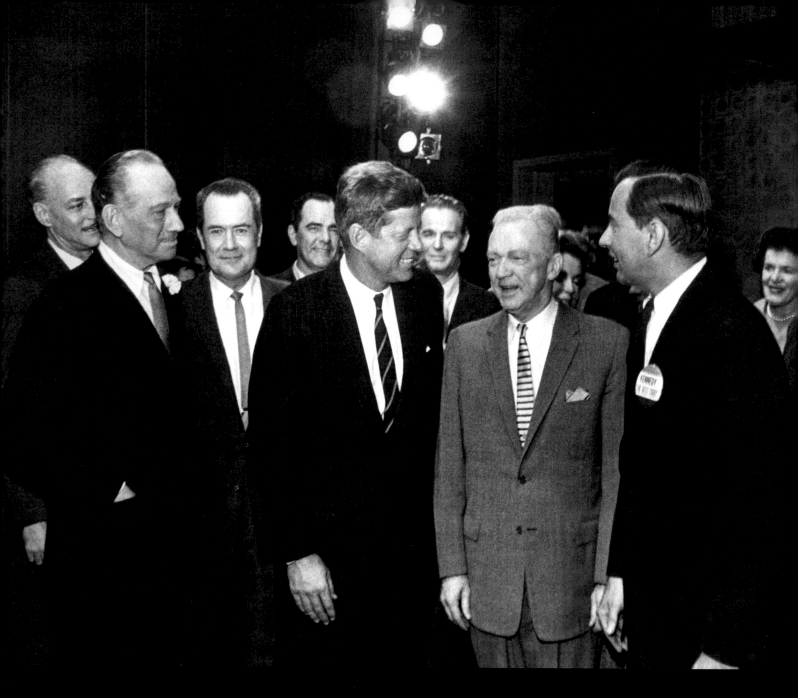

After he'd been elected president, the first play that Jack Kennedy saw was *The Best Man*. Here he is backstage with some of the cast and myself. I believe all of us had voted heartily for him.

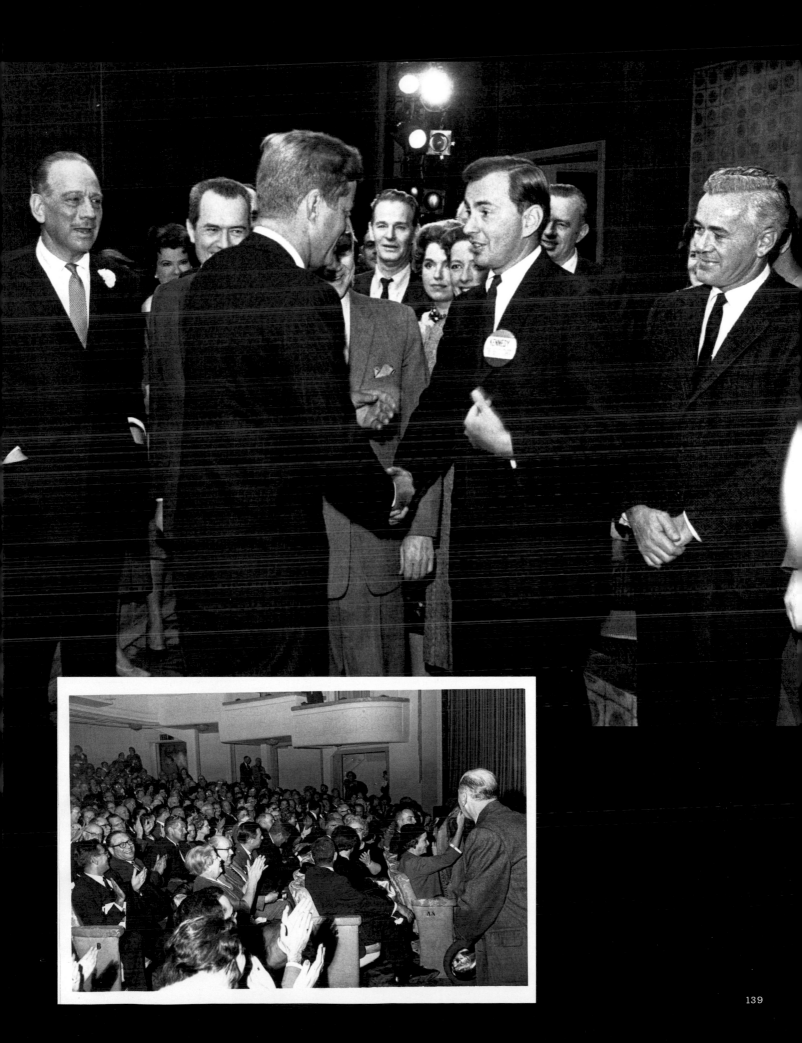

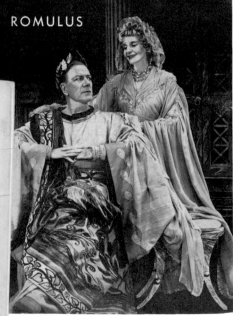

A nice photograph of Joe Anthony, the director of *Romulus*, Cyril, and Cathleen Nesbitt. Everyone looks happy, but Cyril and Cathleen did not like each other, and he accused her of counting to a hundred before responding to his cues. I found her fascinating, personally, if not as what she was cast as, the empress of Rome, but for her memories, both theatrical and personal. I was much impressed by the fact that she had been the lover, in youth, of Rupert Brooke.

ABOVE The Newmans in loyal attendance.

RIGHT A letter my television colleague
Paddy Chayefsky wrote me about *Romulus*.

PADDY CHAYEFSKY

Thursday - 3/7/62

Dear Gore

I don't think I ever told you
how much I enjoyed "Romulus" -
I saw Howard Da Silva the other
night which brought my remissness
back to me - I thought it the
best play you've done, and it
suffered only from its high level
of skill - I thought it a brave
play and lucid; the cut was
direct, the reasoning existential -
all the things a play must not to
be properly recognized in its own
time - Hope to see you soon -

Paddy

141

Various snapshots from a busy writing life during this happy period when I wrote *Myra Breckenridge* (no, I have never seen the movie). During the time that my novels were being blacked out I began to write essays, particularly for the new literary paper *The New York Review of Books*, which had been started by friends of mine, particularly Barbara Epstein, all of us inspired by Edmund Wilson.

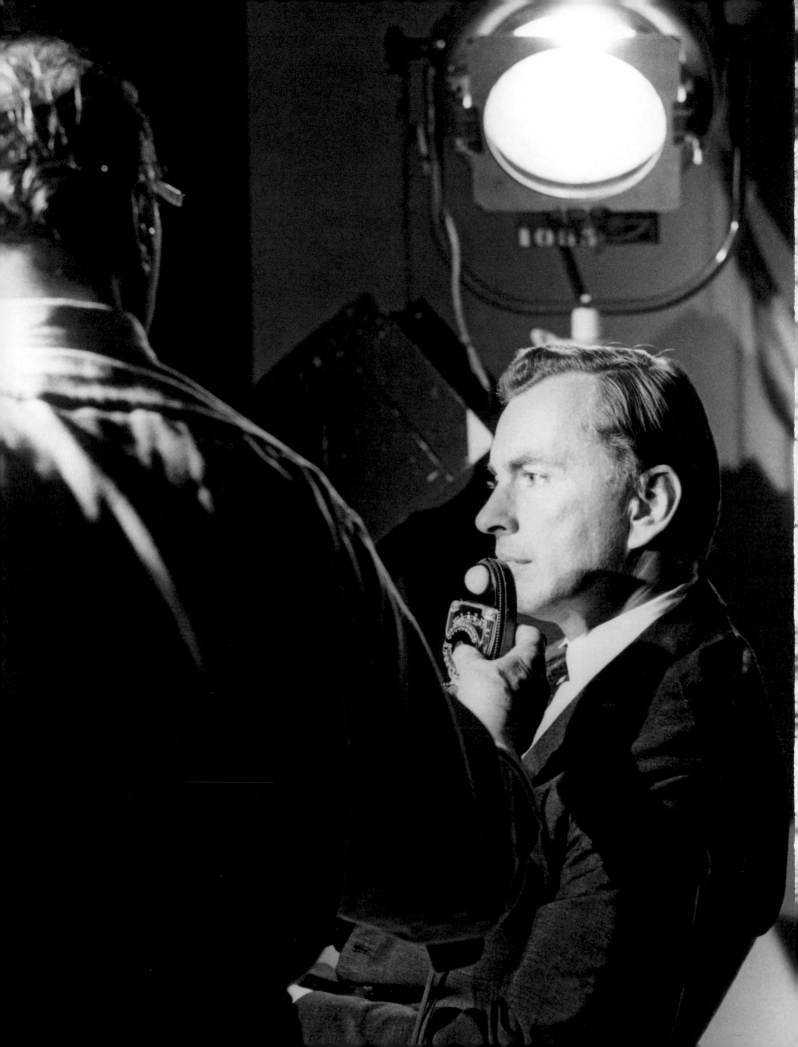

I think of the sixties as being primarily a decade stolen from those of us who were living in it. It was almost entirely a cluster of media events for many of us and the viewers and so not quite real to me or to much of anyone. There is the pageantry between the colonial experiment in North America–turned–imperial and the murders of emperors at Dallas and of priests in Memphis, neither much analyzed by a media almost entirely based upon extreme displays of local disturbances, yet all of them of great interest symbolically and literally during a time when the idea of the nation was being revised, to the surprise of many. The universality of television had made everybody everywhere a potential player. This was, for many, irresistible. There were the self-styled beats of Kerouac lusting for TV time and there were candidates for political office raising millions of dollars so that their images might be ever put forward so that we might be tempted for no particular

As long as I was interested in politics, I kept on appearing, as you see here, as a TV talking head.

reason to vote for this one or, indeed, that one. I would say that this was a decade for me and everyone else of incoherence to which we can thank that god that Chancellor Bismarck said especially looks after the United States of America.

When I was asked by the director Fellini to comment, on camera, "Why, Gorino, you live in Rome?" I said, according to his film, *Fellini's Roma,* "What better place to watch the end of a world than from a city that calls itself eternal?"

The artist Bill Walton, a friend of Jack and Jackie's and mine, asked me why I had asked for nothing in the Kennedy administration. I told him that I had already been assigned, unconsulted, to a culture committee, which I did not appreciate, but I was interested in anything to do with water in the Hudson River. I noticed recently that one of Bobby's sons has been working nobly for a cleanup of the Hudson, and I am happy that he has proved to be so efficient at what I never had the chance to do. After the election, with some relief, I removed myself to Rome, finished the novel *Julian*, and settled in a Roman flat in the Via di Torre Argentina 21, where Howard and I lived for the next twenty years. My New York life was over.

ere are some shots of the interior of the Rome flat. I think it symbolically correct to show flowers on the table as we were only a block or two from the Campo dei Fiori, an ancient marketplace of the city, where flowers and produce came in every day, celebrating our contented way of life.

Howard and I and the Australian terrier seated side by side.

Scenes from our Roman life in the seventies.

A film Jules Dassin and I never got made.

GORE VIDAL
Travel (Cont'd.)

May 9 to May 11 — Vienne - For piece

May 12 to May 14 — Paris, p

May 14 — Return

June 15 to June 16 — Publicit

June 16 to July 1 — New Yor

July 1-2 — TV Show

July 3 — New Yo

July 11 to July 18 — To San for We

July 19 to Sept. 1 — Bel A to MG Ronso New Y direc

Sept. 1 — Retu Octo

Oct. 9 to Oct. 20 — Clar for and

Oct. 21 to Oct. 24 — Par Laf

Oct. 25 to Nov. 2 — Tou Fre

GORE VIDAL

TRAVEL

TRIPS TO GREECE for background and locations for a movie about Pericles:

Feb. 2 — Rome to Athens (plane)

4 — Rented Hertz car to visit Peloponnesus: Nauplion : Hotel Amphitryon

5 — Argos - Mistra - Sparta (Xenia Hotel)

6 — Pyrgos - Olympia - Hotel Spap

7 — Athens - Grand Bretagne Hotel

14 — Delphi - Vangos Hotel

15 — Athens - Hotel Grand Bretagne

16 — To Rome (plane)

Mar. 10 — To New York City (Italian Line) from Naples for opening of "THE BEST MAN" and publication of "JULIAN".

19 — Arrive N.Y.C., Plaza Hotel (paid by U.A.)

Mar. 19 to Apr. 6 — Publicity for film in New York

Apr. 7 to Apr. 9 — Hollywood (publicity)

Apr. 10 — To Chicago, to publicize film.

Apr. 11 to May 2 — To New York City, film publicity and book publicity.

May 3 to May 9 — Cannes Film Festival, for "THE BEST MAN"

I had completed the novel *Julian* in 1964, a book that I had begun so many years before. *Julian* was a surprise best seller for the publisher, as it was a firm rule in American book-chat land that ancient history was mysteriously taboo, as it was contrary in some ways to American interests. I was also the first writer to go on the road city to city and do local television around the country. Here is one of my itineraries for *Julian* and the resulting best-seller list.

Although in 1964 the lumpen Jesus-loving population was generally hidden away, a sufficient number of evangelical blowhards were highly visible in the new "universal" medium. (Although on the fringes of the republic there was a great deal of vigorous preaching, not to mention instant cures of various diseases formerly, miraculously, cured by the touch of a king or queen or the intervention of an almighty located somewhere back of the clouds.) Yes, coming events were casting their shadow. The honest little republic to the far west of the real world had found a role to play, and played it vigorously. As I write these lines I find myself marveling at how much for granted we took our huge post–World War II prosperity.

I remember that the canny publisher Victor Weybright, creator of Signet and Mentor paperbacks, was the only one who said, "*Julian* is going to have a great success with an untapped public." *I* was not sanguine but he proved to be right. He was a Maryland squire as well as an extraordinary publisher. In his capacity as squire on the outskirts of the old Confederacy, he said, "No one in New York is interested in Christianity or anything to do with the religions and hopes and fears of a nation that is still on the edge of feudalism, but in the republic itself there are people hungering for information." He was referring particularly to what has become the national religion, despite the Constitution, and how it came to be. Many questions are answered in *Julian* about how, out of a great mix of religious feeling around the world, Christianity became a peculiar property of the former colonies of the English, the so-called United States of America. The curiosity of my countrymen came, I was happy to note, to my aid over the decomposing bodies of such entities as the daily *New York Times*.

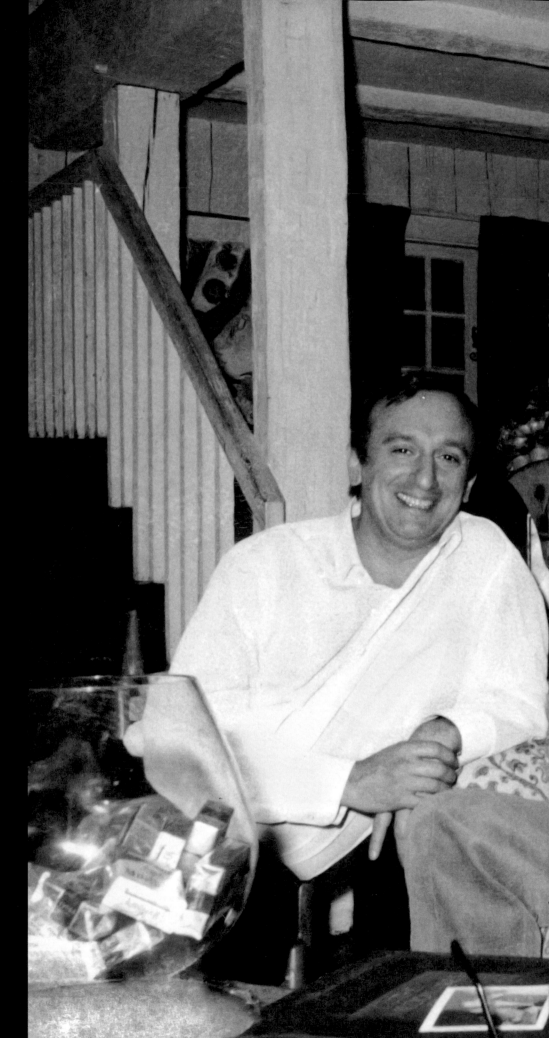

Paul, Joanne, and I at their Connecticut house. Paul is goofing. One significant thing that we had in common was being the same age. This meant that when I was seventeen I enlisted in the U.S. Army; when Paul was seventeen he enlisted in the U.S. Navy, and that's how we won the war, or somebody did. But each of us had missed having a youth, which we later compensated for a bit too long after adolescence had officially ended for us.

I recall the day when Joanne and I, reading Shakespeare, did all of *Richard II*, which we duly recorded and played for Paul to see if he could guess who the actors were. He identified immediately Richard Burton (me) and couldn't figure out who the actress was (his wife). This knowledge of one of my favorite plays has recently stood me in good stead, as England's current great actress Fiona Shaw, preparing for her appearance at the National Theatre in *Mother Courage*, had the notion of showing shots of me ranting against the American empire and war and then, serendipitously, said, "Let's do a scene from *Richard II*." And so we sat upon the ground and told sad stories of the death of kings.

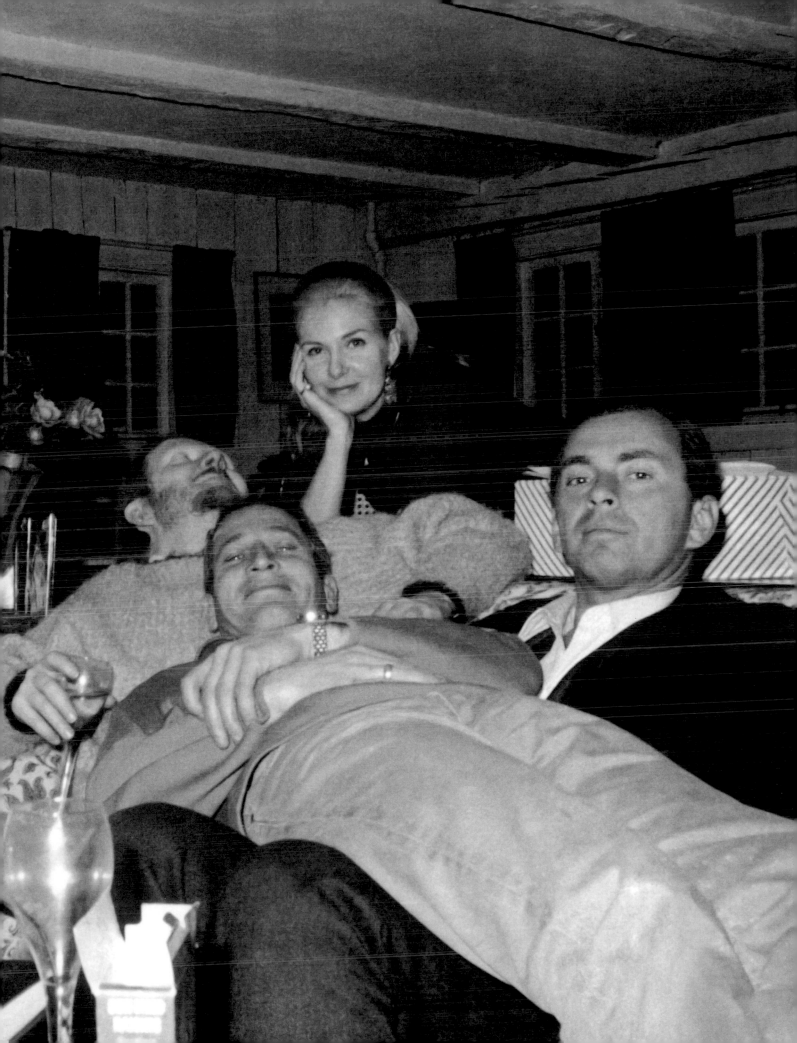

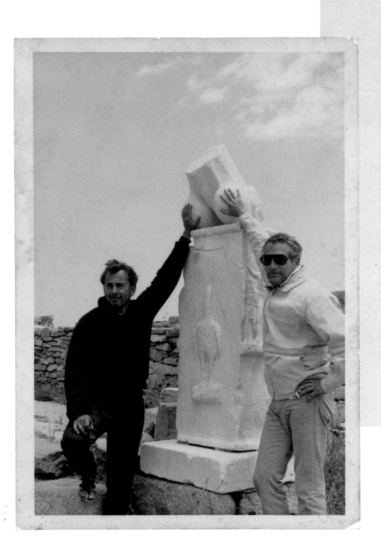

December 8, 1965

Gorvie:

Having absolutely nothing better to do and having an
idle typewriter, idle secretary, idle wit, idle groin,
thought I'd write.

Remote possibility exists that we could come and visit
near the end of May. Do you have room? Where will
you be? Will depend upon finish dates, weather artist
temperament and early May stock market positions.

I am getting sentimental in my dotage and long to
crack a bottle with you. It's been a long time since
I have seen you face down in the urinal. Actually,
the sentimentality arises from the fact that we are
going back to Connecticut for Christmas. 'Twould
have been nice to have been surrounded by aging
buddies. The pilgrimage to Rome, if it occurs, will
be therapeutic. One look at you and I know I'll
feel twelve years younger.

Things are going well here, and everybody feels rotten.

PL

During a cruise of the Greek Islands, here are
Paul and I on the island of Delos, where Apollo
was born and, apparently, promptly castrated,
from the look of the statue. Rereading Paul's letters to me
reminds me what a funny natural writer he was.

The high point of our trip in a rented caique was the
island of Santorini, whose explosion ended the Minoan
empire; it was a fantastic trip into the past of our race.

5) Eat two fisted bowl by bowl
 with Tony Perkins
6) Masturbate two fisted with anyone
 in their twenties.
7) Hang by your toes and learn Russian.
8) Write faster.
9) Write easier
10) Write better
11) Smile sweeter.
 Cross your legs sweetie We've only
 got the one nail
 ①
 PL

Gorvie —

Indulge! It's Your Birthday!

Well —
Just think of the things you can't do anymore
1) Run the 440 in 3-30 flat
2) Stand infront of the mirror and say "Hot shit"
3) Match taut buttocks with the Corps de Ballet
4) Drink two fisted bowl by bowl
 with Nick Nolte.

March 14, 1963

Dear Howard:

Darling Gore:

Well, it looks as though we've blown
the visit to Rome. Marty's picture
which was supposed to go earlier is
now going later so I had to slip a
commitment in between. The way it
looks now Joanne and I will be head-
ing, with family, to Sweden for three
weeks or so for "The Prize" and then
head back to Los Angeles (ugh) for
completion. What can I say after I
say I'm sorry? It is possible how-
ever that Joanne could make a week-
end flight down from Stockholm. I
don't know about myself. I just got
a new Lambretta motor scooter and I
think of you all the time. I think
Joanne and I should stop making plans --
long distance plans that is. The only
way we ever consumate a visit is when
the invitation is extended at 3 o'clock
in the afternoon and we are off at 5:00.

News of the Rialto -- "Strange Inter-
lude" is a howling success! I can't
remember a theater movement which was
greeted with such hope. Even them that
hoped for a dismal failure glazed their
eyes with hatred and admiration. The
interesting thing is that Strasberg
himself, after Quintero had directed

Bobby Kennedy said some wonderful
things about you on the Jack Paar
Show and I think you should write
him a note and apologize.

Brother-pot bit Lissy-bear on the
lip. Would you like a couple of
small dogs who are wonderful with
adults and especially fond of her-
maphrodites?

You write such newsy letters.

I am exhausted.

P C

the proceedings with his head up his
rear, pulled the whole thing out of
the fire. The thing that I think is
most amazing is that the Studio Theater,
after years of promises by actors,
directors, producers, crackpot vision-
aries, etc. ad infinitum, is really
the first to come through --- and to
accomplish same with that creaky old
museum piece is most extraordinary.

My beard is growing and I am now being
referred to as the road-company Alfred
Drake.

It will be September 1967 before we
really have an opportunity to enjoy
our country place.

It will be September 1967 before we
get into our apartment.

It will be September 1967, since our
trip to Rome has been cancelled, before
I get into Gina Lolllebritches britches.

Stewart has written a novel, seven short
stories and a one act play to be pub-
lished by Harpers.

Edward Albee has two full length plays,
two novels, a short book of long poems
to be published by Scribners in Septem-
ber.

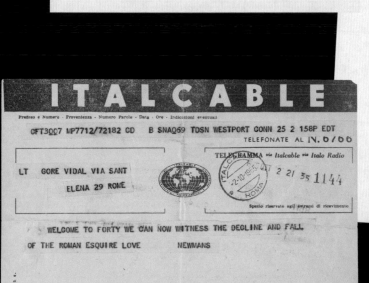

ITALCABLE

Prefisso e Numero - Provenienza - Numero Parole - Data - Ore - Indicazioni eventuali

CFT3007 MP7712/72182 CD B SNAQ69 TOSN WESTPORT CONN 25 2 158P EDT

TELEFONATE AL N. 0/00

TELEGRAMMA via Italcable via Italo Radio

LT GORE VIDAL VIA SANT
ELENA 29 ROME

2 21 35 1144

Spazio riservato agli estremi di ricevimento

WELCOME TO FORTY WE CAN NOW WITNESS THE DECLINE AND FALL

OF THE ROMAN ESQUIRE LOVE NEWMANS

COLL 29

It was also during this period, in 1964, that I was fortunate enough to get Henry Fonda to play the lead in the film version of *The Best Man*, which explains why no one managed to steal the credit from me. Luckily (if that is the word), political films were thought to be a disaster at the box office. Also, luckily, Fonda was far too formidable an actor for the Screenwriters' Guild to play tricks on him. Incidentally, when *The Best Man* was on Broadway, Paddy Chayefsky produced a play called *The Tenth Man*, about a group of elderly Jews trying to get a quorum for a meeting. The titles *The Best Man* and *The Tenth Man* were confused by out-of-towners. A husband and wife were quoted quarreling outside of Paddy's play. The husband was finally heard saying, "All that I know is that one of the characters is Nixon."

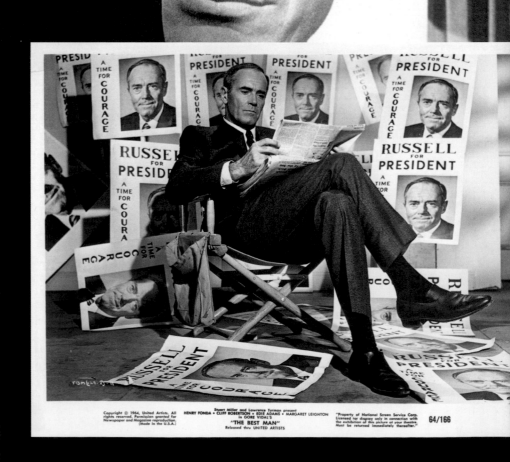

Stuart Millar and Lawrence Turman present HENRY FONDA • CLIFF ROBERTSON • EDIE ADAMS • MARGARET LEIGHTON in GORE VIDAL'S "THE BEST MAN" Released thru UNITED ARTISTS

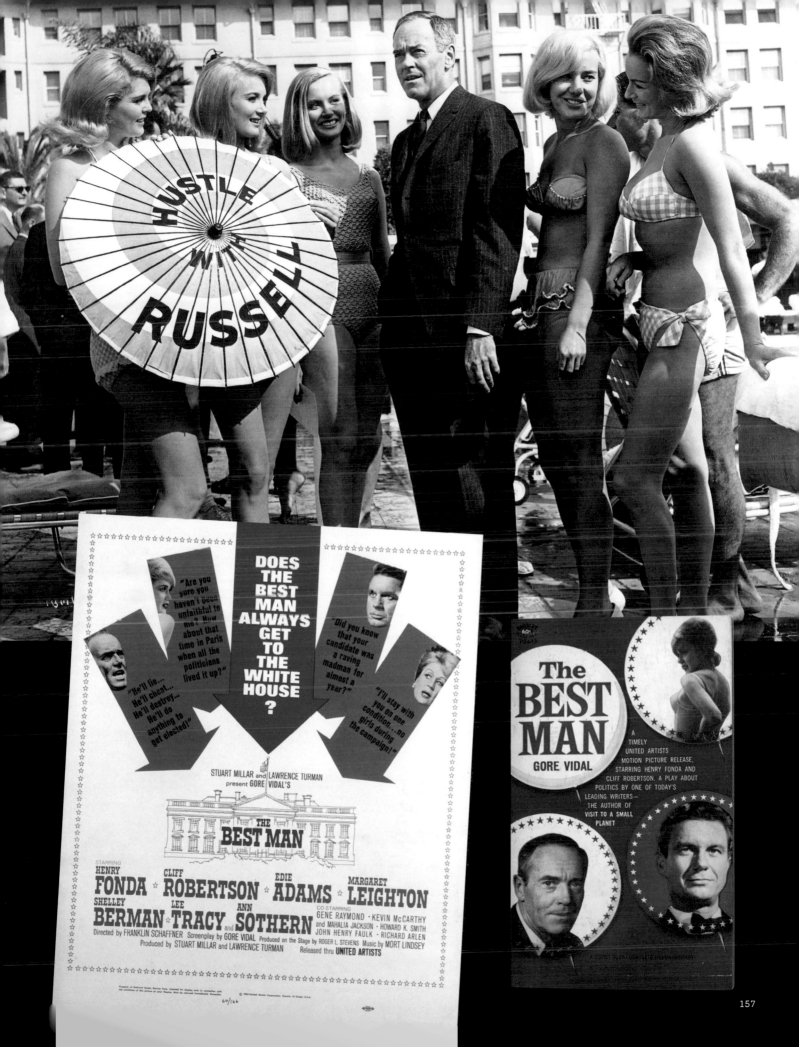

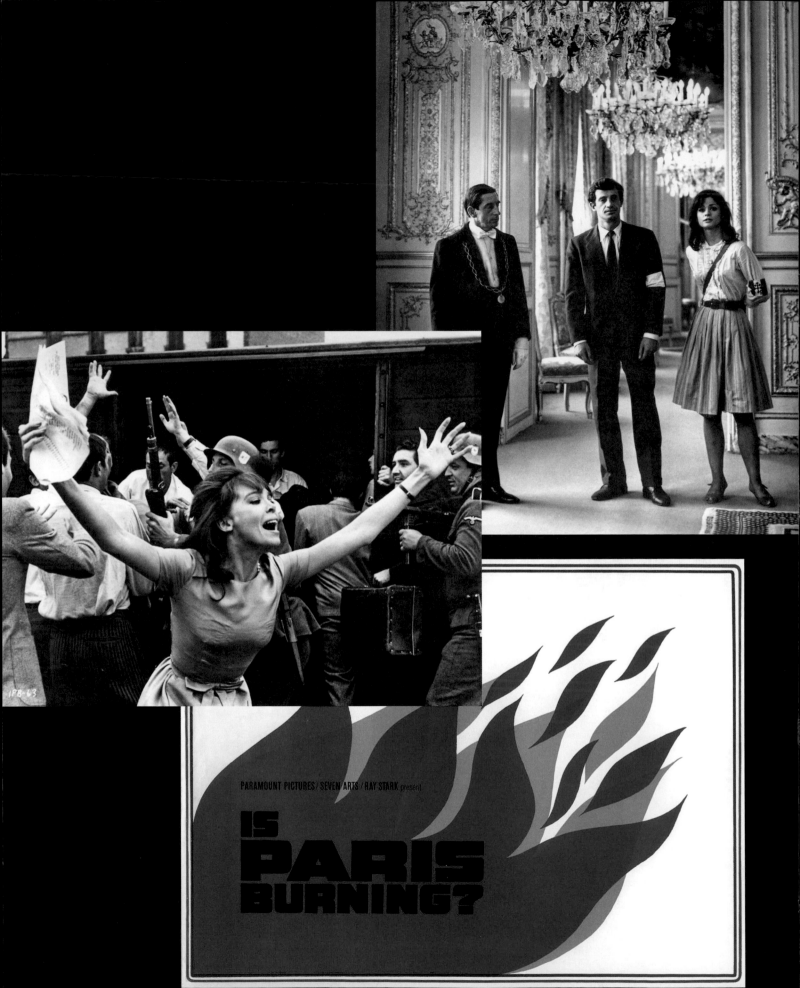

PARAMOUNT PICTURES / SEVEN ARTS / RAY STARK present

IS PARIS BURNING?

To help out my old friend Ray Stark, who had taken over a doomed international picture called *Is Paris Burning?*, I rewrote most of the text in Paris with help from a "junior" writer called Francis Ford Coppola. Since I knew the movie was going to be a disaster, I tried to get out of any credit at all and suggested total credit for him, his first on a major film. I also persuaded Ray to read Francis's screenplay *You're a Big Boy Now*, which launched his career as an original filmmaker. In due course, I got a note from Coppola telling me that he was delighted to have been asked to make a film version of *Finian's Rainbow*. I warned him that no matter what he did in the way of the script there would never be anything but a pot of *merde* at the end of that rainbow. He survived that too. Here is a shot of Orson Welles playing the part of a Swedish consul during the German occupation. Thus I began a friendship with Welles that continued until he died.

The mega-agent Sue Mengers has decided that I might do very well as an actor if I more resembled Tom Selleck and grew a moustache. In any case, I had no time for acting in that period, as I was in demand after *Suddenly Last Summer* to adapt practically anything that Tennessee wrote; I made the mistake of taking on what became a film called *The Last of the Mobile Hot-Shots*, not the Glorious Bird at his feathery best.

The film version of *Visit to a Small Planet* starred Jerry Lewis, who likes to say that I had asked for him to play the part Cyril Ritchard had originated on Broadway, which I did not. I was trying to get Danny Kaye.

During this period I wrote a novel called *Myra Breckinridge*, which inept studio management thought would be a great success as a porno film. Here is a shot of Myra Breckinridge herself about to turn a young stud into her latest prototype for the new human race: a fun-loving Amazon. For the record, I have never seen the film.

The splendid Raquel Welch as Myra Breckinridge. This was the first time that an admittedly fictional character ever appeared on the cover of *Time*.

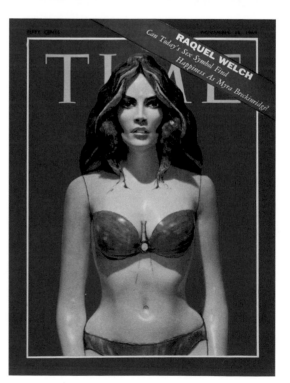

Farrah Fawcett as Mary Ann Pringle, who is put into a love scene with the mischievous Myra Breckinridge, who has just finished raping her boyfriend. Myra herself had begun life as a man, a detail from the book that some of the cast never understood. Farrah had many Texas-style epithets about this scene; I told her that the Cockney director, a one-time bartender and singer, had been given *Myra Breckinridge* to write and direct, and the resulting chaos was predictable. I later reminded the head of the studio, Dick Zanuck, of this when I left the project to fly back to Rome, suggesting, nicely, that by the next year Twentieth Century Fox would be in the hands of the receivers. This proved to be nearly the case, and it was also the first time that a bad movie made out of a book seriously hurt the book's sales: a one-time first!

I did several interviews for *Playboy*, because they agreed to my only ground rule: I would write the answers, since they would then sound the way I spoke, and we would get a better interview. I was also able to keep away from the cliché questions that lesser publications always asked, such as "What are you most proudest of that you have done?" To which my standard answer has always been, "Despite provocation, I have never killed anyone."

ENTERTAINMENT FOR MEN JUNE 1969 · ONE DOLLAR

PLAYBOY

Memo to: Staff

Here are the photo Playmate-of-the-Year issue that includes a interview with Gore "Playboy's Guide to Mutua by Michael Laurence, a gre story by Ray Bradbury, Shepherd recalling his j prom, a chilling report on Paramilitary Right," Rob Morley rating "The Grand Hote of the world, and a reveali pictorial on the filming of "D Sade," plus much more, course.

should be the capper

H M H

PLAYBOY

to make Vidal a frequent White House visitor in Camelot's first years. Vidal spent much of his childhood in the company of his maternal grandfather, Thomas Pryor Gore, the blind Senator from Oklahoma, guiding the fervidly isolationist old man around the Capitol and reading newspaper editorials, the Congressional Record and works on monetary theory to him. At Exeter, still very much under his grandfather's influence, he organized a group that propagandized against American participation in World War Two. By the time he decided to run for Congress in 1960, the conservatism of his youth had evolved into a tough, if not radical, liberalism—favoring recognition of Communist China, Federal aid to education and a decrease in defense spending. Vidal lost the race but garnered more votes than had any Democratic candidate in the district since 1910.

Committing himself again to writing—and to the novel, with "Julian," a fictionalized biography of the Fourth Century Roman emperor who tried in vain to turn back the tide of Christianity—Vidal rejected two subsequent offers to run for office in New York. And in March 1963, he broke his links with the Kennedy White House in a magazine article called "The Best Man—1968." "There are flaws in his persona hard to disguise," he wrote of then-Attorney General Robert F. Kennedy. "For one thing, it will take a public-relations genius to make him appear lovable. He is not. . . . He has none of his brother's human ease; or charity." Vidal's opinion of Robert Kennedy changed as Kennedy himself did in the following years, but the possibility of a conventional political career for the writer was closed.

His fascination with the ways of power, however, remained very much alive. In "Washington, D. C.," which was published in 1967, Vidal shifted novelistically from Roman to American imperial politics, tracing the fortunes of a number of archetypal figures who, in the years from 1937 to 1952, helped transform the American republic into what Vidal calls "possibly the last empire on earth." Like "Julian" before it, the book was an instant best seller.

In "Myra Breckinridge," Vidal moved from the surgical dissection of political venery to a broader and bloodier attack on America's social and sexual mores. The book's title character participates in orgies, an interminable anal rape and a sadomasochistic coupling that ends in a broken neck for one ecstatic partner, all in the course of what Vidal considers "a mad hymn to bisexuality." Most critics found the book's theme less affirmative. In the words of The Reporter, "Others, including . . . Mailer and Albee, have declared war on the American Dream, but no one so far has disposed of it in quite such a nightmare fashion."

With h polemical critical ess ideas. Abo of his hav New York "Vidal is clasts. For hold gods disarmed second ant book—is Ship," pu Brown. It comment Guardian has an which ma aginable t

Vidal in Rome, writing, though a him a fr year. Shoo his adapt "The Sev is both w film versie satisfies h for the Ne after the Carthy an cratic Co with the year and new Adm

PLAYBOY: volved in first as a Eugene M political Republica —what d pact of this coun

VIDAL: "F Eleanor sorrow th he is and can't chan a popular but in rea experience adroit at never bee only in se al career accomplis an occasi tributed did fight became Presidenti meetings, about issu promoting

PLAYBOY: week sug tions as are amo

4

78

a candid conversation with the acerbic social commentator, political polemicist, playwright, producer and author of "myra breckinridge"

One of the few happy developments of 1968—a year disfigured by police riots, student rebellions, political assassinations and a rancorous Presidential campaign —was the emergence into the national consciousness of Gore Vidal. "Myra Breckinridge," Vidal's controversial 11th novel, which appeared in February of last year, has sold some 4,500,000 copies—an almost unheard-of success for a serious literary work in America. And Vidal reached an even larger audience six months later. At both political conventions and on election night, he appeared opposite William F. Buckley, Jr., as a commentator for ABC. Except for one vituperative exchange between the two authors on the bloodiest night of the disturbances at the Democratic Convention in Chicago—an exchange that neither man really won—many observers agreed that the pugnacious polemicist and editor of the National Review had finally met his caustic match in Vidal. At least the television audience discovered that there was someone on the left with a tongue and a mind as sharp as Buckley's on the right.

Vidal's mixed-media breakthrough as a first-magnitude celebrity was neither a surprise nor an overnight success. Though he's only 43, he has been excelling in a remarkably disparate number of careers for close to a quarter of a century. Often concurrently, he has been a novelist, a writer of television dramas, a Hollywood scenarist, a theater critic, a playwright, a member of inner White House social circles, a political columnist, a television personality and even a political candidate.

Literary success came early. Graduated from Philips Exeter Academy in 1943, Vidal served out the War on a ship transporting men and supplies from island to island in the Aleutians. His first novel, "Williwaw," was based on these Wartime experiences. Written when he was 19, it was followed in 1947 by "In a Yellow Wood," and Vidal found himself in contention with Truman Capote for lionization as America's brightest young literary light. But both books are marred by a tendency to mime the styles of Stephen Crane and Ernest Hemingway. "I was," Vidal conceded later, "easily the cleverest young fox ever to know how to disguise his ignorance and make a virtue of his limitations." In his third novel, "The City and the Pillar," Vidal wisely forsook the flat realism of the first two—but he also abandoned convention. A frank and sympathetic homosexual romance, it cast him out of literary favor with readers and critics alike.

Five more novels followed in quick succession. About three of them—"Search for the King," "The Judgment of Paris" and "Messiah"—Vidal says, somewhat bitterly, "These works resembled hardly at all the books that had gone before, but unfortunately, I was by then so entirely out of fashion that they were ignored." In 1954, thoroughly discouraged and in need of money, Vidal turned to writing for television. A score of scripts through the next two years—some originals, some adaptations—earned him as much money as had the previous near decade of novel writing. The most successful of his

television plays, "Visit to a Small Planet," presaged Vidal's deepening political concerns. The visitor of the title—a sophisticate from outer space—comes to earth to see a war, even if he has to start one himself, because, he explains, "It's the one thing you people down here do really well," Vidal adapted the show for Broadway, where it enjoyed a two-season run. In the late Fifties, he wrote two more plays for the tube (in one of which he played a minor role) and worked on a number of filmscripts, including "Ben-Hur" and Tennessee Williams' "Suddenly, Last Summer." His second Broadway play, "The Best Man," followed in 1960—and also ran for two seasons.

By 1960, in fact, it began to seem as if Gore Vidal was the collective nom de plume of a half-dozen equally gifted men. Three movies written or inspired by Vidal, as well as the play, were appearing simultaneously in New York; Jack Paar and David Susskind had discovered in him a provocative new guest; and his theater criticism was appearing regularly in The Reporter. To top it off, Vidal was the Democratic candidate for Congress in New York's 29th District.

The writer's active interest in politics came even earlier than his commitment to writing. ("I have, since childhood," Vidal told The New Yorker, "said that I would rather be President than write.") His parents were divorced when he was ten, and his mother married Hugh D. Auchincloss, who is also the stepfather, through another marriage, of the present Mrs. Aristotle Onassis—the link that was

"If we survive long enough to evolve a rational society, there will be a trend toward bisexuality. For one thing, bisexuality is, quite simply, more interesting than monosexuality."

"The people recognized themselves in L.B.J. and recoiled. He was the snake-oil salesman, just as Nixon is the realtor intent upon selling us that nice development land that turns out to be swamp."

"It is quite true that 'Myra Breckinridge' has earned me a great deal of money. If I were to say that I had written it in order to make money, I would be understood and absolved of sin."

[left margin fragments:]
...ecoming increasingly often turned to the ...years to promote his ...g the Boat," the first ...ctions of nonfiction, ...ohn V. Lindsay wrote: ...ngratiating of icono- ...is leveling the house- ...ustating sally, he has ...he sliest grins." The ...d Vidal's most recent ...ns upon a Sinking ...is spring by Little, ...of literary and social ...ify the Manchester ...cement that "Vidal ...impish intelligence ...he nearest thing in ...model Bernard Shaw." ...time between homes ...he does most of his ...New York City—al- ...l projects have made ...ollywood visitor this ...a few weeks ago on ...Tennessee Williams' ...s of Myrtle," and he ...producing big-budget ...ian" and "Myra." He ...n politics by working ...which he helped found ...Senator Eugene Mc- ...odshed of the Demo- ...Our interview began ...turmoil of the past ...d the outlook for the

...ho was intimately in- ...'s electoral process— ...supporter of Senator ...candidacy, then as a ...tor for ABC at the ...mocratic Conventions ...as the probable im- ...Administration on the world?

...what they are," as ...used to say, more in ...umph. Nixon is what ...Mrs. Roosevelt—"You ..." There is, of course, ...at people do change; ...nous slush fund. He ...don't. With age and ...imply become more ...nemselves. Nixon has ...ed in issues or ideas, ...ion. His Congression- ...erfect blank—nothing ...ne represented except ...for those who con- ...nous slush fund. He ...nies, however, and so ...eports on his Vice- ...show that at Cabinet ...a had anything to say ...good deal to say about ...y.

...r the election, News- ...at Nixon's qualifica- ...e political technician ...deeming Presidential

[right margin fragments:]
...that is happening. Vio- ...i greatest pleasure, wheth- ...or in the barroom.

...ing of violence on televi- ...most memorable moments ...Presidential campaign was ...natch with William Buck- ...ring the Democratic Con- ...rospect, how do you feel ...ude?

...eluctant to appear with ...or one thing, I knew it ...me to his level—I'd look ...entertainer, balancing his ...n act. But the size of the ...tempted me; as a polemi- ...good an opportunity to

...your point of view, were ...ccess?

...es, yes—though poor Bill ...best. I've never seen any- ...uch as he did on camera. ...ction night, he refused ...ebate me—or even meet ...worked with a velvet ...us, answering Howard ...stions separately. I can't ...t such a reputation as ...nd him a bit of a bird- ...to pursue any train of ...y, no doubt because he ...let on to what extent ...t-minded, as I implied he ...-"fascist," by the way, is ...e often—and is therefore ...n to Nixon's White ...o be honest, he is forced ...ccusing Norman Mailer ...and so on. Needless to ...ad hominem attack is ...red by the kulaks.

...response to my sugges- ...s a "crypto-Nazi"? He ...he shrieked, because he ...infantry—non sequitur ...punch me in the nose: ...a fascinating display of ...ith eyes rolling, tongue ...bist and, as always, the ...ssimulation: The only ac- tion he ever saw was in a classroom, teaching Spanish. For the record, I was in the Pacific with the Army during the War. Thus, to make—or avoid—a point, he will say anything. Contrary to his usual billing, Buckley is not an intellectual: He is an entertainer and self-publicist, and since the far right have practically no one they dare display in public, he has been able to make a nice niche for himself as a sort of epicene Joe McCarthy.
PLAYBOY: Though you say you don't usually use the word "fascist," you've already used it twice.
VIDAL: It's on my mind, obviously. Pressures from students, New Left and militant blacks could cause the conservative majority of the country to counterattack, to create what would be, in effect, a fascist society behind a democratic façade.
PLAYBOY: Do you think Americans, at this


But what is to take its place? The New Left not only have no blueprint, they don't want a blueprint. Let's just see what happens, they say. Well, I can tell them what will happen: first anarchy, then dictatorship. They are rich in Tom Paines, but they have no Thomas Jefferson.
PLAYBOY: Nixon has announced that after an era of confrontation, we must now begin an era of negotiation. Do you see this as a hopeful sign?
VIDAL: He enjoys taking trips abroad and thinks himself an international expert because, over the years, he has met a great many heads of state with whom he has spoken through an interpreter for as long as 30 minutes. I think he'll do a lot of traveling, but nothing much will change. You know, empires have their own dynamic, and individuals don't much affect

...an a liberal.
VIDAL: The sad paradox of liberalism is to want majority rule while realizing that the majority is instinctively illiberal. The Bill of Rights was the creation of the educated few, not of the ignorant many, who would have rejected it—and in practice do reject it, quite as firmly as Mayor Daley did last August in Chicago. Watching the police attack the educated, the odd, the nobly intentioned, I found myself admiring—if only briefly—Stalin's treatment of his kulaks. The police represent the same class in this country, as its most bitter and ignorant. At Chicago, they had a chance to revenge themselves on their economic and intellectual betters. The result, as the Walker Report said, was "a police riot." At the moment, the real danger to America is not anarchy but repressive police power. The fact

here to escape persecution. In actual fact, they were driven first out of England, then out of Holland, because of their persecution of others. We had a bad start as a country. But then things improved in the 18th Century, and we had a good beginning as a nation, with a rich continent to sustain us. Unfortunately, our puritan intolerance of other races and cultures, combined with a national ethos based entirely upon human greed, has produced an American who is not only "ugly" but, worse, unable to understand why he is so hated in the world. The social fabric is disintegrating. We face the prospect of racial guerrilla warfare in the cities, institutionalized assassinations in our politics, suppression of dissent in our Chicagos and a war in Asia that can at any moment turn nuclear—and terminal. Yet the white majority

77

79

ABC asked me if I would debate William F. Buckley Jr., a writer whom I deeply disliked not only for his politics, which were absurd, but for his reckless ad hominem attacks on just about everyone he thought was not capable of hitting back. He had many lawsuits going, apparently; in fact, as a result of a lawsuit he had against the *New York Post*, which had offended him, he got Dolly Schiff, an old friend of mine and liberal warrior, to give him a column if he dropped the suit. In those days, newspapers, magazines, etc., were very quick to settle lawsuits for whatever they thought was the minimum, and that is how Buckley got for himself a regular column at the *New York Post*. A Mr. Lenny Goldenson, the amiable head of ABC, thought it would be a great notion to have the two of us debate each other during the 1968 Republican and Democratic conventions. Paul Newman warned me that I was running a risk because, "You will be confused with him as a sort of left-wing idiot, just as he is a right-wing one." I said I thought I could run that risk safely. Over the years so many people have told me how much they delighted in those debates that if I kept count I would have proof that everyone on earth had been watching, which, happily, was not the case.

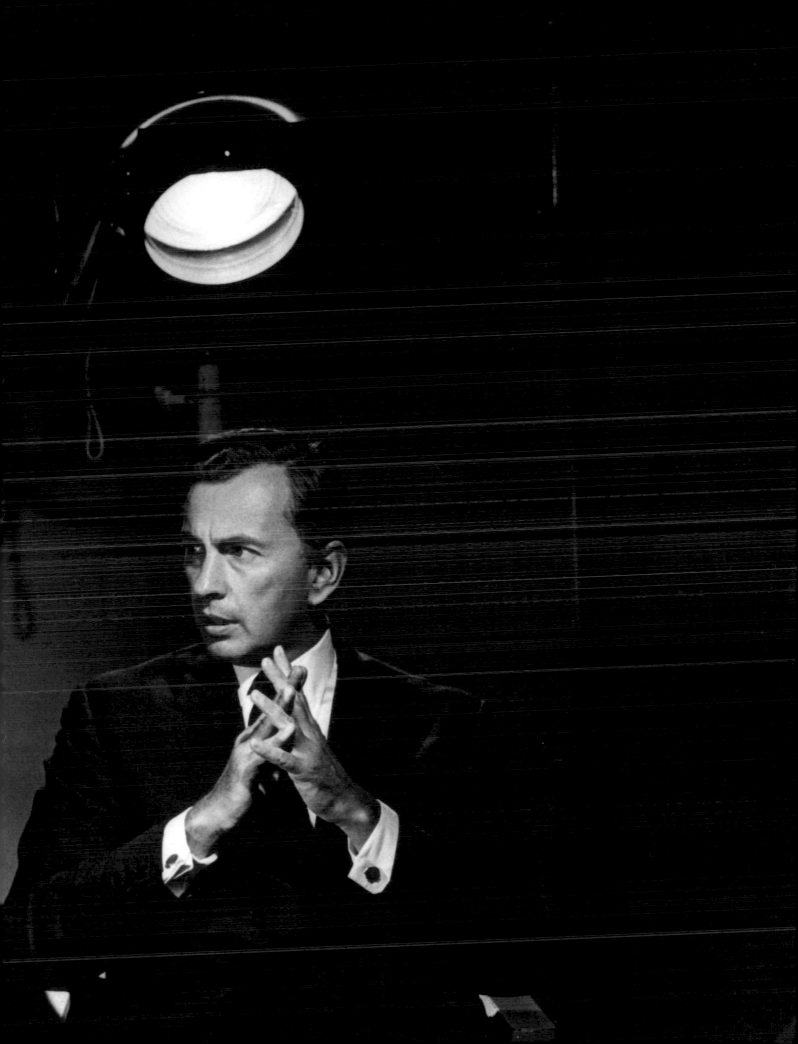

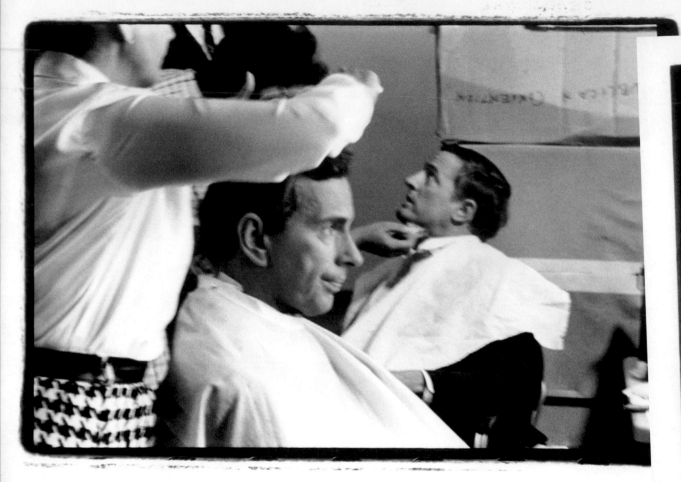

Here I am being made up for one of the Vidal-Buckley debates on ABC Television. Thanks to these debates, ABC—always, until then, the third network—suddenly became number one in the Nielsen ratings, much to the delight of Mr. Goldenson. Each morning, in Miami, I'd meet him on the beach of the Fountain Blue (as Miami called the hotel), and he'd quiz me: "What *were* the two of you doing at five minutes to midnight?" I didn't know. "There was a slight dip in the ratings. We follow you second by second in the ratings, and want to know how you lost them and also how you got them back."

I should note that without makeup everyone's face vanishes on television. Laura Berquist, a splendid journalist of the period, wrote a fairly serious piece about me in *Look*, which ran a photograph of Buckley with a quote in which he declared solemnly that he *never* wore makeup on television. He was the sort of unlucky public liar that always gets found out.

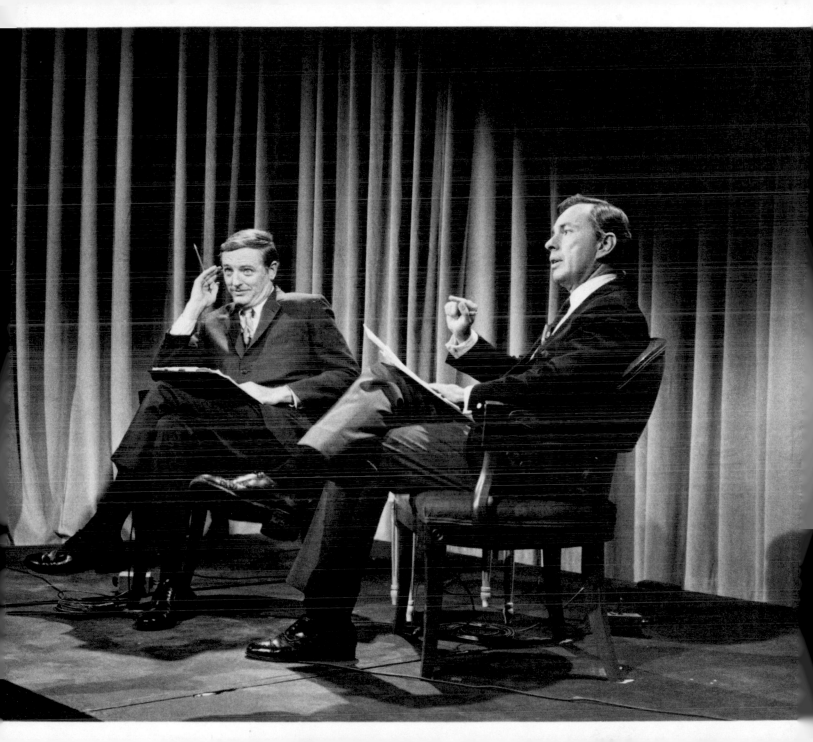

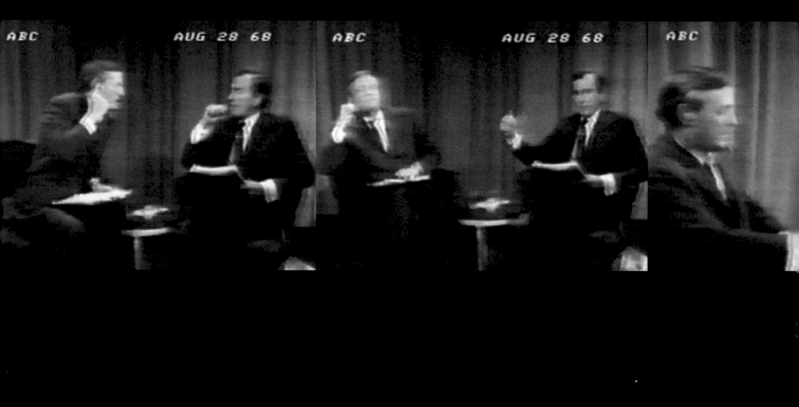

Buckley and I during our debates at the Republican and Democratic conventions of 1968. Howard K. Smith, the venerable newsman, was supposed to be our referee, but he was a referee totally on the side of Mr. Buckley.

As the reader might not perceive, Mr. Buckley was not as nice as he looked.

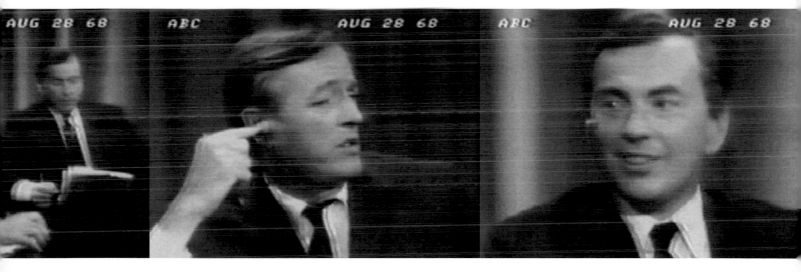

On Experiencing
Gore Vidal

by William F. Buckley Jr.

*Can there be any justification in calling a man a queer before
ten million people on television?*

I have here a recent issue o[...]
a piece entitled "Faggot [...]
precisely about a column [...]
highly displeased this [...]
faggot logic," my critic w[...]
year, and Buckley's spiteful sp[...]
off, even more than usual." Tha[...]
The East Village Other, and I r[...]
something about the nature of [...]
author went on, referring to th[...]
"is nearly invariably an exerci[...]
think this peculiar mode of inte[...]
ally inimical to the public weal, [...]
season notwithstanding—to en[...]
of one of his scabrous evacuatio[...]

Alas, many many words later,[...]
he didn't know before about th[...]
my case was nothing at all, an[...]
would not likely come to appreh[...]
way elusive under the guidance[...]
thought proved to be as barren[...]
alongside him over an endless st[...]
the cheerless conclusion (hardl[...]
Govern), that the author likes [...]
we should get out of Vietnam if[...]

Even so the piece sticks in th[...]
rhetorical effort at homicide—[...]
with all the bad words; and yet[...]
got." That was the warhead. Ve[...]
vealing in the context of the gen[...]
faggotry, the unmetaphorical pr[...]
to, or so it would seem. On pa[...]
advertisements as plainspoken[...]
"NUDE MALE FILM CLUB. .[...]

ical opinions on the grounds that he is [...]
ite a book like *Myra Breckinridge*. It [...]
roics about the show going on despit[...]
ffered in a fall on his boat [—heroics[...]
ybe; heroics, no—] had less to do wit[...]
n with eagerness to get his claws int[...]
Now under the stress of my conversati[...]
anchor of Miss Harrington's argumen[...]
drifts away into fantasy. *Still*, she [...]
rning which there has been consider[...]
levant: so that (fulldisclosurewise) [...]
breviated but not censored, of my de[...]
owledging Miss Harrington's and oth[...]
alings figured, yes indeed, in the meeti[...]

In January of 1962, appearing on [...]
promote his play *Romulus*, Vidal [...]
serve that I had "attacked" Pope [...]
left wing": which sorrowful reco[...]
from the audience horrified trem[...]
Paar was evidently pressured to invit[...]

AUGUST 1969
PRICE $1

Esquire
THE MAGAZINE FOR MEN

Public decency on the screen, stage,
and in the streets.
The stripper gives her views.

See page 104

When Buckley realized that it was generally thought I had bested him in our television debates, he wrote a defamatory piece about me in *Esquire*. I wrote a response revealing some Buckley family secrets, including the occasion when three of his siblings wrecked an Episcopal church in Sharon, Connecticut. The minister's daughter was the wife of Steve Allen, who hosted a very popular television program, and she came to my aid with a number of stories recollecting the crimes that the Buckleys had committed against the Protestants of Sharon, among others. Buckley, who had injured me, brought suit against me, saying I had injured him. This is very much a Buckley ploy. He dropped the suit against me when I said I was delighted with my information about him and his family, and was ready to go into court. He then sent out numerous press releases saying that *Esquire* and I had settled with him for hundreds of thousands of dollars. He did get some free advertising for his magazine from *Esquire*. Like Hitler, but without the charm, he believed the bigger the lie, the more it would be accepted.

**Vidal Is Sued by Buckley;
A 'Nazi' Libel Is Charged**

William F. Buckley Jr., the conservative columnist, filed a $500,000 suit yesterday against Gore Vidal, the liberal writer, saying that Mr. Vidal had libeled him by allegations that he was a Nazi.

Mr. Buckley's lawyer, C. Dickerman Williams, filed the Federal Court charges here claiming "a campaign of persistent, false and defamatory villification by allegations, both oral and written, that he [Mr. Buckley] is a Nazi."

The court papers asserted that Mr. Vidal's comments on a television program last Aug. 25 during the Democratic National Convention showed "reckless disregard" for the truth.

Mr. Buckley also mentioned an interview in The Daily News last Aug. 27, in which Mr. Vidal reportedly declined to apologize, and an article by Mr. Vidal in the March issue of Esquire magazine.

A Distasteful Encounter with William F. Buckley Jr.

by Gore Vidal

Can there be any justification in calling a man a pro crypto Nazi before ten million people on television?

During the evening of May 13, 1944, Christ Episcopal Church at Sharon, Connecticut was vandalized. According to *The Lakeville Journal*: "The damage was discovered by worshipers who entered the church for early communion the following day. The vandalism took on the appearance of similar occurrences in New York, according to witnesses. Honey mixed with feathers was smeared on seats, obscene pictures were placed in prayer books, among other desecrations." According to the local police lieutenant "the crime [was] one of the most abominable ones ever committed in the area."

Twenty-four years later, on Wednesday, August 28, at nine-thirty o'clock, in full view of ten million people, the little door in William F. Buckley Jr.'s forehead suddenly opened and out sprang that wild cuckoo which I had always known was there but had wanted so much for others, preferably millions of others, to get a good look at. I think those few seconds of madness, to use his word, were well worth a great deal of patient effort on my part.

Last month, in a lengthy apologia, Buckley reprinted this exchange which, he proudly tells us, "rocked television." For purpose of reference, I must briefly reprise what happened. On the night of August 28, the Chicago Police riot was at its peak. Predictably, Buckley took the side of the police. This was particularly hard to do since, just before we went on the air, ABC had shown a series of exchanges between police and demonstrators which made it clear that the boys in azure blue were on a great lark, beating everyone in sight. Buckley attacked me for defending the victims. That did it. I was now ready for the *coup de grace*. I began: "... only pro crypto Nazi I can think of is yourself. ..."* As Buckley knew, there was more to come. He created a diversion: "Now listen, you queer. Stop calling me a pro crypto Nazi or I'll sock you in your goddamn face and you'll stay plastered. ..." It was a splendid moment. Eyes rolling, mouth twitching, long weak arms waving, he skittered from slander to glorious absurdity. "I was," he howled, "in the Infantry in the last war." Starting as always with the improvisation first, I said, "You were not in the Infantry, as a matter of fact you didn't fight in the war." I was ready to go

that but by then he was entirely out of control and, as our program faded away on much noise, a few yards from us Hubert Humphrey was being nominated for President. All in all, I was pleased with what had happened: I had enticed the cuckoo to sing its song, and the melody lingers on.

For eleven nights we had "debated" one another on television, first at the Republican Convention in Miami Beach and then at the Democratic Convention in Chicago. The American Broadcasting Company had asked us to discuss politics, and so I had spent a number of weeks doing research on the major candidates as well as on my sparring partner. From past experience, I knew that as a debater Buckley would have done no research, that what facts little had at his command would be jumbled by the strangest syntax since General Eisenhower faded from the scene, that he would lie ("McCarthy never won a majority in any state he ever ran in . . .") with an exuberance which was almost but not quite contagious; and that within three minutes of our first debate, if the going got tough for him on political grounds, he would mention my "pornographic" novel *Myra Breckinridge* and imply its author was a "*degenerate*." This is of course what happened. This is what always...

*There is some confusion about what was actually said on the telecast. The "Nazi" was first introduced into the discussion by Howard K. Smith who to raise a Vietcong flag in Grant Park was the equivalent to raising a Nazi flag during the Second War. I said it was not the same thing: officially there is war between us and Hanoi. More to the point, a sizable minority in this country disapprove of their government's policy and if flaunting a North Vietcong flag gives them comfort they have every constitutional right to do so (as developed, the "flag" raised was underwear). Buckley once again attacked the dissenters; I defended their right to dissent. Unfortunately, two lines of mine leading up to "pro crypto Nazi" remark are not clear on the tape. It is my recollection that they had to do with communism and the dissenters' relation to the Conspiracy. Whatever they were, my own outburst was not a declarative sentence but the beginning of a response to Buckley which was—so notoriously—cut short. Incidentally, I had not intended to use the phrase "pro crypto Nazi"; "Fascist-minded" was more my intended meaning, but the passions of the moment and Smith's use of the word "Nazi" put me off course.

Buckley Drops Vidal Suit, Settles With Esquire

The legal battle between William F. Buckley Jr. and Gore Vidal, arising out of their public exchange of affronts, apparently came to an end yesterday with an announcement by Mr. Buckley of two acts: the dropping of his suit against Mr. Vidal and an out-of-court settlement of $115,000 with Esquire magazine.

Mr. Vidal, the novelist, playwright and critic, wrote an article, "A Distasteful Encounter with William F. Buckley Jr.," that ran in the September, 1969, issue of Esquire. The title referred to their celebrated dispute on television a year earlier.

Mr. Buckley, the conservative editor and columnist, sued Mr. Vidal, who countersued Mr. Buckley. Mr. Buckley also sued the magazine. The court dismissed Mr. Vidal's action but ruled that Mr. Buckley's suit against him should go to trial.

Arnold Gingrich, publisher of the magazine, said last night: "The whole matter has been settled. Our motion for summary dismissal of Buckley's action was denied, which meant that we'd have to proceed to trial. We simply felt that under the adversary system, nobody wins but the lawyers. This agrees to call off the mutual spending of money."

Mr. Gingrich confirmed that Esquire would publish a statement in its November issue disavowing "the most vivid statements" of the Vidal article,

calling Mr. Buckley "racist, antiblack, anti-Semitic and a pro-crypto Nazi." The Magazine will pay $115,000 for Mr. Buckley's legal expenses.

Mr. Buckley said of Mr. Vidal, "Let his own unreimbursed legal expenses, estimated at $75,-000, teach him to observe the laws of libel."

Photographer's photographer

There is one man who stands head and shoulders above his competition...who is called upon to lecture to professionals all over the world. Josef Schneider is the foremost portraitist of children today. His wide-ranging experience as a child photographer and his complete mastery of the techniques of photography put him squarely at the top of his profession. Call for an appointment today. No obligation, of course.

Josef A. Schneider

119 West 57th Street, New York City • 265-1223

urr was the first of the books that I wrote at La Rondinaia, finishing a week before Christmas 1972. From then on my next few novels were dramatized biography or history or a combination of the two, a survey of our culture (all the way up to the ironically titled *The Golden Age*), the entire enterprise being summed up in *Creation*, where I lodge myself firmly and, perhaps, forever, in the fifth century BC. A tale of the beginning, as I see it, of everything: Philosophy, Zoroaster, and other subjects that intrigued me and, according to Mr. Weybright, my fellow countrymen, who are indeed curious about the religious and intellectual background of us all. With the exception, of course, of *The New York Times*.

In 1968 I was invited by Westinghouse to be a TV commentator at the San Francisco convention, which would be nominating Barry Goldwater for president, at the Cow Palace. I accepted out of curiosity, although I was not considered an urgent presence at Republican conventions. Above left, you see me with some fellow historians/political commentators. Also, before the convention got under way, CBS Television asked me to "debate" Senator Goldwater, whom I had written at some length about in *Life* magazine, in a piece that gave no joy to his supporters but about which he himself—that self being a genial and serene soul—never complained. I should note that my uncle, Brigadier General Felix Vidal, was a crony of Goldwater, as each was an Air Force Reserve pilot and each, I must confess, highly conservative in the way he looked at the world. Here we are, top right, Goldwater and I, getting ready to go on air in Chicago. He was thought to be the lead over every other Republican contender, including Senator Margaret Chase Smith, of Maine, another friend of my uncle. After my chat with Goldwater, he began to sink in the polls and Margaret Chase Smith began to rise. Nevertheless, in due course, he was nominated, and his

principal rival, Nelson Rockefeller, was heartily booed by the convention with a chorus of very strange women screaming, as he tried to speak, "Lover! Lover! Lover!" Apparently, Rockefeller had done the unspeakable: He divorced an old wife and married a younger one, who was, if the chorus of Furies was to be believed, an employee of the Rockefeller interests—there is nothing like real politics to set the blood flowing. The Greek chorus persisted for some time, screaming their hatred of Rockefeller until, out of the woodwork as it were, appeared the former president and forever general Dwight D. Eisenhower, who stood high on the stage and glared at the ladies until one by one they shut up, and he left the scene. I then headed, along with several other liberal commentators, like David Brinkley, through the kitchens and out the back door of the convention hall, with furious Texans in pursuit.

Although the collective activities of the Screenwriters' Guild were sometimes pointless and most of the time hopeless, I soldiered along with them, briefly.

During those troubled years, here I am on television with Abbie Hoffman.

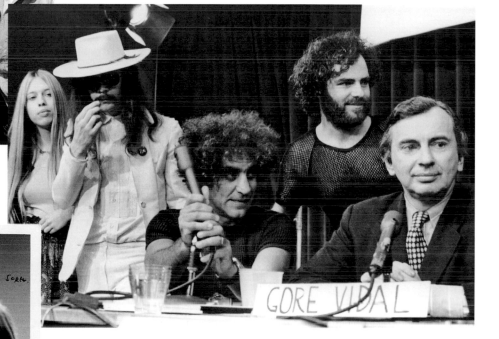

TO GORE VIDAL – MY
FAVORITE CENTERFOLD FOR SCREW.
FROM NOW ONE
OF THE RARE
HONEST PRICKS
LEFT. STAY
UGLY AND
HEALTHY.
al

GORE VIDAL

Here I am with the moralist Al Goldstein, a fierce warrior for the American way of life in his unique magazine *Screw*. Later he was indicted because he was too exuberantly reveling in the First Amendment, never truly allowed in Freedom's Land. There is also a copy of a telegram asking if I would help out in his trial, which I suppose I did. People were more interesting in those days.

1975 MAR 3 22 41

NNNN
ZCZC PUA315 WUR767 2-237572E062
ITRM CO UWNX 246
TDMT NEW YORK NY 46/45 03 0429P EST

GORE VIDAL VIA DI TORRE ARGENTINA 21
ROME 111

PLEASE CALL. WE REALLY NEED YOUR HELP IN SCREW'S UPCOMING TRIAL
JUDITH CRIST AND BRENDAN GILL AMONG OTHERS ARE HELPING AS
WITNESSES--BUT WE REALLY NEED YOUR HELP AS WELL
 AL GOLDSTEIN

COL 21

Ordinarily, at least once a week I would walk down these stairs, usually to Amalfi, where I would buy the foreign newspapers and then take the bus back up to our piazza. When people ask me, "Well, what did you like about Ravello that brought you there for so many years to live?" I just say, "Look at this picture." Ilex trees line the staircase, which goes back centuries. And it was a great walk and kept me in condition until the wheelchair years began. The purest air and the best exercise. Off camera there are groves of lemon trees.

Howard's emphysema was getting worse and worse and, as I grimly suspected would happen, turned into brain cancer. In preparation for this I had bought a villa called La Rondinaia on the Amalfi Coast, a beautiful place where we were quite happy. The fresh air did him much good, as did a successful operation to remove the diseased part of his right lung. During this period, I, despite never having been very social, invited many people to visit as company for him. I mostly invited people he would like to know, starting with Andy Warhol, who was escorted by Mick Jagger, Bianca, and baby Jade. From time to time our old friends the Newmans would visit. This was really as pleasant a last stand as I could have made for him. He also kept on singing during this period, to his many local fans in the piazza, and despite the loss of part of the lung he was in superb voice. Later, on a brief trip to Brazil, he entertained the entire parliament in the

first-class lounge of the Brasília airport as we waited for our flight to Rio de Janeiro. He was in great form and earned the standing ovation that the entire government of Brazil gave him as all of us boarded the plane to Rio. Like General de Gaulle, I, too, regarded and regard with much fondness Brazil as, in the general's phrase, "the nation of the future, as it always shall be."

At the beginning of this chapter I am walking up the stone steps from Amalfi to the villa, some 2,300 feet. In the background is the port of Maiori, where there was a great victory for the U.S. Navy in World War II.

A somewhat long shot of La Rondinaia, taken from a helicopter, and behind it, Amalfi, with Ravello in the distance. If the helicopter had faced the other direction, one could have seen Positano and the Galli islands, on one of which lived our friend Rudolph Nureyev, who said grimly, "One day I want to die here on my island, but now they tell me I must go and die in the United States in some hospital," which is what he did: of AIDS.

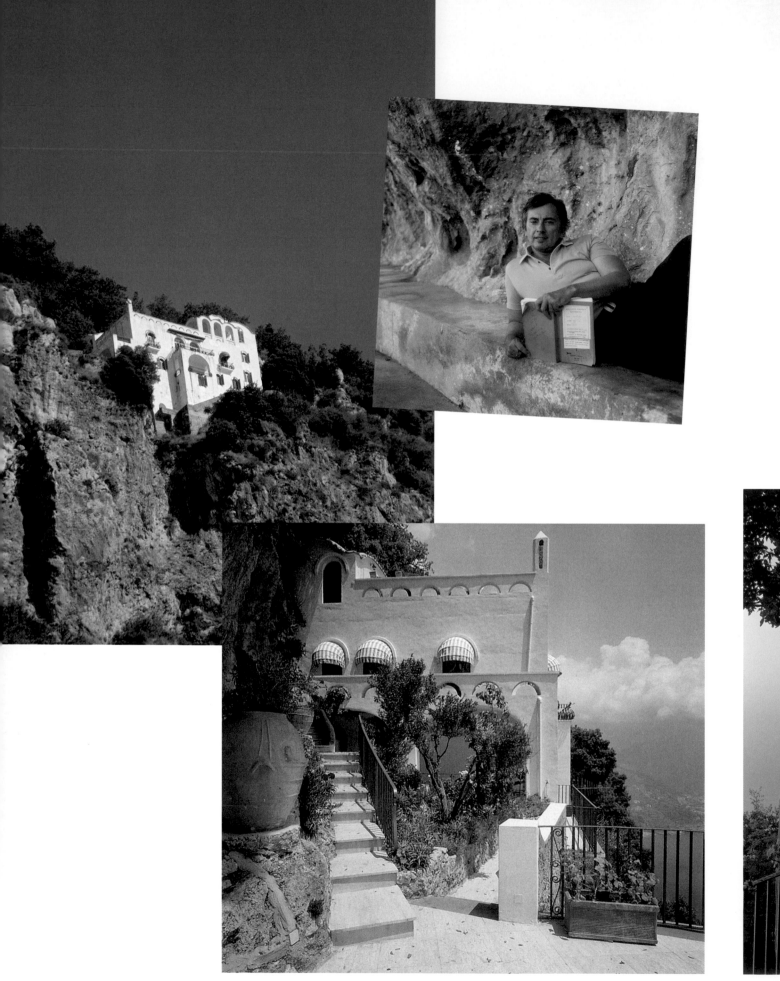

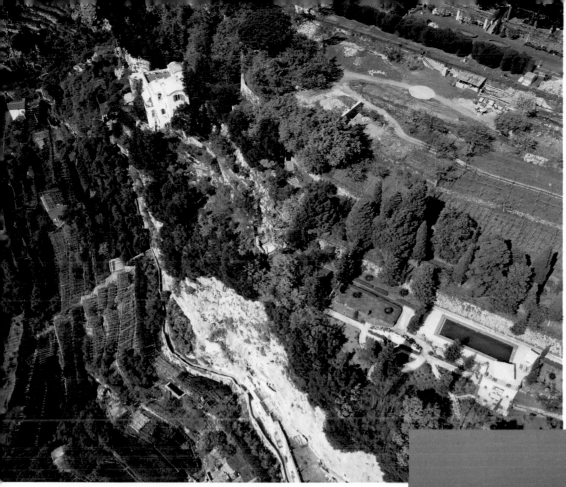

On the villa's roof, one magical night, as the moon rose, James Taylor serenaded Howard and a dozen young people from the piazza. His famous lyric "You've got a friend" applied very nicely to himself, as he demonstrated to Howard during that period.

More shots of the villa. The orange cat is looking suspiciously down the steps. Today he is very much alive in the dull Hollywood Hills, so unlike his outdoor life in Ravello, where he is often constricted to the house because of coyotes.

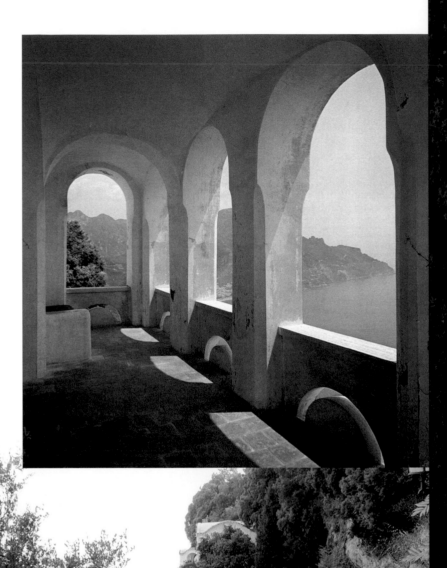

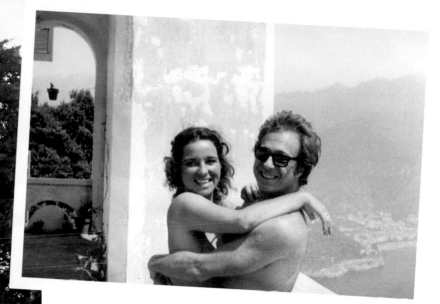

Howard and girlfriend, with the Mediterranean behind them, where, on a clear day, as they say, you can see the temples at Paestum.

Princess Margaret on a trip to visit us on the Amalfi Coast. In the foreground is her son, Lord Linley. Today he is, deservedly, the most celebrated cabinetmaker in England. I give credit to HRH, his mother, for allowing him to do what he wanted to do, and, as it turned out, allowing him to triumph. And I also take some credit for my having persuaded her to forget about fashionable schools or, indeed, Oxbridge itself, to be followed by the military, because he had the calling of an artisan, at which he proved to be extremely good and therefore had something that had been denied her, something rather unusual in royal families—a happy life.

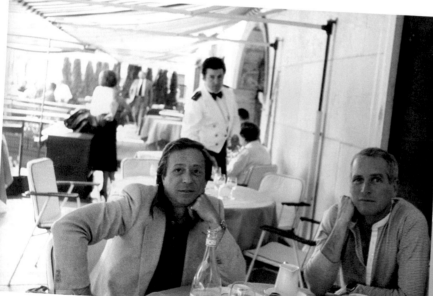

Howard and Newman in the piazza of Ravello. Luigi, the waiter in the background, is responsible for so many of the photographs we have. In exchange for a license to photograph the guests, he worked for us as busboy for nothing. As you can see, he has a pretty good collection.

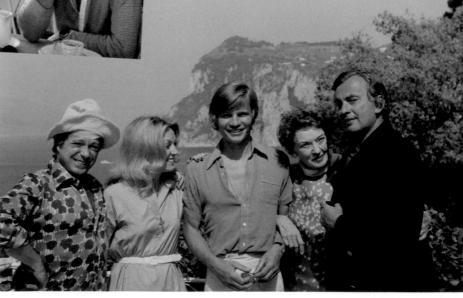

Mona Bismarck at her Capri villa Fortino, which was built upon the ruins of a villa that once belonged to the Emperor Augustus. To her right is the actor Michael York.

Leonard Bernstein, who had come to Ravello to persuade me to do a new libretto for his musical about the White House. As he stayed up very late every night, noon found him in a generally bad temper, as the sun seemed to have hours that did not coincide with the maestro's timing, and he constantly missed the pool and complained about the darkness of everything. I said that the hours by which he was living life had to change if he was to get more sunlight, if not limelight. But he was fixed in his ways. A glorious companion for anyone not a famous tenor.

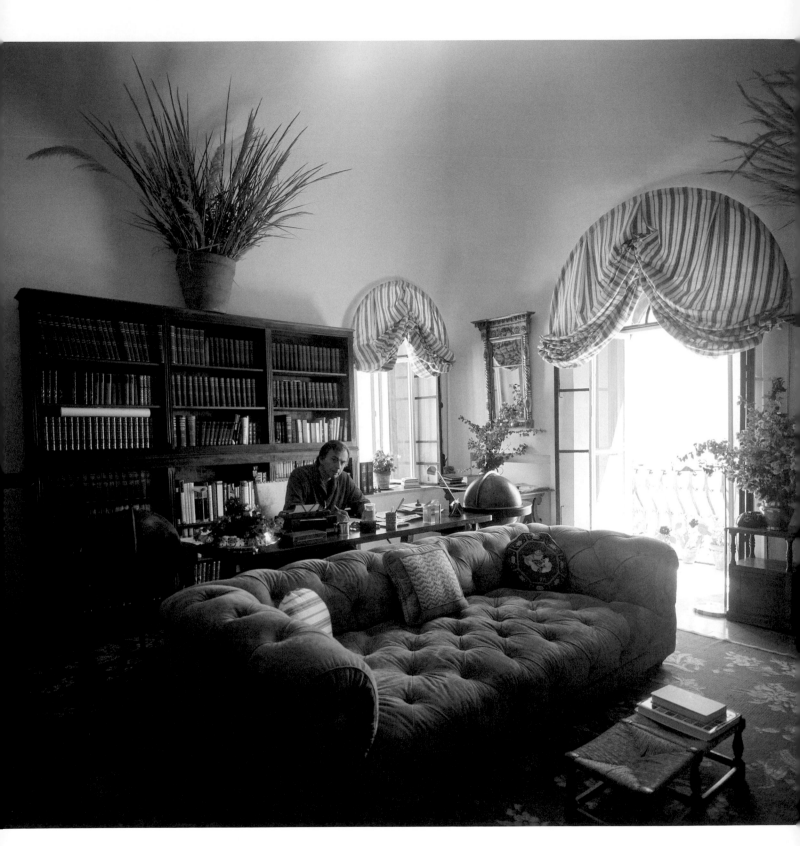

The studio in La Rondinaia, which overlooks the Tyrrhenian Sea. I wrote a dozen books in this room. On the opposite page, the *salone* in the villa, with its tufa fireplace.

An old friend, Lauren Hutton,
with the white cat.

A photograph of Mrs. Onassis-to-be that she signs, mystifyingly to me, of all people, "Jacqueline Kennedy." She hated being called Jackie in the press and instructed her Kennedy sisters-in law, "the toothy girls," as she called them, that, henceforth, she wanted to be known always as Jacqueline, causing the droll Eunice to remark, "Ah, *Jacqueline?...* because it rhymes with *queen?*"

Howard holding court in the
salone one evening after dinner.

ABOVE In the villa, I am working out, sauna behind me.

LEFT Newman having a go at the piano.

The dining room, with some weird Neapolitan furniture, beloved by the great literary critic Mario Praz. (I have just made the sign to ward off the overactive evil eye that he was reputed to have. Once, at the mention of his name as we looked out the window on a Roman street, a taxi ran into the house we were in; he merely shrugged.)

The metal chairs in the dining room had been used for Mrs. Ben-Hur Sr.'s breakfast nook. I found them later at a Roman antique shop, where I was assured that they had belonged to a maharajah. I told the owner that it was not in fact a maharaja's set; rather, they had been made especially for the movie *Ben-Hur.*

At dinner with Madame Agnelli and my—by then—old friend, Italo Calvino. This photo was taken at the time I was created an honorary citizen of Ravello, and many people came from various parts of Italy to wish me luck.

When we first moved into the villa, everyone that we had known, or thought that we had known, soon arrived to case the premises. Here I am greeting Andy Warhol (not pictured) and Mick and Bianca Jagger at the port of Amalfi. For the record, Mick was a perfect sightseer, up at dawn, guidebook in hand, examining the old churches and castles in the neighborhood. He was also fascinated by early memories, one of which, for him, was of the end of World War II. He said they had had dark curtains (of the sort that we still had in the bedrooms) so that the invading Nazis could not see the light from their windows, and he still remembered the day when his mother took down the curtains and said, "The war is over."

Warhol, who was endlessly charming, acted as if he were in the Land of Oz when he was in Italy; everything was strange to him. I asked him, as a joke, to autograph the front of the house so I could sell the entire estate as a Warhol sculpture; he did not do this but instead took some Polaroid pictures of the villa. When I complained how blurry the pictures were, he said, "But doesn't that look more artistic?" I quite agreed. And so he signed the Polaroids with the priceless *W*, which I implore readers not to cut out so they can claim they have a Warhol original.

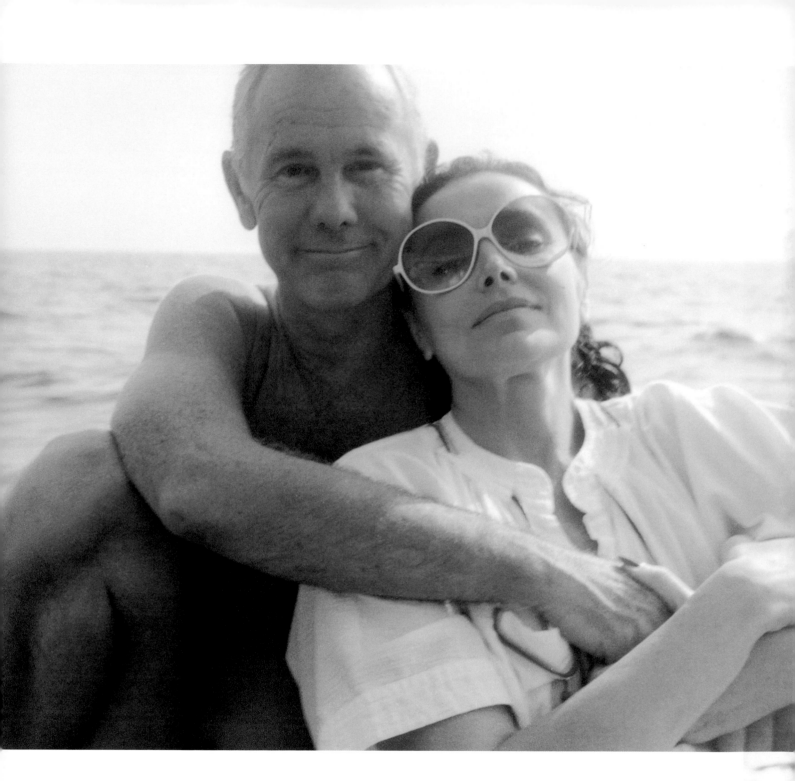

During Howard's last days Johnny Carson and his second wife Joanna came to stay, and we all went over to Capri, where she had some shopping to do. I delivered them both to the Countess Bismarck, who was thrilled, as her life was so removed from that of the common folk. She was delighted to meet so significant a figure in American culture as Johnny. The Carsons, who had been having marital problems, came to see me hoping that Ravello could erase their problems, but they were not erased until they returned to California, where they were promptly divorced. Apparently, Howard and I often had that effect on people.

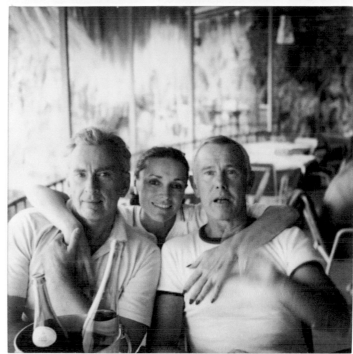

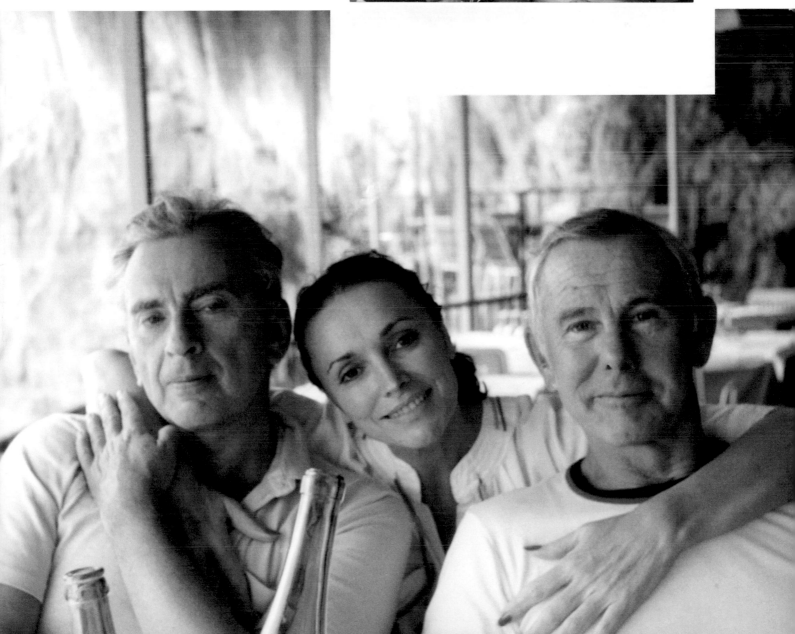

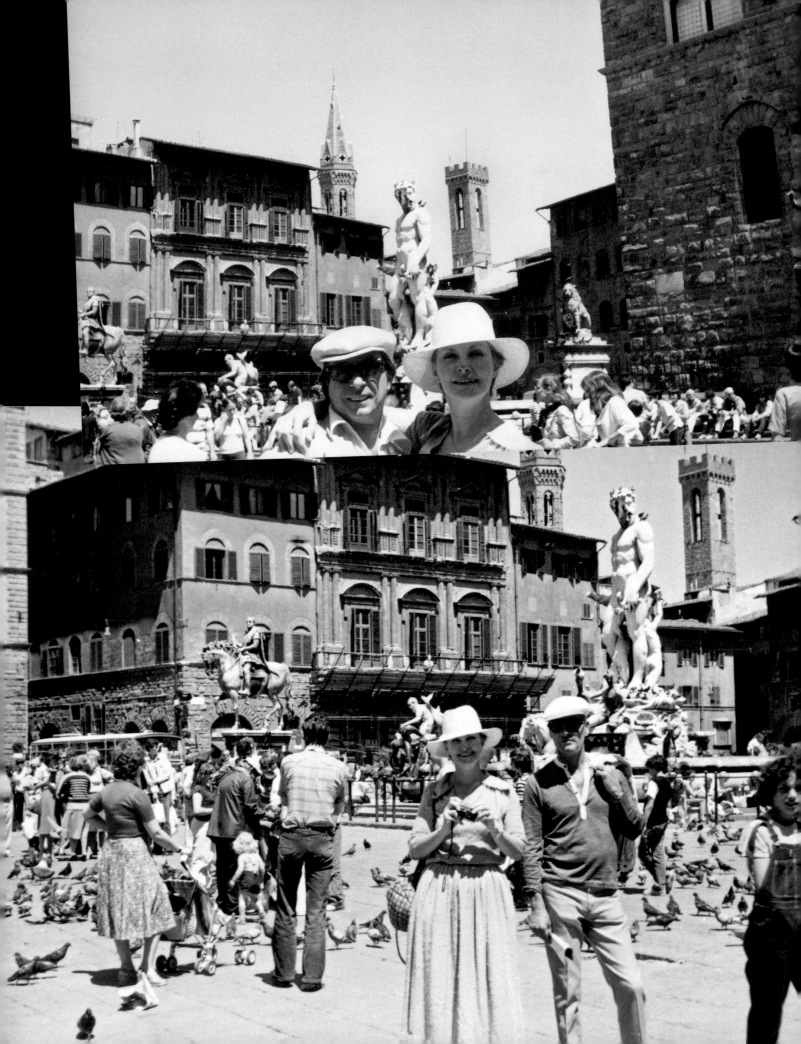

The great piazza in Florence, where Paul, Joanne, Howard, and I spent a happy week.

Welcoming the Newmans to the coast and sharing a boat
with them as we all approached the port of Amalfi.

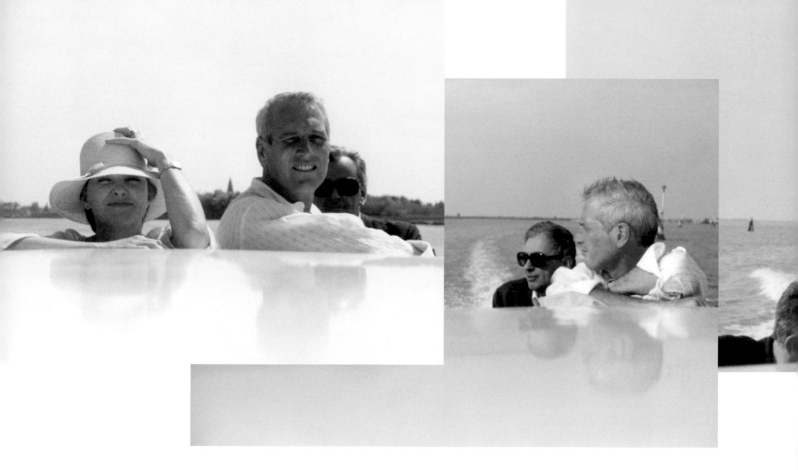

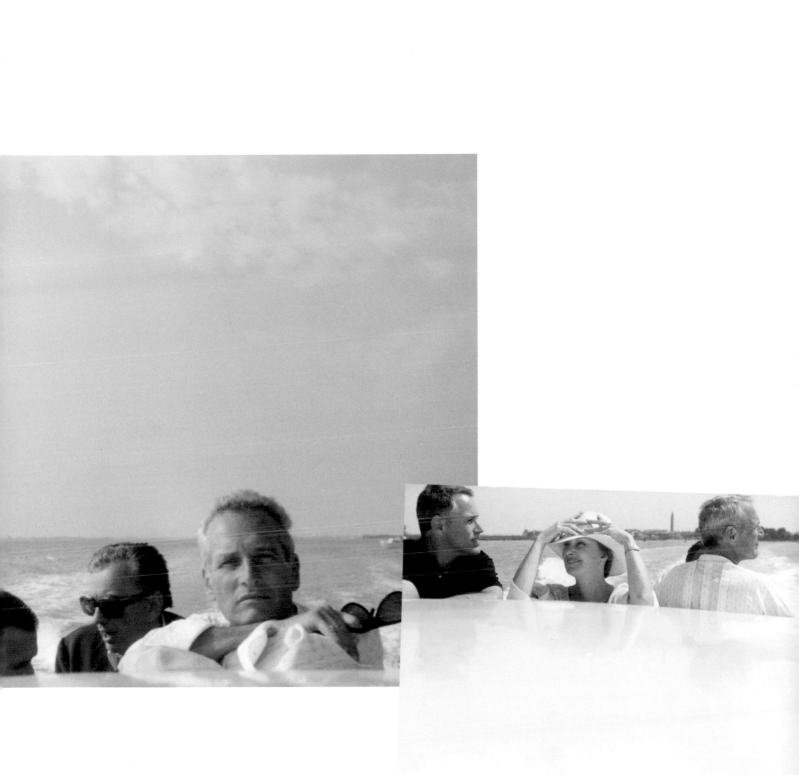

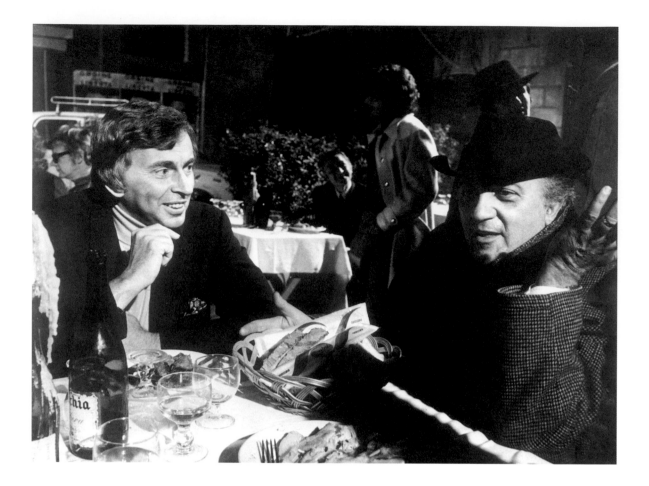

Once settled in Rome, and later, Ravello, I was drawn into the movie life of that still most creative of peninsulas. One day, Federico Fellini came to the flat in Via di Torre Argentina to ask me to appear as myself in a film he was making about Rome, which would star four people who could "live anywhere, but chose to live here." The "Romans" were Anna Magnani, who was, of course, a pure Roman by birth; Alberto Sordi, a wonderful comic Italian actor; Marcello Mastroianni; and, representing the foreign hordes within the city of which I am one, me.

Here is a snapshot of Fred and me in a small piazza that he is pretending is Trastevere (the Rome on the other side of the Tiber), during the summer festival of Noi Altri. The festival takes place in hot weather, but we were obliged to reenact it in Rome during the winter. I am seated at a table with Howard and two American friends; waiters come and go with huge plates of dead fish and other delicacies. Fred's idea of directing was to let us say anything we felt like saying, which he, carefully, did not record. After all, we were expected to come back half a year later to dub our voices ourselves. Meanwhile he was experimenting with the visual scene before him, and

in the midst of my principal aria I heard something rather like the Third World War behind me. Fred had added six white horses and a wagon to the background scene; this is how he built a scene as he went along.

Fred always called me Gorino, a diminutive I did not like, and I called him Fred, which I hope he did not like either. The film was to be called *Roma*, but then it was called, to trick all the plagiarists, *Fellini's Roma*. I worked with Fred again when I wrote the English version of a film he had made about Casanova with Donald Sutherland. He was endlessly inventive and, though my dislike of liars must be fairly obvious by now to the reader, his lies were so gloriously bizarre that I welcomed them rather more than any plain truth that he might be capable of. Since he began his career as a satiric cartoonist, the caricature was always present in his work, even inclusive in a secret book he was keeping about what is known in Italian slang as *cazzi*. In the draft of a book he has made, he does studies in ink of clearly labeled *cazzi* with such characterizations as "the happy cock," "the angry cock," and "the vicious cock," which he delighted in showing to innocent starlets, reveling in their screams.

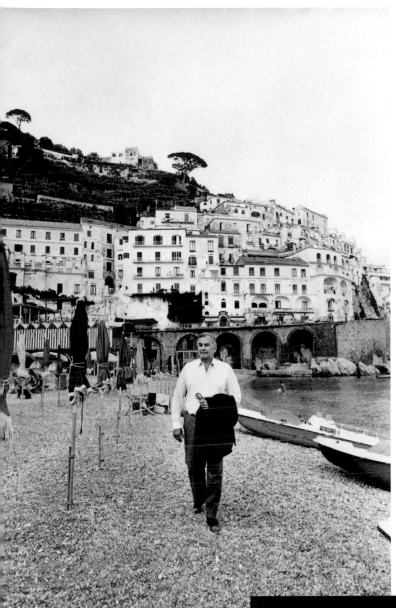

One season, to improve my Italian, I read all of Italo Calvino's published work in Italian. Then, one day in Rome as I was walking toward the Pantheon, the master, who also lived in the area, and I met and, finally, spoke. As I had written a long piece about him and his books in *The New York Review of Books*, he thanked me and I said I was perfectly honest when I wrote it—he was the only great writer in any language in my part of the twentieth century. It was wonderful knowing that he was alive and nearby and working. He lived between Rome and Paris. In youth, he had been political, briefly, in the Communist interest, but he later decided, wisely, that for his sort of writing, which was rather better than anyone else's of his generation, partisan politics was of no use. For those who would like to start reading him, there are good English translations of *Cosmicomics* and a story called "The Argentine Ant." We came to know him and his wife, Chichita, a vigorous keeper of the flame from Argentina whom he had got to know in Paris. I have written elsewhere about the extraordinary effect of the death of Calvino on the entire Italian peninsula, and I have described what it was like as I stood there while they poured the cement over his grave, only to find myself staring into his face, attached mysteriously to a man standing opposite; it turned out to be his brother.

Here I am at Edinburgh, fawning upon the only important English literary critic of my generation, V. S. Pritchett. We only met at our common club, and he was marvelous as he discussed the serious people in the bar of the Athenaeum.

My old friend Claire Bloom with her husband, actor Rod Steiger. Theirs was not an entirely happy marriage but it did provide the world with one Anna Steiger, a splendid diva who sings opera around the world.

The President and Mrs. Carter
request the pleasure of your company
at a reception to be held at
The White House
on Sunday, December 2, 1979
at five-thirty o'clock

Black Tie

An invitation from my cousin, President Jimmy Carter. Relations, on my side, were cold after the failed attack on Tehran, but warmed up considerably a year ago when we were all together in a Welsh castle. I had come to admire more and more his advice on foreign affairs during the era of America's very own Caligula, George W. Bush.

Sometimes returning from the United States to Italy I would stop off in Morocco to visit Paul Bowles. Paul was a splendid letter writer, I an unreliable one. Once or twice Howard and I would stop in Tangier, though neither of us liked anything about it. But then Paul didn't like anything about Italy, so our occasional visits to Tangier were the only opportunities I had of seeing what was, after all, one of my oldest friends.

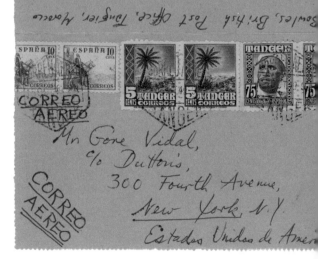

2117 Tanger Socco,
Tangier, Morocco.
14/viii/84

Dear Erog:

Writing the name caused an anagram to appear: Ergo. valid.

If the next book is entitled Truman, I can see you explaining to the same lavender mob in Venice: Not about Capote.

I just consulted the postmark on your recent letter: it's dated June 15, and I'd thought it was July, merely because it arrived in late July. So it dawdled for six weeks on its trip. Usually such wandering missives fall by the wayside, but the post is peculiar this year, and one can't foretell anything. Buffie, who has been here for two months, hadn't received anything until yesterday, when twelve letters were handed to her, mailed on various dates in June, July and August. She found this very upsetting, being only a part-time resident here and not having so far grasped the complete arbitrariness of everything official. She still imagines that logical questions bring logical answers which will pierce the curtain of mystery. But I think each summer she's a little more re-signed and confused. One difficulty is that she was here in 1938, and when she returned in 1982 she found that the later Morocco didn't meas-ure up to her memories of the colonial era.

I never met Montherlant; someone recently gave me a coffee-table book of his bullfight sketches.

Nice to be able to go back to God's country for brief tournées and then escape. I can't imagine myself doing it, but then, I'm considerably older, as I tell myself reassuringly. At least you see the place and know what it's like. But my last visit was in 1968, so I don't know what it's like (although I have my imagination to fall back on.) A meeting indeed, but where and when?

Anyway, all best, Lup

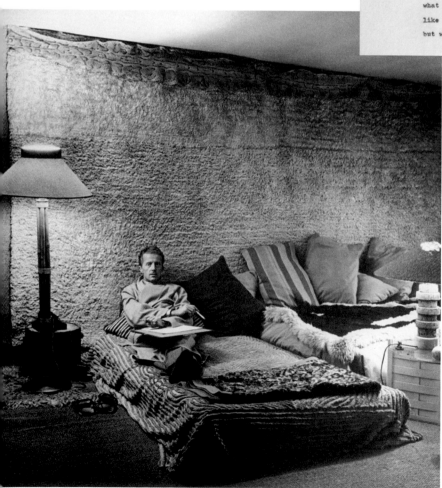

Bowles, British Post Office, Tangier, Morocco

Mr Gore Vidal,
c/o Dutton's,
300 Fourth Avenue,
New York, N.Y.
Estados Unidos de Ameri

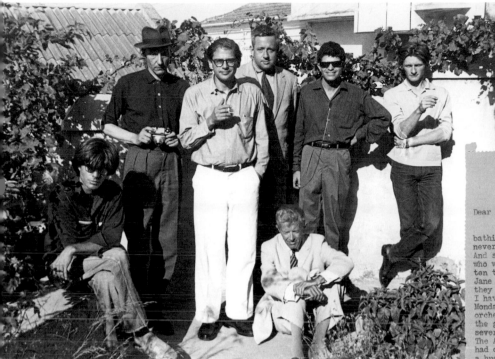

Dear Gore:

I started this, (the heading) this afternoon while sunbathing on the highest terrace of the house, which you would never recognize now. Then it got too hot and I got too lazy. And some old turbaned Arab arrived to gab with the masons who were building the stairway below and I was trying to listen to what they were saying, but I couldn't understand. Now Jane and Truman and Jack are out at Cecil Beaton's, where they seem to go every day at one time or another, but where I haven't been as yet. Although Truman gave a mad party on Monday night at the Caves of Hercules, with a large Arab orchestra, much champagne and hurricane lamps fainting in the gale. Themistocles passed out on hashish, after drinking several bottles of champagne. Cecil said; "How heavenly!" The Arab orchestra, plus porters and pussycats (Vidalese) had cases of Coca Cola. The sand sifted in and Truman found a huge centipede at his feet, nearly dying of horror. Well, actually it was a night of horror; everything went wrong. But I shan't tell about it for nothing. I could get good cash for a synopsis of that evening. At one point the place was in absolute darkness and bats wheeled about, just missing people's heads. Anyway, Tangier isn't the same now that Cecil is here, and, to make it still more interesting, Mary Oliver has returned from Paris. But you don't know her. Ask Touche about her, though. But he knew her years ago while she could still move. My Saharan novel came out today in London. Do you really want to go there? I shall be here I daresay. And we could take our time on the great trek. But we mustn't stay in Tangier at all,--the weather is too unreliable. Tennessee is already in New York, isn't he? Or, I mean Hollywood, whither he and Frank went the other day. Yes, Themistocles is still quite undug, pobrecito. He is about to go quite mad, seriously. Let me know more about your Sahara plans. I may go to London next month for a week or so, although I don't quite see the point, do you? The novel was chosen by the Evening Standard as its September Book of the Month. But Lehmann says that means nothing. Shall I hear from you one day soon? Luap sdnes tseb. Paul

Dear Gore:

Weather unbelievably beautiful these weeks; we are living in a rather fancy modern house called the Villa Mektoub, where Cecil Beaton stayed when he was here. Jane hates it, and has retaliated by having measles for the past ten days or more. Now she is over the reddish phase, but can't see. If and when she is well we are driving up into the Rif for a few days' proper convalescence. In ten more days we'll leave on the Djenne for Marseille. If only the weather holds! So far I've seen only two rave reviews of my book: one the one you mentioned and the other from The Observer (Sunday). Most of the others seemed respectful but puzzled. And one reviewed Prokosch's Storm and Echo along with mine, because they were both about trips in Africa. I must say that there I came out a little bit better than he did, although neither book called forth ecstatic noises from the reviewer. Our own house is about finished, or so we think. Allah doubtless knows otherwise and has already imparted His knowledge to Mohammed Ouezzani, our contractor, who, each time he goes to the place now, unmakes it a bit more, so that soon it will be back where it was in August. It's comforting to know that everyone is living in the Chelsea even in these troubled days. We lived there, on and off, for years beginning in 1936, and going on into 1943, although since October of that year I haven't spent a night within its precinct. I'm going to write Tenn this morning. By the first of December I ought to be en route back in this direction, UNLESS I take a boat to Ceylon and stay there three weeks or so, and then return here. I still have a mad desire to see that part of the world, even briefly. And how long will one be able to? Not long. So then. While one can one should. Tangier always amusing. As long as there's no rain. Rain here ghastly. I leave for Sahara at first drop. So would you, I think. But I'm not sure. Pussy conditions here enticing, really. Perhaps not for you in Sahara. So. Love. Paul

aul Bowles crouching in front. His attitudes toward same sexuality were as liberal as his attitudes toward *kif*, a drug much smoked by Moroccans, not to mention by Paul himself. Then, to the horror of his wife, Jane Bowles, an irritable but fastidious woman, when the Beats started their crusades to be noticed, they all came to Tangier to sit at the feet of her husband. Paul was, as always, pleasantly cool, while Jane detested the whole lot of them. Here is a batch of them assembling themselves around Bowles, their reluctant master. But they duly revered him, which was comforting during his late years. Paul tried to entice me with *mahzum*, a candy made out of hashish, but it never caught on with me. I still read out of fascination such works of his as *The Delicate Prey*. Burroughs, depicted here standing on the far left, owes, I think, a good deal to Paul. Although A. J. Connell of the Los Alamos Ranch School was perhaps a more devastating master to the young Burroughs, heir to a typewriter fortune.

Of the Beats, the only one whom I really liked and sometimes admired was Allen Ginsberg, standing second from the left, though I did suggest when he was very young and one of the worst poets that I ever read that he might be better off in advertising, for which he had a gift.

Truman Capote's imaginative babbling about people whom he barely knew or did not know at all delighted the press so much that on one occasion, after he had told a series of lies about me in a magazine called *Playgirl*, I, finally, had enough of his fantasies involving me and decided to sue him for libel, and I had clearly been libeled. (Incidentally, one of his first fantasies was an interesting if weird stealth of my life. He convinced many, many people that at the age of ten in the Louisiana swamps he had flown an airplane, which is what I had done, out of Washington, D.C.) Later, he had said in an interview with *Playgirl* that I had been picked up bodily by Bobby Kennedy and thrown out of the White House. The idea of Bobby Kennedy, a very small man, picking me up anywhere on earth is grotesque; in those days I was, and perhaps still am, six feet tall and weighed 220 pounds. And while it is true that Bobby and I had had a row, Truman would have had no idea what it was about, as he had no interest in politics, just gossip.

Truman, despite demurs to the contrary, was, thanks to my cautioning of Jackie, never invited to the White House, but his numerous fans felt that he *must* be there, if only in spirit. So he perpetrated a number of lies about how close he and Jackie had been before she got married to Jack. This, of course, in a period before he had even met her. She told of their first actual meeting; it was at a lunch party of a lady called Guest, where he sat next to her and proceeded to slander everybody not in the room, and then gave a melodramatic sigh and said, "Now you've seen me singing for my supper!" He was a figure of great glamour and tragedy in his own eyes. For the record, I said to Jackie, "Yes, you will enjoy his dreadful stories about everybody that you've ever heard of, but remember, if you get to know him you will eventually hear that he has told similar stories about you as well and you will not be pleased." As she was a wise woman, she never had him anywhere near her, and although his numerous journalistic fans believed that he was a constant figure at the White House, along with the ghost of Abraham Lincoln, he never visited there, according to Bill Walton, a Kennedy friend as well as mine, who kept careful track of such comings and goings.

During my lawsuit against him we had, unfortunately for me, the same shared publisher, Random House, which did not work very well as they were forever coming to me, with the exception of the noble Barbara Epstein, to ask me to desist because Truman was so ill, so sad, so broken, a broken reed in the swamp of literature. A lawyer who triumphantly told me at a dinner party that he had represented Capote when I made my "vicious" attack on him referred to my lawsuit as "silly." I did not regard it as silly to be depicted in a number of crude drawings by the press sailing out of the White House, with Bobby Kennedy visible in the corner. But for ambulance chasers any lawsuit that might mention their name is apt to be dismissed as such. In the final summing up of the case, Capote lost and I was persuaded not to ask for the million dollars that I knew he had. So, being lied to yet again, I said to my lawyer, Peter Morrison, "I'll settle for a letter of apology."

Gerald Clarke, in his surprisingly good biography of Capote, sheds some light on what finally happened. Why do I use the adverb surprisingly? Clarke knew when he started his book that Capote was a liar, so how could you trust anything he said about anybody? Clarke gets away with it most of the time, but he has to use Truman's euphemisms to describe what his subject had said in the *Playgirl* interview. Clarke writes, "Not untypically, Truman had embroidered events."

For the morbidly inclined, Capote's letter of apology to me, which I suspect is yet again a series of lies, can be found on page 520 of Clarke's biography.

LAW OFFICES OF

MORRISON, PAUL & BEILEY, P. C.

110 EAST 59TH STREET · NEW YORK 10022

AREA CODE 212-593-0100 · CABLE MORRPAUL
TELEX 640612

MIAMI OFFICE

PAUL, LANDY, BEILEY
& HARPER, P.A.
PENTHOUSE
PENINSULA FEDERAL BUILDING
MIAMI, FLORIDA 33131
(305) 358-9300

PETER H. MORRISON
ROBERT PAUL
BURTON A. LANDY *
STANLEY A. BEILEY *
MAX FOLKENFLIK

KEVIN T. ROVER
MARK V. JACKOWSKI
PAUL A. METSELAAR

*ADMITTED IN FLORIDA ONLY

December 22, 1983

Mr. Gore Vidal
21 Via de Toree Argentino
Rome, Italy

Re: <u>Vidal - Capote</u>

Dear Gore:

I enclose a copy of the letter which has been
signed by Truman Capote and proffered as a basis for
settlement. While I would prefer to delete the words
"from your representatives", I do not think it makes
a significant enough difference to turn it aside as
a basis for closing the matter. My recommendation is
that we accept it and put the matter behind us.

I look forward to hearing from you.

Very truly yours,

Peter H. Morrison

smk

Enclosure

Seasoned Greetings.
P.

209

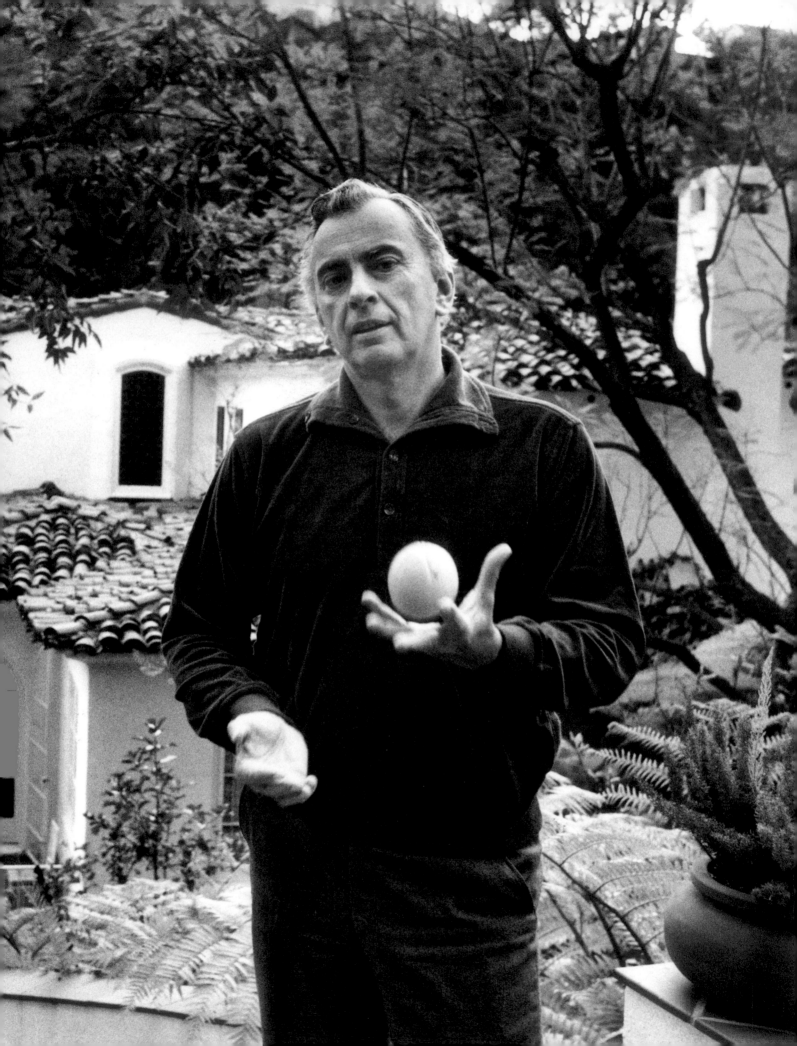

T he rise of the so-called neoconservatives, many of whom I had known in their liberal days, was a phenomenon I thought I should address from time to time, and I did. This was a troubled period politically in the country. Reagan was president, and liberalism, whatever that might be, was in retreat. During this time we began to fix up a house that I had long owned in the Hollywood Hills as a sort of refuge, as it was clearer and clearer that Howard's cancer was spreading and that we would both one day need a house closer to an American hospital than La Rondinaia.

Here I am in the Hollywood Hills, holding in one hand the bounty of my lemon crop.

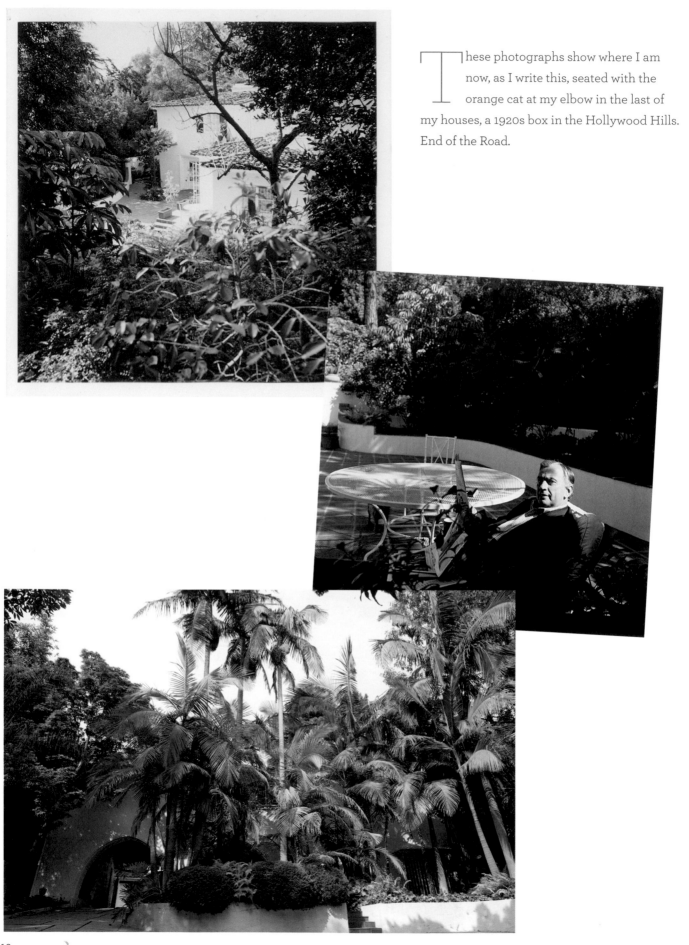

These photographs show where I am now, as I write this, seated with the orange cat at my elbow in the last of my houses, a 1920s box in the Hollywood Hills. End of the Road.

When Princess Margaret made her first trip to Hollywood, she came to see us. Like many British royals, she was fascinated by the place. A party was given for her by Kathleen Tynan, the second wife of Kenneth Tynan. In this picture Kathleen is in the back row next to the director Tony Richardson, with a batch of Tynan children; next to him is the princess, then me; I am resting my dark sunglasses on the shoulder of Jack Nicholson. Although Ken was the most famous drama critic of the English language, his season in Hollywood was less than successful. The Hollywoodians are not readers, and the fact of *who* he was carried no weight. As he said to me at the end of one evening, "I don't seem able to make much contact with these people. Why, they don't even bother to wait for me to stop stammering."

When Howard and I were not in the Hollywood Hills, we rented out our house. One disastrous tenant was a lady who not only failed to pay some forty thousand dollars of her rent but carefully tore out all of the beautiful French material that Diana Phipps had so lovingly put into place, room by room; the resulting barbaric mess achieved a certain rustic look that had been lacking before.

An idle lunch at the Hollywood house. Among those I now recognize are Howard, as well as birds of passage like Clive James, a sort of Leonardo da Vinci of television, and Diana Phipps, the latter two properly residents of London.

The studio at whose desk I wrote so much. At one point Diana Phipps came to help out with the furniture transplanted, along with ten thousand books, from Italy. She made this upstairs studio where I work a copy of Macaulay's studio a hundred years earlier. It is now mostly used by the eighteen-year-old surviving cat from Ravello, ever watchful to make sure that a current resident puppy does not crowd him.

The interested press is always with us, and here I am being interviewed by Mike Wallace for what I hope is the last time. We first performed together on his original program years earlier. He was famous for asking personal questions that made his subjects, often, burst into tears. Usually, I remained dry-eyed.

When things go badly, I often, if I can, get a job and turn to acting. This is what I did as my film *Caligula* was being made a mess of. Luckily, at that moment, Norman Lear was making his most brilliant television invention, a soap opera to end all soap operas called *Mary Hartman, Mary Hartman*. I play myself, a friend of Mary Hartman, who thinks he knows how to get her out of the loony bin. Louise Lasser, in the title role, was marvelously funny, which made it difficult to do scenes with her without breaking up in unsuitable laughter. She got us a nice laugh when she asked me, "What is a *caligula*?" and I said, "It's the Latin word for 'turkey,'" as it proved to be in real life.

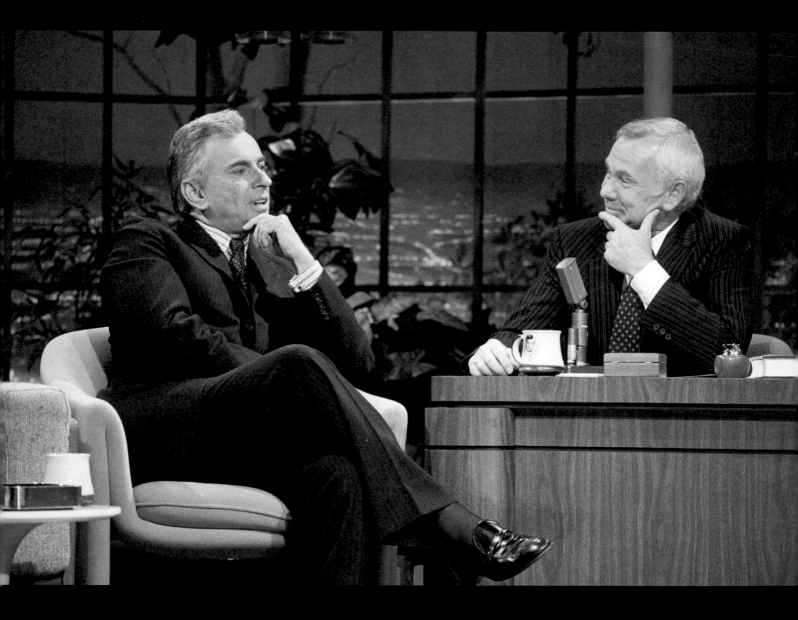

One of the last of countless programs that I did with Carson before his retirement. I was the only guest of Jack Paar, the previous host of *The Tonight Show*, that Carson kept, and we worked together comfortably for a decade or two. With great fanfare Carson finally retired, but not being a self-referential TV hack, he did not share with the audience the reason why he was leaving: He had been diagnosed with cancer. His various replacements have not, to say the least, measured up.

Carson was a complete master of his time on air, and he got the audience he wanted and the guests he wanted, but, as the years passed, occasionally a guest might very well not be what he had hoped for. When this occurred, he began to watch, obsessively, a great clock that was placed opposite his desk, as he tried to figure out how much more time he had left. Finally, a couple of joke-minded grips put the clock ahead midprogram, and Carson looked relieved when he checked the clock, as he knew that his stint was almost over; when he realized the prank, anger flared—he was always the absolute professional. His ultimate departure made everyone realize that without him there was nothing in the evening worth watching.

Of the television interviewers, Dick Cavett is one of the best. He likes to astonish you with a number of variations on your name; included is such a list. I particularly like "Evil Gorda."

Snapshots of Mailer and me in action on Cavett's program, where Cavett got the biggest laugh of his career when Mailer sneeringly said to him, "Why don't you go back to your question sheet and ask a question?" and Cavett, a master of the extempore, replied sweetly, "Why don't you take that sheet of paper and fold it five ways and shove it up to where the moon don't shine?" This brought down the house. Time to go. I was generally pretty protective of Mailer because I was fond of him, despite his outbursts against me, which had nothing to do with any reality at all. He was constantly trying to do things for which he was not suited, such as trying to one-up Dick Cavett. Like most great television performers, Dick Cavett knew how to take care of himself, and if anyone tried to step on his tail they would soon discover that it was a dragon's tail. I trust Norman learned this that night.

Mailer seemed to feel that once he got into the limelight on television or wherever everything would work out. We appeared together at a theater in New York before a large audience and, of course, he had done no preparation and just thought that to open his mouth and mumble a few words would be a performance. Halfway through I caught him in the wings and realized that he realized he was not carrying the audience. He had told a joke that he had thought was very funny and I thought it could have been, but he didn't know how to deliver it. So there I was in the wings explaining to him what is known in comedy, by some, as the three-way build. It's a matter of rhythm. You set up the joke, you give the audience a glimpse of what might be coming. They start to pay attention. The example I gave Mailer backstage: One: President Reagan's library burned down. Two: The tragedy was he had not finished coloring the second book. This gives you time for a very good payoff, in which I shall not indulge my readers. It's mechanical, but it works very well if you know what you're doing. He never did. But his strange appearances, often uninvited by the program that he was gracing, were not good for him, as he could be quite wise, but never, as the gods do not give us every gift, funny.

Some time after this frantic scene, Mailer rang me in Italy to see if I could come to Provincetown, where he was going to do a production of *Don Juan in Hell* by Shaw, with himself as Don Juan and me as the Devil, which we had done once before for the Actors Studio in New York. So I flew to Provincetown and we did our performance, with the enchanting Mrs. Mailer as Donna Anna. It was a pleasant time. And when we were done he saw me off in front of his brick house on the beach. A light rain was falling and, as I got into the taxi that would take me to Boston, he nicely saluted me, correctly, unlike those sloppy draft-dodger salutes that the forty-third president liked to inflict upon us. And, reflexively, I responded in kind. That was the last time I saw him.

In 1982 I entered the Democratic primary in a race for the U.S. Senate against the incumbent governor Jerry Brown, who wanted to transfer over to the U.S. Senate. As it turned out, Jerry defeated me, and a Mr. Wilson in the subsequent general election defeated Jerry.

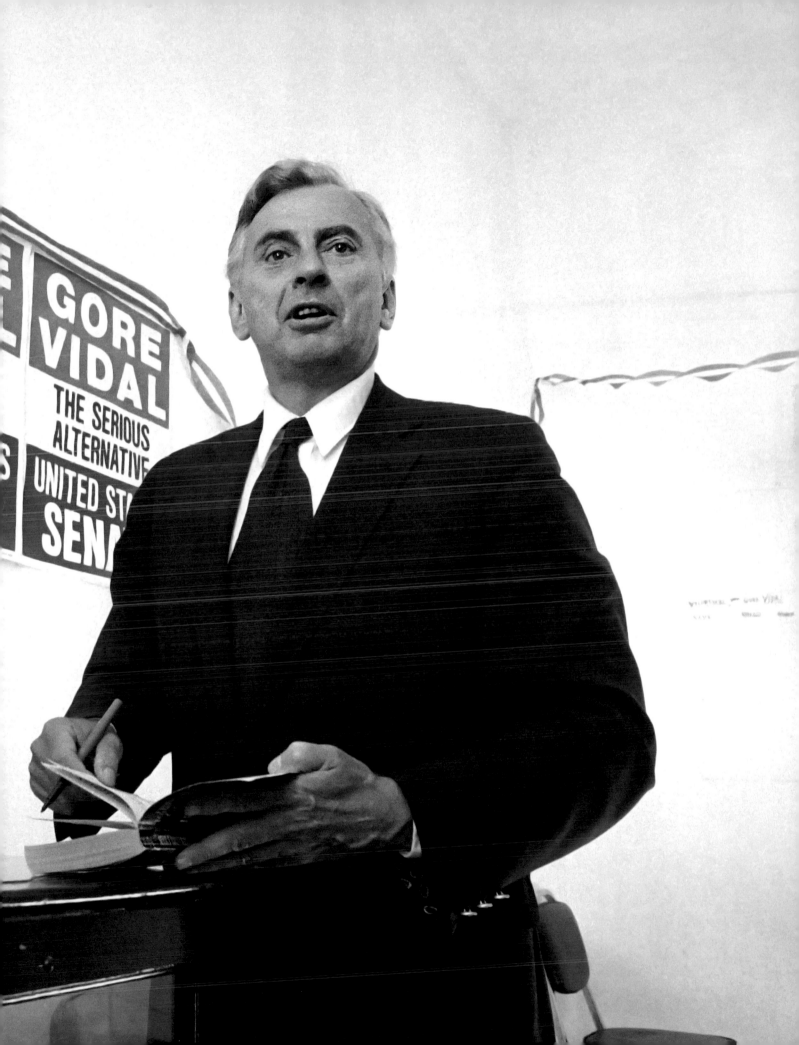

16 Part I/Thursday, June 10, 1982

California Returns

Statewide Races

U.S. Senate

99% Precincts Reporting

	Vote	Pct
Democratic		
Brown	1,352,179	51
Vidal	401,754	15
Carpenter	401,422	15
Whitehurst	158,872	6
Morgan	91,098	3
Metzger	73,987	3
Buchanan	53,891	2
Hampton	36,192	1
Caplette	30,887	1
Dubinsky Chote	29,767	1
Wertz	29,752	1
Republican		
Wilson	823,506	38
McCloskey	551,939	25
Goldwater	393,380	18
Dornan	176,050	8
Reagan	114,186	5
Schmitz	46,152	2
Bruinsma	36,178	2
Shockley	7,959	0
Cortes	7,775	0
Hickey	7,495	0
Booher	7,258	0
McDaniels	6,580	0
Pemberton	5,648	0
American Independent		
Dietrich	14,797	100
Peace and Freedom		
Wald	7,299	100
Libertarian		
Fuhrig	12,512	100

Governor

99% Precincts Reporting

	Vote	
Democratic		
Bradley	1,690,740	62
Garamendi	667,489	24
Obledo	127,594	5
Thomas	50,039	2
Parnell	44,718	2
Bagley	39,663	1
Abbott	26,479	1
Trevino	18,916	1
Marcus	15,645	1
Lienbenberg	14,932	1
Kimmett	14,911	1
Ramos	12,660	0

Secretary of State

99% Precincts Reporting

	Vote	%
Democratic		
Eu (inc.)	1,948,952	76
Smith	237,063	9
Keyser	191,462	7
Howard	177,419	7
Republican		
Duffy	1,038,713	48
Margosian	754,005	35
Rose	357,950	17
American Independent		
Smith	15,760	100
Peace and Freedom		
Taker	6,396	100
Libertarian		
Buerger	12,189	100

Controller

99% Precincts Reporting

	Vote	
Democratic		
Cory (inc.)	2,141,674	84
Clark	401,255	16
Republican		
Flournoy	678,143	37
Coombs	428,646	23
Speraw	251,608	14
Ware	193,199	11
Campbell	169,647	9
Bales	109,032	6
American Independent		
Graham	16,701	100
Peace and Freedom		
McDonald	6,852	100
Libertarian		
Gingell	12,652	100

Treasurer

99% Precincts Reporting

	Vote	
Democratic		
Unruh (inc.)	2,232,960	100
Republican		
French	693,832	41
Kazanjian	454,055	27
Lloyd	314,186	19
Stieringer	216,530	13

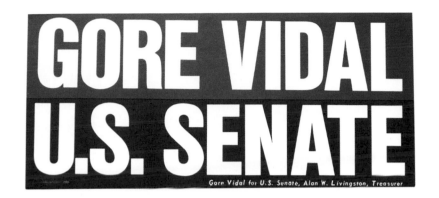

Gore Vidal for U.S. Senate, Alan W. Livingston, Treasurer

I highly recommend to anyone who wants to get to know the state of California a race for the Senate, because it's like running for office in an entire country. Also, from La Jolla to Santa Cruz there are extraordinary surprises in the way of flora and fauna.

ewis Calhern, a wonderful stage actor of my youth who was also successful in the movies, always said of his success in a medium so different from stage acting, "I manage quite well in most films. Whenever the other person starts to speak, I look at him in smiling disbelief; it does such wonders for the story, if not for the other actor."

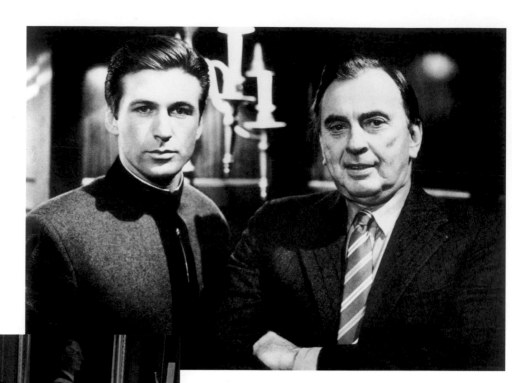

Of all the plays that I wrote for television, my favorite is *Dress Gray*, starring a then relatively unknown young actor, Alec Baldwin. Lucien K. Truscott IV, a direct descendant of Thomas Jefferson and himself a graduate of West Point, as were so many members of his family (not to mention of my own family, including my father, uncle, and two stepbrothers), wrote the original book, about a murder at West Point. The book was initially shunned by West Point graduates but, he tells me, once *Dress Gray*, the miniseries, aired on television, his phone lines were aflame with many an ancient general weeping to him for all that had been lost. I once discussed West Point with David Eisenhower, who, like myself, was born in West Point's cadet hospital and served as a civilian in the military. We were analyzing my father and his grandfather's code, which was "Duty, honor, country," and I said, "It's like a great family: You're born into it and they never let you go, no matter how much they may hate you for political reasons." He said, "No, I don't see it like that. I see it as a major religion, which they are stuck with and we are not." But I am stuck with it.

Here I am as the headmaster of a church school like Saint Albans, which I attended, as did my nephew Burr Steers, who wrote and directed a film called *Igby Goes Down*, in which he sweetly portrays me in relentless long shot. He has now done his second film, that great success *17 Again*. My great moment with cue cards came in *Igby Goes Down* when, in a crucial scene, my cue card was held by the star herself, Susan Sarandon.

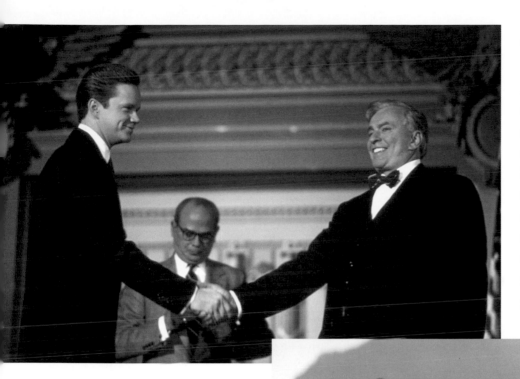

In this shot from the film *Bob Roberts*, I am in a scene with Bob Roberts himself, played by Tim Robbins, who also wrote, directed, produced, and catered. I worked without a script, at Tim's request, because he was intrigued by how lifelike we could make improvisation, as opposed to my being driven to reading off cue cards. Below I am in Arizona during the production of *Billy the Kid*, with a couple of wranglers. And below that a photograph of me as the villain— that is, a murderer in *Gattaca*.

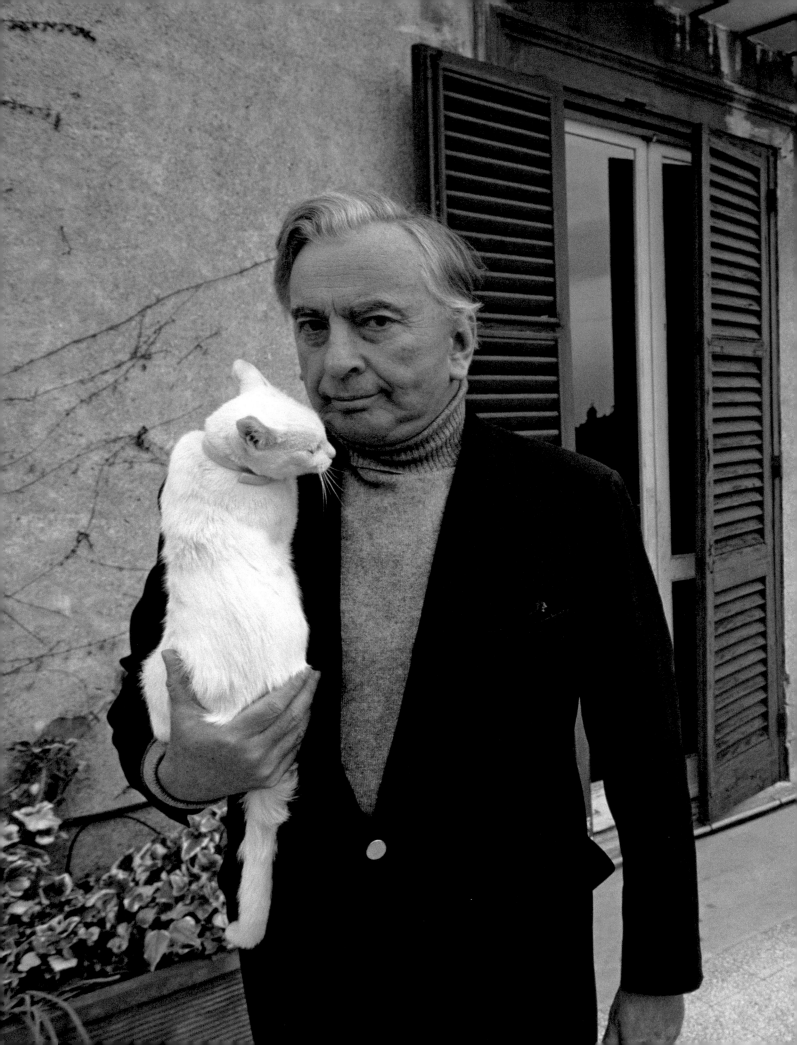

I n childhood days, more than once, at one or another school (and there were a lot of "another schools," thanks to my mother's restless disposition), in a gesture of comity, one boy or girl at the end of the semester would suggest to the class, fifty years hence (Washington kids are very much aware of epochs and of history), "Why don't we all meet together and see what has happened to us and to the nation?" Needless to say, no such ad hoc gathering ever took place concerning any of my schools that I know of. I was mildly curious about those of us at Exeter, while Saint Albans seemed as incoherent as life itself, and I had no desire ever again to set foot on the mesa called Otowi (and so did not). So much for school days.

On the terrace of the Rome flat. From the expression on my face, I seem to be in a disciplinary mood, but the white cat, as always, is in charge.

17 January 1985

Dear Gore,

Yes, we must do our best to outlive one another. The Egyptians think the dead man only retains 1/7 of the strength he knew when alive. Fearful for each of us to contemplate the other seven times stronger.

Let me tell you of one reluctant change PEN has made. We were going to have fifteen authors for ten evenings, five nights in the spring, five in the fall. Now, owing to theatre costs and a late start, we're down to eight evenings, all in the fall. The dates are September 22, October 6, 20, 27; November 10, 17; December 1, 15. Also, we are up to 16 authors, final. Of necessity, we must all share an evening. The likeliest and simplest form is an hour more or less to do whatever one wishes, then an intermission, then another author for the second hour. I hope this is to your taste. Frankly, it's not to mine--I would have enjoyed an evening to myself. There is, however, no choice, just logistics.

The next problem is to avoid egregious maneuvering. I'd like to draw the authors by lot, but given our tenuous truce, would rather offer you a perk. Do you have someone you'd like to go on with? Here, in alphabetical order, is the complete list of the others: Woody Allen, Saul Bellow, William F. Buckley, Joan Didion, John Irving, Norman Mailer, James Michener, Arthur Miller, I.B. Singer, Susan Sontag, William Styron, John Updike, Kurt Vonnegut, Eudora Welty, and Tom Wolfe.

Also, you suggest, "I'm not sure anyone will like the result" (of what you, G.V., will say). Fine. Be lugubrious, be scalding and appalling, be larger than Jeremiah. I will doubtless feel wistful at my pulled fangs.

Anyway, let me know if you have a preference for a stablemate, and for a particular date. (As I have always feared, I am now reduced to doggerel.)

Cheers,

The cast of *Don Juan in Hell* in Mailer's production at the Actors Studio in New York. We are, from left to right, Gay Talese, Susan Sontag, who played Donna Anna, Mailer, and me.

Mailer had a powerful Walter Mitty side to his nature. His first wife, a painter, told me that they had gone to a Picasso show together and he immediately determined that he could do as well as Picasso. As soon as they got home he began painting, and he kept at it all night. I said, "Well, was he as good as Picasso?" To which she replied, "No, but he was amazingly good."

Norman also realized, as we all did, that we were living in the age of the film director—which didn't bother me too much since I wrote films and occasionally enjoyed watching them—and, with his interest in power in all its forms, he saw the film director as a kind of paradigm in our society. As he had no experience at all of filmmaking, however, he had a sort of platonic, essential view of the moviemaking process. He made several interesting films out of his own head and from time to time he would corral some actors and other professionals to help him put out a film. The results were varied, to say the least.

At one point, he too crossed over into theater, and he talked me into appearing in a version of *Don Juan in Hell* by Shaw, in which he wanted me to play the part of the Devil, which is the best part—although Norman did not realize this until we actually had the play on its feet, as they say. For his last production of the play, he thought he would be happiest not only as director but also as Don Juan, and he asked me to again play the Devil, which I was delighted to do. This final performance was done at Provincetown, as I have already mentioned. I stayed with Norman and his wife Norris, a very bright and attractive woman, well suited to his moods. Overall the week was a pleasant one, though giving him line readings of the script proved difficult, and I thus discovered that whatever his histrionic gifts in life he had none of the instincts for the art of acting. But we slogged our way through the script and the Provincetown audience did not seem to be too distressed at the result.

Christopher Isherwood had a house on the edge of Santa Monica, close to the beach, as he was very much a beach personage, whether in Europe or in California. He would often invite old friends, passing through town, to dinner at his house—events that Howard and I sometimes attended. Seen here is a snapshot of Allen Ginsberg, me, and David Hockney at Christopher's last dinner party, as he was soon to die, ridiculously, of prostate cancer, of which he had been warned for a year or two; but, unfortunately, he then forgot to go back to the doctor. And so it spread. Last time I saw him he was in bed; I touched his forehead to find that it was icy cold. The engine was clearly running down. I had just come back from England and filled him in with what news of his old friends I thought would interest him. I suddenly found myself discussing politics and the maladministration of the Tories, in which many government surpluses were beginning to dwindle, a subject on which I unfortunately dilated. The word was that the British government was in some kind of economic trouble. We both marveled at that, because each had been aware of the discovery of oil in the North Sea, which was going to benefit everybody on the island. But, apparently, it did not, it was gone. "A nation of grasshoppers," I said pejoratively. His last words to me on this earth were as follows: "So what's wrong with grasshoppers?"

(Incidentally, David Hockney would leave Southern California soon after that last supper, despite his ownership of a beautiful studio in the Hollywood Hills. He left because he objected to the antismoking laws, which he regarded as a personal affront. And indeed they were intended to be just that for anyone who smoked, a vast group that never included me, as smoking was the one vice I had never taken up.)

I cannot think where this photograph of me with Lauren Bacall and Joan Didion was taken, but Betty—the real name of Bacall—was an old friend and Didion was a new one. If I were Truman Capote, I would invent several pages of witty dialogue for the two ladies, but I am not Capote.

Here I am in an advertisement for Absolut vodka, proving what a healthful elixir it is. The photograph was taken by Annie Liebovitz in something like twenty minutes, for which she deserves a Nobel Prize in Photography.

Kevin Spacey and I in a scene from the yet-to-be-released film *Shrink*. He wanted me to improvise my part, much as I had done in *Bob Roberts*, while he kept to his script as star of the film.

A picture from the cartoon saga *The Simpsons* on the occasion of a sort of literary salon presided over by a white suit.

Here I am with a very attractive dog who, in a cartoon series called *Family Guy*, has been deploring to me on air the dumbing down of talk shows, a sentiment with which I am absolutely in agreement.

GORE VIDAL
ABSOLUT DEFINITION

ne in a series of 20 portraits celebrating ABSOLUT VODKA's 20th anniversary.

GORE VIDAL
THE MEANING OF TIMOTHY McVEIGH

Americans were fed the story of Timothy McVeigh's trial and execution as a simple, unquestionable narrative: he was guilty, he was evil, and he acted largely alone. Gore Vidal's 1998 *Vanity Fair* essay on the erosion of the U.S. Bill of Rights caused McVeigh to begin a three-year correspondence with Vidal, prompting an examination of certain evidence that points to darker truths–a conspiracy willfully ignored by F.B.I. investigators, and a possible cover-up by a government waging a secret war on the liberty of its citizens

March 31, 2009

Dear Gore,

I have been fixin' to write* you for some time after seeing the New York production of "Terre Haute" by Edmund White. This turns out not to be such a good idea if you are interested in prompt correspondence. That was back in February.

Bill Noble and I disliked it, since it seems to be nothing but an autobiographical wet dream by Ed White, inflected with a lot of your language and well-known political views. There's probably not a thing I could tell you that you haven't already seen in it, but at least I will say the politics of it all was dismaying. It turned what was in real life an exchange of letters about imperial American policies and domestic violence into an apolitical confession of an aging European male's fascination with a conveniently caged hustler. Instead of the political implications of the Oklahoma City bombing, it became the latest installment of the American gay/same-sex/homosexual/queer/you name it soap opera, Why O Why can't us two guys get together? The disavowal in the program wasn't persuasive: "the writer, a fierce defender of civil liberties, honesty and transparency in government...becoming more and more involved with the handsome, isolated and virginal prisoner." The closeted love scenes were right up there with twenty-eight young men and all so beautiful, with that woman's hand passing unseen over their glistening, friendly bodies. The actor who played you (Peter Eyre) was good—with a British accent, of course, to convey sophistication—but the young one who played McVeigh (Nick Westrate) was stuck in one mode, scream and rant, *sempre fortissimo crescendo*. I'll say in his favor that he looked unhappy in the part, probably relieved when the performance was over.

As were we. I hope this letter finds you in the best of health and spirits. I called some time ago but you were just getting back from a long trip and I didn't want to call back then. Since then I've taught probably my last student, supervising a thesis on imagining Petronius in 20th century literature and film ("Quo Vadis, Arbiter?"—as in Quo Vadis, Domine?) and that seems fine by me. Chicago is publishing my next book next spring, one I wrote with a mutual friend and former colleague of Jay's, Bill Cook. We completed it last year, mostly, before he had a stroke, and I've been looking after him and his affairs ever since. The title has no gerund and no colon, *African American Writers and Classical Tradition*.

I'll try to call you in a week or so to say hello. I hope to get to LA in the not too distant future. I hope your Romanitas flourishes.

[signature]

* Old High Texan Imperfect Future Progressive Incomplete.

A professor friend at Dartmouth, James Tatum, sent me the following letter after he saw a play called *Terre Haute* by Edmund White, a truly dismal writer, always on the attack. Mr. White had the bizarre idea of inventing a love affair between me and Timothy McVeigh, who had blown up a federal building in Oklahoma City. From death row McVeigh had written a number of letters to me on political subjects as well as constitutional ones, such as the Posse Comitatus Act. To a writer of advanced years, the idea that another writer, working only with his imagination and bad prose, would invent a play based upon an imaginary love affair between me and the murderer Timothy McVeigh was horrifying; this was tried out at Edinburgh and I certainly tried to stop it. I don't think that living people should be involved in fictional stories, and particularly nothing like this; White was drawing on the subject to which he likes to advert, the passion of certain writers for violent action and murder, listing Capote, Mailer, and me, yet I am not drawn to such things. When McVeigh began to write to me, out of the blue, our subjects were mostly constitutional. Sex was never mentioned and we never met. He did ask me to come as witness to his execution by the state in Terre Haute, Indiana, but as I am not a necrophile, I did not want to go. According to Professor Tatum's letter, the part of me was played by that excellent actor Peter Eyre and I would not have minded to be a fly for a moment on that wall to see how he dealt with it.

234

A cartoon of Updike and me and Roth, writers who were writing dirty books that year and thus losing their immortal souls at the *Ladies Home Companion. Good authors, too, who once knew better words / Now use only four-letter words / Writing prose / Anything goes*, from "Anything Goes," by Cole Porter, was the press's witty notion to explain our joint transgression.

PLAYBILL

VIRGINIA THEATRE

GORE VIDAL*S THE BEST MAN

WWW.PLAYBILL.COM

Many years after the premiere of *The Best Man* on Broadway it was revived, again on Broadway, and was as big a success, unchanged, as it had been the first time.

POLITICS

GORE AND PEACE
Gore Vidal, a native of Washington, the grandson of a U.S. senator, and a frequent critic of an American empire run amok.

WASHINGTON, WE HAVE A PROBLEM

The author's political wit and wisdom have drawn raves on Broadway, with *The Best Man*, and from readers of his latest book, *The Golden Age*. Now he has a few things to say to the president-elect. Number one: Take back the Pentagon, before it destroys America

BY GORE VIDAL

...ratulations, Mr President-Elect. Like everyone ..., I'm eagerly looking forward to your inaugural ...ress. As you must know by now, we could nev-... your speeches during the recent election in ...an won, as he always does in what Spiro Agnew ...d "the greatest nation in the country"

...first speech to us as president, I hope you don't ... few suggestions, much as I used to do in the ... my regular States of the Union roundups on ... TV show of blessed memory Right off, it strikes ... beginning may be a good place to admit that for ... we have been waging what the historian Charles

A. Beard so neatly termed "perpetual war for perpetual peace."

It is my impression, Mr. President-Elect, that most Americans want our economy converted from war to peace. Naturally, we still want to stand tall. We also don't want any of our tax money wasted on health care because that would be Communism, which we all abhor But we would like some of our tax dollars spent on education. Remember what you said in your terminal debate with your opponent, now so much charred and crumbling toast? "Education is the key to the new millennium." (Actually, looking at my notes, all four of you said that.)

In any case, it is time we abandon our generally unappreciated role as world policeman, currently wasting Colombia, source of sa-

ILLUSTRATION BY RISKO DECEMBER 2000

As I had often declared that I would never go in for autobiography, I immediately sat down and wrote one called *Palimpsest*, a difficult title that I thought, incorrectly, would ensure a small readership. At least its narrative was not as off-putting as the memoir that Paul Bowles wrote for a publisher, *Without Stopping*, using only notations from his address book and a calendar.

I collected a lifetime series of essays in a volume called *United States*, based not upon the greatest nation in the history of the human imagination, but, on as I explained in the volume's preface, various states of my own being: one, state of the art; another, state of the union; and another still, state of being.

As American politics got more and more crazed and I was not up to writing essays on the subject, I thought I would go back to the beginning of the republic and write short books like *Perpetual War for Perpetual Peace* in order to make political argument. These pamphlets, as I call them, proved to be reasonably popular.

Susan Sarandon and I with my godson, Miles, one of her sons by Tim Robbins. We are in the swimming pool that Howard and I installed at Ravello, which, above all else, I wish I had access to in the tropical heat of Southern California. Susan began her extraordinary career as an actress by appearing in a play of mine on Broadway called *An Evening with Richard Nixon*. In this play she acted a number of parts, one of them Martha Mitchell, the slightly crazed wife of the attorney general John Mitchell. As I write these lines, she has rung me to say that she is again on Broadway, in Ionesco's play *Exit the King*. I once asked a famous, somewhat elderly actor how he found employment in his old age, and he said, "Well, the best thing is that I now get to play the king, which means there is always a throne nearby and I can sit down."

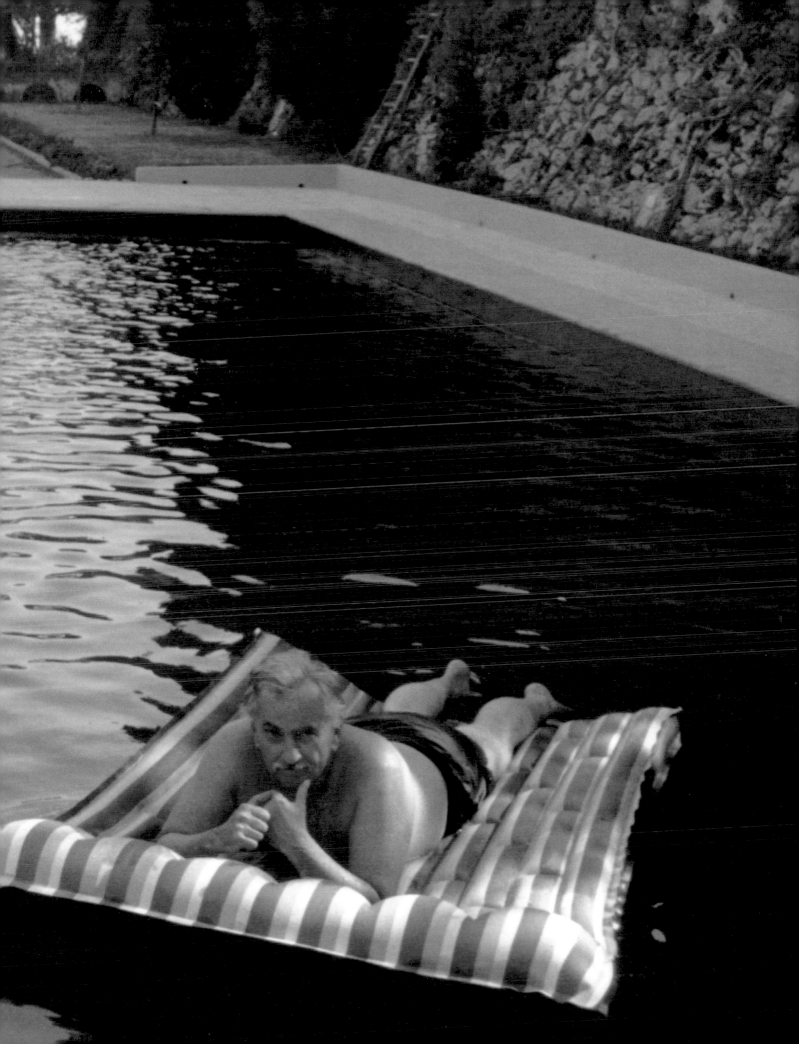

On the cliff overlooking Amalfi, one of the last evenings at Ravello before Howard died. Susan and Tim were staying in the house and attracted, as you can see, Sting and his wife, Trudie, Bruce Springsteen and his wife, Patti Scialfa, and others. That summer night was dedicated to music in honor of Howard, who sang.

Dennis Hopper, whom I have known since he was, I think, a teenager, at which point he was already a very interesting actor. One night at Malibu, when Dennis decided to talk dirty in front of my sister, Newman and I picked him up off the beach and threw him into the Pacific. He later revealed himself as a gifted painter and photographer (not as a result of being thrown into the Pacific).

ellow Virginian Shirley MacLaine and I. She comes from Arlington, which is near Fairfax, where I came from. We grew up a few miles from each other. I always liked to see her in our galaxy.

enny Bernstein and I had been discussing, at Ravello, the possibility of my doing a new libretto for his musical about the White House. His attention has apparently strayed, as he seems now to be discussing a future face-lift.

Susan Sarandon, Howard, and I with her sons, Miles and Henry, and her daughter, Eva.

The lady in white is the witty Mrs. Bentsen,
wife of Clinton's secretary of the Treasury.
Also pictured are Hillary, first lady and
senator- and secretary of state–to-be, and me, with
DiMartini, the mayor of Ravello. We are about
to make Hillary, all of us politicos of the region, an
honorary citizen of Ravello, which, by now, if she
had played her cards right, she might have become
the mayor of. She had abandoned the president in
Naples, where he was attending a G7 meeting,
as she preferred to visit Howard and me at La
Rondinaia, which she did with her mother, the
extraordinary Mrs. Rodham, a magnificent New
Dealer from the 1930s, and her daughter, I
trust yet another *magnifica*.

In the year 2006 I received an invitation from
one of my numerous Swiss cousins, a famous
sculptor, to visit him in the Engadin. As I had
never known anything about several thousand
cousins living in the valley of the Engadin, I was
delighted to meet them all. On the occasion of my
arrival, there was a festival, presided over by the
mayor of Sent, with a brass band playing and much
of the female population in folklore costumes. At
the peak of the ceremony, here I am with the mayor
of Sent, our native town, as well as the Italian
ambassador to Switzerland and other officials.

Col. Robin Olds of the Eighth Tactical Fighter Wing with subordinate officers on returning from his 100th mission over North Vietnam.

Robin Olds, 84, Fighter Ace; Hero of Big Vietnam Battle

By DOUGLAS MARTIN

Brig. Gen. Robin Olds, a World War II fighter ace who became an aviation legend by commanding the Air Force wing that shot down seven MIGs over North Vietnam in the biggest air battle of the Vietnam War, died last Thursday at his home in Steamboat Springs, Colo. He was 84.

The Air Force said the cause was congestive heart failure. He had earlier been treated for prostate cancer.

General Olds, who in the course of a long career flew 65 kinds of military planes, almost perfectly filled the role of hotshot flier. Piloting P-38 Lightnings and P-51 Mustangs, he shot down 12 planes during World War II. In Vietnam, he led the Eighth Tactical Fighter Wing, which scored 24 such kills, an unsurpassed total for that conflict.

In all, he downed 16 enemy aircraft in the two wars, making him a triple ace. (Five kills are needed to become an ace.) And when he could not wrangle a combat assignment in the Korean War, he participated in transcontinental jet races and flew with the Air Force's first aerobatic demonstration team.

Adding to his glamorous image, General Olds was a former all-American football player at West Point

How 'Operation Bolo' trapped seven MIGs over Vietnam.

and the husband of a movie star, Ella Raines. In a gesture of individuality, he grew an enormous, meticulously waxed handlebar mustache. And even as a commanding officer, he made a point of placing himself on the flight schedule as a rookie pilot under officers his junior.

But his greatest moment came on Jan. 2, 1967, when, as a colonel, he created an aerial trap for enemy MIGs. Called Operation Bolo, the trap entailed use of radar-jamming devices and other tactics to make faster, more maneuverable F-4s appear to be the slower F-105s used for bombing missions. When the MIGs responded by attacking what seemed to be F-105s, the F-4s downed seven of them.

"The MIGs reacted as we had hoped," Colonel Olds, who had led the mission himself, told a news conference in Saigon shortly afterward. "To make a wonderfully long story short, they lost."

The New York Times that May called him "everybody's choice as the hottest pilot of the Vietnam War," and last year the History Channel televised a computer animation, complete with his commentary, of his big Vietnam battle.

General Olds went on to serve in many countries and positions, including assignments to Air Force headquarters and the Joint Chiefs of Staff. From 1967 to 1971, he was commandant of cadets at the Air Force Academy.

At a time when the Air Force was focused on nuclear strategy, General Olds argued for strengthening conventional warfare capabilities. "Throughout his career, he was a staunch advocate for better fighters, better pilot training and new tactics, culminating in the war-winning air-to-air tactics and doctrine of surgical precision bombing that we use today," Gen. T. Michael Moseley, Air Force chief of staff, said in a statement after General Olds's death.

Robin Olds was born on July 14, 1922, in Honolulu. His mother, Eloise, died when he was 4. His father, Maj. Gen. Robert Olds, a World War I combat pilot who helped devise the United States' air-power strategy, reared him as a single parent.

Robin first flew at age 8 in an open-cockpit biplane operated by his father. At 12, he vowed to attend West Point, where he hoped to play football and begin the path to becoming a military aviator. He did win admission, and played for the renowned coach Red Blaik, compiling so stellar a record as a tackle on both offense and defense that in 1985 he was inducted into the College Football Hall of Fame.

He was commissioned on June 1, 1943, and completed his pilot training later that year. He was assigned to the European theater, where he flew 107 missions and was credited with destruction of 11¼ aircraft on the ground — another pilot assisted in destroying one of them — in addition to the dozen he shot from the sky.

After World War II, General Olds became one of the first Air Force pilots to fly jets. But partly because his manner of defiant individualism was a thorn in the side of superiors, he was unsuccessful in efforts to be assigned to Korea, and did not return to combat for 22 years.

General Olds received many medals, including the Air Force Cross, the branch's second-highest decoration. He pointed out on occasion that he had never received a Purple Heart, but he did come close.

In March 1967, he led a strike against a steelworks in North Vietnam. He was flying so low, he said in an interview that year, that it seemed the gunners on roofs were shooting down at him. An enemy round tore a hole the size of a basketball in his right wing, but the fire went out and he made it home.

For a brief time his father was married to Nina Gore Auchincloss, making General Olds a stepbrother of the writer Gore Vidal. His first wife, Miss Raines, a favorite pinup girl of the era, died in 1988. A later marriage, to Morgan Olds, ended in divorce. He is survived by two daughters, Christina Olds of Vail, Colo., and Susan Scott-Risner of North Bend, Wash.; a half-brother, Fred Olds of Virginia Beach; and a granddaughter, Jennifer Newman of Santa Monica, Calif.

General Olds once said his magnificent mustache represented his defiance. It lasted until, as a colonel, he went to Washington after his service in Vietnam to meet the Air Force chief of staff, Gen. John P. McConnell. General McConnell stuck a finger under Colonel Olds's nose and commanded, "Take it off."

The New York Times, as a self-styled newspaper of record, recently published the following obituary of fighter pilot Robin Olds, who won great renown during the three wars in which he elected to serve: World War II, Korea, and Vietnam. I remember seeing my future stepbrother when Nina's longtime gentleman friend Major General Robert Olds dropped by on a hot summer day with two very large West Point cadets. The young men had not yet graduated from the academy, where Robin was an All-America quarterback, much as my father had been back in 1917. Robin was eager to serve and proved in his career to be the most formidable ace in the short history of the U.S. Air Force.

After World War II, he used his acedom as a fighter pilot to go—at his request—fight first in Korea, and then again in Vietnam. Finally, his superiors thought he was of such propaganda value that when it came time to create the Air Force Academy, he was chosen as first commandant of cadets, where he became somewhat notorious for holding the cadets in on weekends to look at his aerial combat shots. Part of his running commentary at the time was, "Vietnam is not much of a war, but it's the only war we've got." He also had a running commentary on the irony of becoming stepbrother to Gore Vidal, an enemy of the only war we've got.

The usual ending to a story like Robin's is at Arlington. But what made him such a standout in the U.S. Air Force were his reenlistments. I will now call upon *The New York Times* to illuminate, in its own luminous prose, what Keats would have called Robin's cloudy trophies.

oward and I playing one of the thousand backgammon games we played over the years in Ravello, from which we left early one morning, as his cancer had worsened to such an extent that he could no longer travel on an ordinary standard-air-pressure plane. We hired a private jet to fly us back to Los Angeles. On the table below is the orange cat, who, in the way that cats know when you are leaving, reminded us to take him with us, and we did.

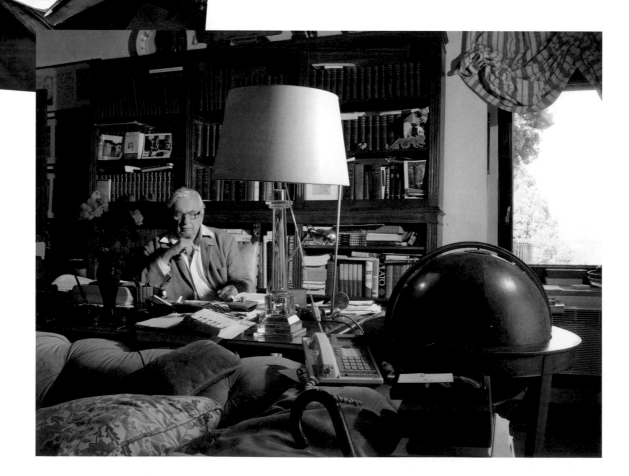

Howard and I
pose in the villa.

Rudolph Nureyev had come to the villa
to say good-bye. He was in a melan-
choly mood. He did not want to leave
his island but AIDS was rapidly killing him and
he needed a major American hospital where his
blood could be changed from time to time;
usually, on his island, a doctor from Paris would
fly in to change his blood, lengthening his life.
He told droll stories about his collapsing career
in America, where each tour was shorter than
the last; worse, equally shrunken were the
number of musicians who could travel with
him. During this time he was reading about the
life of Oscar Wilde, whose last tour often
followed the same route as Rudy's: "We both
liked Lubbock, Texas."

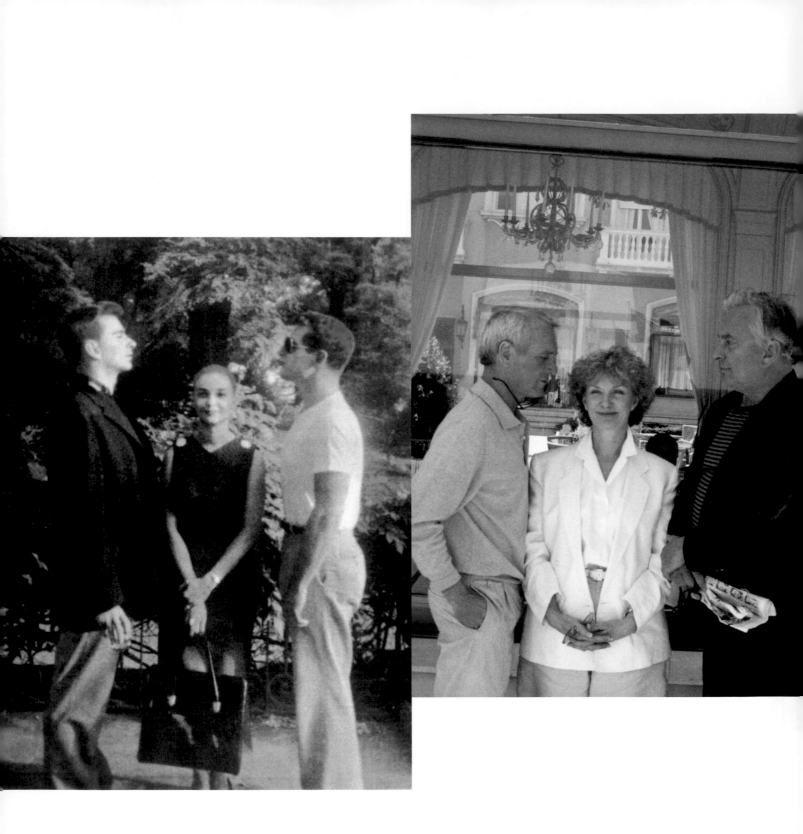

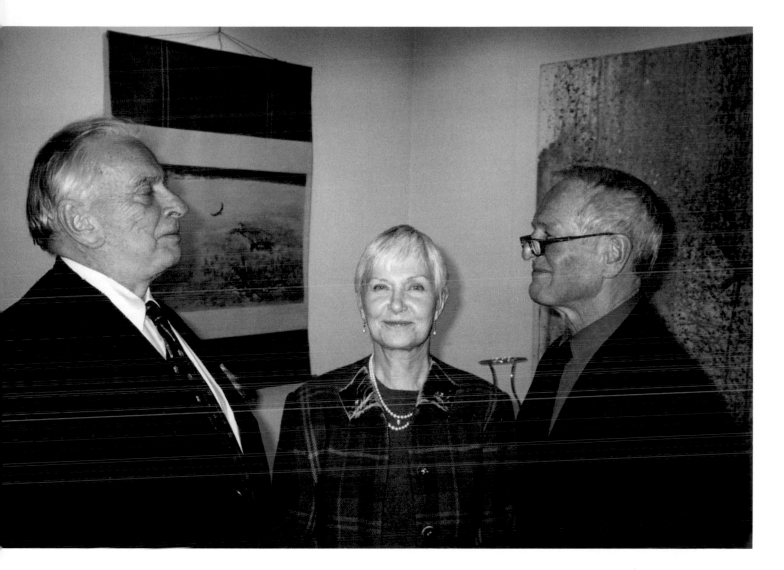

Three family pictures of the Newmans and me. The first is when they were about to be married and the final is when we are recalling those merry days of youth. Time is getting short. At least Paul chose his time of departure. He had missed an appointment with the doctors for chemotherapy, and when Joanne reminded him the next morning that he had an appointment to go back, he said, firmly, "I am never going back." And so he died on his own terms, without undergoing the dreaded chemotherapy.

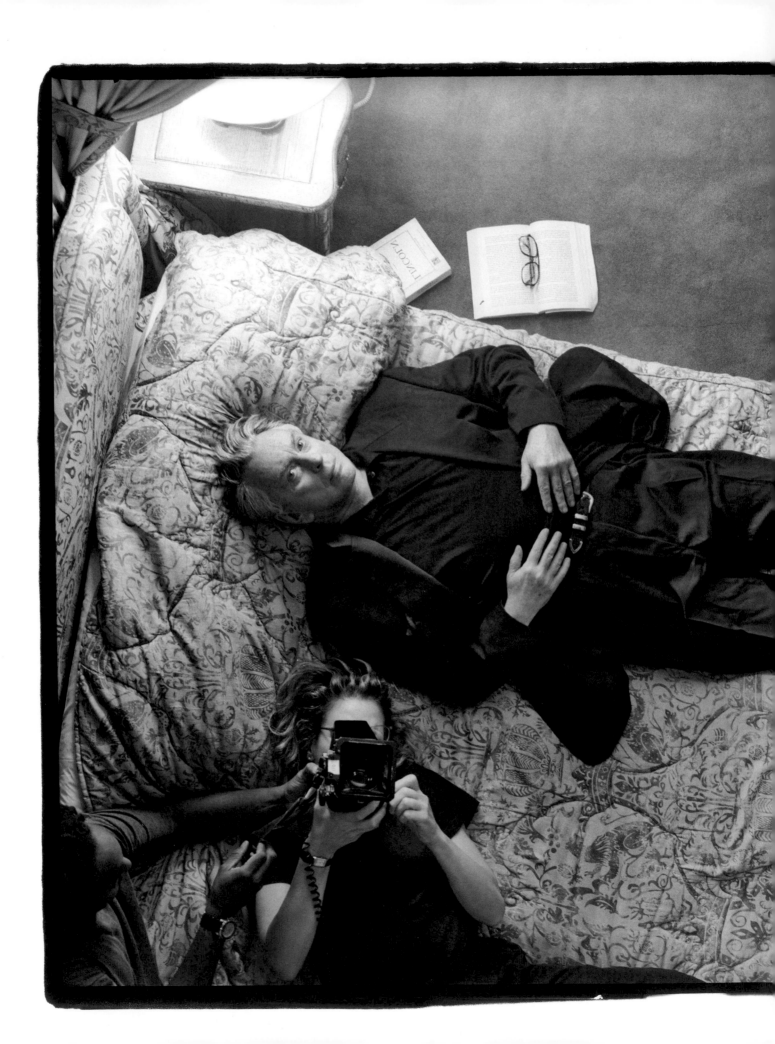

A possible masterpiece of Annie Liebovitz's. The one who was so often photographed is plainly dead. And now let us go to where he will be interred, in Rock Creek Cemetery. As you will see, Howard is already in place, and I not.

I see that this book is now at an end. There is no more tale to be told. So what better way to dramatize the ending of a picture book than with a picture of the statue that Henry Adams ordered to be made and put over the spot in Rock Creek Cemetery where his wife Clover and, soon thereafter, he himself were buried. Howard and I also have a common grave there, which he now occupies, sad to say, if not to be. For the record, speaking as a sort of tour guide for my section of the twentieth and twenty-first centuries, the only truly beautiful thing in the capital of our country is Rock Creek Cemetery. Here many of the nation's founders, among them the Gores of Maryland and others from Virginia, are buried. Not far from Howard and one day, me, are Alice Roosevelt Longworth, a great wit, and George McGovern's wife, Eleanor. George has transferred himself from Arlington where, as an American hero in World War II, he was in demand, choosing to one day join us in the cemetery out of loyalty to his daughter and wife. I recommend that any of the readers who can get to Washington, D.C. go see the monument of grief commissioned by Henry Adams and sit opposite it in the semicircular seat where Mrs. Roosevelt, whenever she was undergoing troubles in her stormy early marriage with Franklin Roosevelt, would go for consolation. She is a very good ghost to have in our cemetery.

The publisher would like to thank Richard Morris at Janklow & Nesbit Associates
for helping make this book possible.

Editor: Deborah Aaronson
Designer: Sarah Gifford
Creative Consultant: Kevin Kwan
Production Manager: Jules Thomson
Editorial Assistance to Gore Vidal: Daren Simkin
Image Research Assistance: Alexis Dinniman, Erika Frankel, and Rose Meacham

Library of Congress Cataloging-in-Publication Data

Vidal, Gore, 1925-
 Gore Vidal : snapshots in history's glare / by Gore Vidal.
 p. cm.
 ISBN 978-0-8109-5049-8
 1. Vidal, Gore, 1925- 2. Authors, American—20th century—Biography.
I.
Title.
 PS3543.I26Z47 2009
 818.5409—dc22
 [B]

 2009018741

Printed and bound in the United States
10 9 8 7 6 5 4 3 2 1

Abrams books are available at special discounts when purchased in
quantity for premiums and promotions as well as fundraising or
educational use. Special editions can also be created to specification.
For details, contact specialmarkets@abramsbooks.com, or the address below.

115 West 18th Street
New York, NY 10011
www.abramsbooks.com

Index

Image Credits

ABC News VideoSource: Pages 170–171.

© Jihan Abdalla Photography/By permission of *Shrink* LLC: Page 232 (top).

Collection Steven Abbott/Copy work by D. James Dee: Pages 66 (top left), 67 (bottom left), 150, 175 (top left; top center; bottom center), 236 (bottom center), 237 (top center; bottom center).

The Carl Albert Center, Congressional Archives, University of Oklahoma: Page 45.

A.P. Images: Pages 114 (top left), 119 (top left), 122 (top), 202.

Herb Ball/NBCU/A.P. Images: Page 218.

Ron Frehm/A.P. Images: Page 230 (left).

Courtesy of the Estate of Nathaniel G. Benchley/By permission of the Houghton Library, Harvard University: Page 133 (bottom).

Billy Rose Theatre Division, The New York Public Library for the Performing Arts, Astor, Lenox and Tilden Foundations: Pages 19 (top right; bottom right), 91 (center), 141 (bottom left).

Friedman-Abeles/Billy Rose Theatre Division, The New York Public Library for the Performing Arts, Astor, Lenox and Tilden Foundations: Pages 132 (top), 141 (top).

David Workman/Billy Rose Theatre Division, The New York Public Library for the Performing Arts, Astor, Lenox and Tilden Foundations: Pages 138–139.

Bison Archives-Marc Wanamaker: Pages 87, 88.

© Karl Bissinger: Pages 74–75, 98.

Copyright © 1949 and © 1984 by the Estate of Paul Bowles, used with permission of The Wylie Agency, LLC./By permission of the Houghton Library, Harvard University: Pages 206 (top; bottom right), 207 (center; bottom right).

© Robert Emmett Bright and Alessandro De Crignis: Pages 181, 183 (top).

Copyright © 1995 by the William S. Burroughs Estate, used with the permission of The Wylie Agency, LLC./By permission of the Houghton Library, Harvard University: Page 44.

Dick Cavett/Daphne Productions, Inc.: Pages 220–221.

Courtesy of the Estate of Paddy Chayefsky/By permission of the Houghton Library, Harvard University: Page 141 (bottom right).

Robert Emmett Bright/*Architectural Digest* © Condé Nast Publications: Pages 148 (top right; bottom), 184 (top).

Robert Emmett Bright and Alessandro De Crignis/*Architectural Digest* © Condé Nast Publications: Pages 182 (bottom), 183 (bottom right), 185 (bottom), 189 (bottom left), 191 (top).

Derry Moore/*Architectural Digest* © Condé Nast Publications: Pages 212 (center), 214 (bottom), 215 (center; bottom).

Alfred Frueh/*The New Yorker* © Condé Nast Publications: Page 136 (bottom).

Leombruno-Bodi-Lami/*Vogue* © Condé Nast Publications: Pages 149 (right; left), 182 (left), 188, 190 (top).

© Robert Risko/*Vanity Fair*, Condé Nast Publications: Page 235 (right).

Vanity Fair, September 2001 © Condé Nast Publications: Page 234 (left).

© 1983 *The Man Who Said No*, Gary Conklin Films: Page 224 (top row).

© Bettmann/Corbis: Pages 11, 19 (top center), 21, 22 (right), 23 (top left), 33 (top; bottom), 123, 177 (top left), 204 (bottom), 225 (bottom).

© Leombruno-Bodi-Lami/Condé Nast Archive/Corbis: Page 182 (top right).

© dpa/Corbis: Page 63 (top right).

© Allen Ginsberg/Corbis: Page 207 (top).

© John Springer Collection/Corbis: Page 95 (left).

With kind permission of the Estate of Noel Coward/By permission of the Houghton Library, Harvard University: Page 73 (bottom).

© Langdon Clay: Pages 183 (bottom left), 185 (left).

ELP Communications © 2004: Pages 216 (top), 217 (top left; top right).

© *Esquire*: Pages 172 (top; center), 173 (top; center).

Everett Collection: Pages 92 (top right), 93 (top left).

© NBC/Everett Collection: Page 226 (top).

© Paramount/Everett Collection: Page 227 (top).

Phillips Exeter Academy Archives: Page 47 (top).

© Otto Fenn/By permission of the Houghton Library, Harvard University: Page 62 (top).

© Fornaciari-Nusca/Gamma/Eyedea: Page 228.

Family Guy © 2005 Twentieth Century Fox Television. All rights reserved.: Page 232 (bottom).

Slim Aarons/Getty Images: Page 178.

CBS Photo Archive/Getty Images: Pages 216–217 (bottom).

Jerry Cooke/Time & Life Pictures/Getty Images: Page 206 (left).

Frank Edwards/Fotos International/Getty Images: Page 160 (bottom).

General Photographic Agency/Getty Images: Page 17 (bottom right).

Lisa Larsen/Time & Life Pictures/Getty Images: Page 72.

Leonard McCombe/Time & Life Pictures/Getty Images: Pages 104, 136 (top left).

Fred W. McDarrah/Getty Images: Pages 128 (top left), 177 (top right).

Franco Origlia/Getty Images: Pages 184 (bottom), 189 (top right), 244 (bottom).

Walter Sanders/Time & Life Pictures/Getty Images: Page 132 (bottom, left).

© Dick Miller/Globe Photos, Inc.: Page 94 (left).

Ronald Grant Archive: Page 235 (bottom).

Paramount Pictures/Ronald Grant Archive: Page 161 (bottom).

United Artists/Ronald Grant Archive: Pages 156 (top), 157 (top).

Warner Brothers/Ronald Grant Archive: Page 93 (top right).

© Jerry Hawke: Page 251.

© Jo Healy: Page 73 (top; center).

The John F. Kennedy Presidential Library & Museum, Boston: Page 109 (center).

Collection Harry Kloman/Copy work by Renee Rosensteel: Pages 15 (bottom), 78 (top right), 119 (top right), 224 (center right), 225 (top), 237 (top right; center left).

Transcontinental/Marianne/The Kobal Collection: Page 158 (bottom).

Twentieth Century Fox/The Kobal Collection: Page 162 (top right).